IMAGES

of America

WEBSTER

The founding of Webster was a direct result of the actions of Samuel Slater, who was born in England in 1768. A young Slater became an apprentice to textile mill owner Jedediah Strutt, not only learning about textile machinery, but also adopting a similar philosophy of life in how to conduct business, treat employees, and the importance of control. After surreptitiously leaving England in 1789, Slater established a partnership with Moses Brown, building textile mills in Rhode Island using the highly protected English process. In 1812, looking to expand, Slater established mills in the town of Oxford and later in Dudley, but due to control issues, the relationship with the host towns soured. Slater used his influence in the Massachusetts legislature and successfully petitioned for the creation of the new town of Webster in 1832. Slater died in 1835, but the Slater mills continued to thrive and expand under the direction of his sons and grandson until the end of the 19th century, with the eventual sale of the mills in the 1920s and 1930s. (Contributed by S. Slater and Sons, Inc.)

IMAGES
of America

WEBSTER

John J. Mrazik, Carla Manzi,
and James J. Manzi

ARCADIA
PUBLISHING

Published by Arcadia Publishing
Charleston, South Carolina

Library of Congress Catalog Card Number: 2005921799

For all general information contact Arcadia Publishing at:
Telephone 843-853-2070
Fax 843-853-0044
E-mail sales@arcadiapublishing.com
For customer service and orders:
Toll-Free 1-888-313-2665

Visit us on the Internet at www.arcadiapublishing.com

On the cover: The Pineries was a cottage located on Well Island, also called Bates Island on an 1870 map of Webster. A deed from 1901 locates the Pineries between Point Pleasant, Long Island, and Bay View. The men in this photograph include Louis Howard, Carl King, Arthur Klebart, Wadsworth Crawford, Albert Spencer, and Stephen Travis. (Contributed by Ruth Klebart Lavigne.)

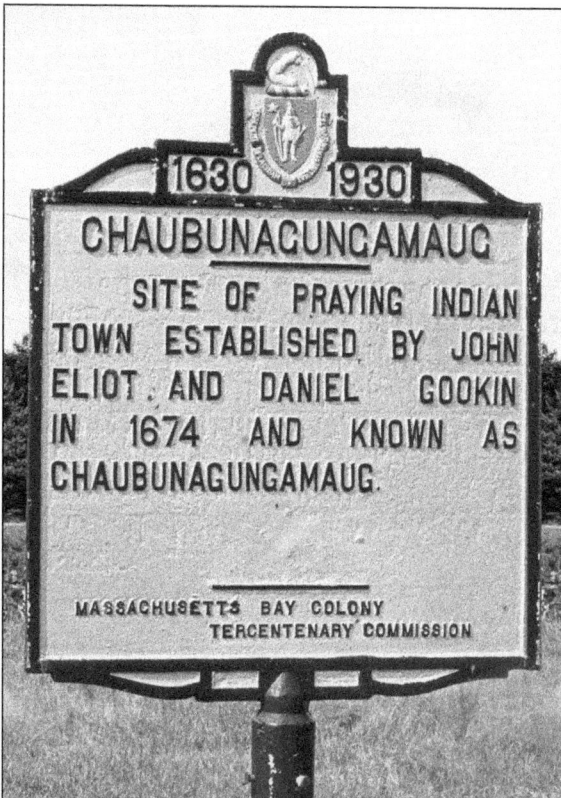

John Eliot, so-called "apostle of the Indians," and Daniel Gookin of the Massachusetts Bay Colony organized praying towns throughout central Massachusetts to introduce Christianity to the Native Americans. This sign at the intersection of Thompson Road, Lake Street, and Birch Island Road marks the site of the Chaubunagungamaug praying village.

CONTENTS

ACKNOWLEDGMENTS

The authors wish to express their gratitude to all those who responded to our requests in support of this project. For the many telephone calls that were returned and for making an effort to help identify people and places, your assistance was most appreciated. In addition, thanks are also extended to the following individuals and organizations: Doug Williamson, Kathy Swierzbin, and Jeff Stefanik of the Webster-Dudley Historical Society, Joseph Rodio and the staff at the Chester C. Corbin Library, Michael Hackenson and Chester Wolochowicz of Bartlett High School, town surveyor Stanley Duszlak, the *Worcester Telegram and Gazette*, the *Webster Times*, the *Patriot*, Marc Becker of Sterling Realty, Chad Pepin of BrainFrog.com for his invaluable technical assistance, and Edward Patenaude for his editorial guidance and anecdotal tidbits of local history. Also, not to be overlooked is the patience and understanding of our families during the yearlong process.

Other sources that provided reference material include the *Webster Times* Souvenir Edition, Anniversary Edition, and 200 Years of Progress issues; the *Historical and Architectural Survey of Webster*, done by the Webster Historical Commission from 1978 to 1979; the *Slater Mills at Webster 1812-1912*; the *Charles Leavens Notes*; *Shoreliner*; and Oldewebster.com.

While we were diligent in our efforts to include a fair and accurate representation of the history of the town within the publication limitations, we realize that there may be errors and/or omissions. We apologize in advance for any unintentional misrepresentations that might have occurred in the preparation of this project.

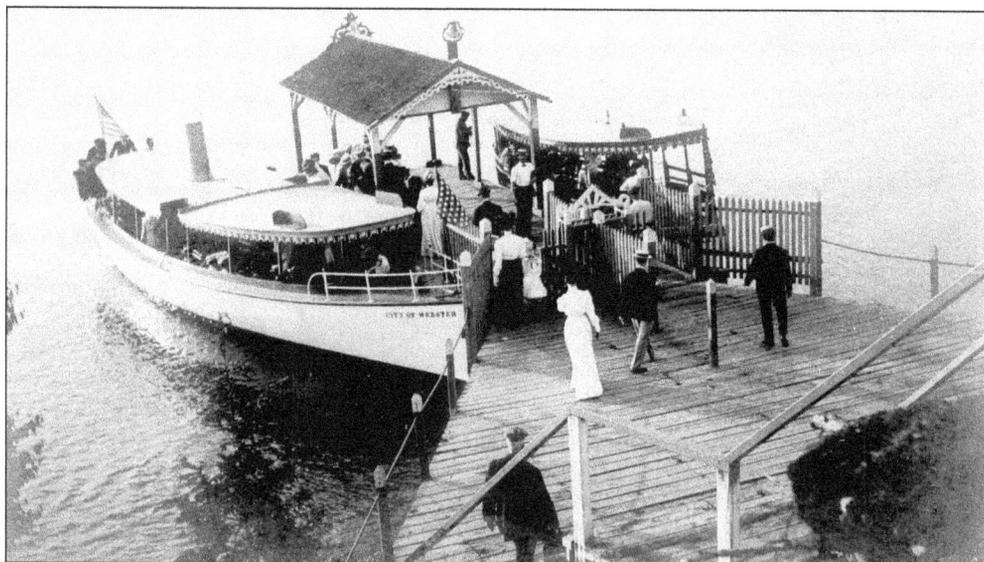

Lake Chargoggagoggmanchauggagoggchaubunagungamaugg, or Webster Lake, is known far and wide for its unusual name and natural beauty. Over the last 100 years, it has served as one of the most popular year-round recreation spots in this part of the state. This photograph, taken around 1900, shows the beautiful steam excursion boat *City of Webster*, which shuttled visitors to various stops along the lake's 17 miles of shoreline.

INTRODUCTION

Webster, a town of approximately 16,000 residents, is located in south central Massachusetts, on Connecticut's northeast border. The community's most distinctive geographic feature is a beautiful glacial lake created thousands of years ago during the Ice Age. This area was inhabited by a significant Native American population, primarily Nipmuc, who were responsible for the lake's long and unusual name, Lake Chargoggagoggmanchauggagoggchaubunagungamaugg. The true meaning of the word is still subject to controversy, but Larry Daly, former *Webster Times* editor, concocted the whimsical interpretation of "you fish on your side, I fish on my side, nobody fishes in the middle," which is the translation quoted most often.

The formation of the town was a direct result of the influence of Samuel Slater. Slater is known as "the Father of American Manufacturers," a moniker established by Pres. Andrew Jackson, who understood the significance of Slater's contributions to establishing a modern textile process in America. After leaving England with an understanding of the highly protected English textile process, Slater set up mills in the 1790s in Rhode Island, and in 1812, he established a mill in what would become East Webster. Slater was attracted to the area by the water potential of the lake, the Maanexit, or French, River to power his mills, and the potential workers available on local farms.

Slater would later establish mills in what would become known as North and South Villages, expanding to both cotton and woolen products in addition to the cambric products being produced in East Village. The Slater mills occupied part of the towns of Oxford and Dudley, and in 1832, the Slater forces petitioned the legislature to create a new town, Webster. Both Oxford and Dudley opposed the action, but Slater prevailed, and the new town was named for statesman Daniel Webster, whom Slater admired. The Slater organization would go on to dominate the town politically, socially, and economically for close to 100 years. In succeeding years, Webster outdistanced both of its seed towns by a considerable margin in terms of population and economic activity, but a close affiliation with Dudley was maintained.

In 1840, the Norwich and Worcester Railroad entered Webster, providing the town with an excellent transportation source to carry passengers and ship goods to Worcester, Boston, and New York via the water connection at Norwich, Connecticut. The establishment of the railroad resulted in a major change in the location of the commercial district of the town. Prior to the coming of the railroad, most of the town's activities centered on the East Main Street area, but a shift to Depot Village, today's Main Street, occurred as the railroad's importance expanded. Two other railroads entered Webster, the Boston, Hartford, and Erie Railroad in the 1860s, and the Providence, Webster and Springfield Railroad in the 1880s. In 1912, a fourth railroad, the Southern New England Railroad, or Grand Trunk, was 80 percent completed before construction was halted, in part due to the death of the railroad's president, Charles Hays, on the *Titanic*.

The industrial base of the community continued to expand in the 19th century as other industrialists established operations in the area. Especially noteworthy was the growth of the shoe industry. Immigrants from a wide variety of nations flocked to Webster looking for opportunities to work in the busy mills. With the growing population, the Main Street business and retail district continued to expand. People from surrounding communities traveled to Webster to avail themselves of the many products and services available. Late in the 19th century, Webster Lake's recreational aspects were parlayed into a significant economic gain, especially after Edgar S. Hill took control of two lake resorts, Point Breeze and Beacon Park. Webster Lake became one of

the top summer destinations in all of Worcester County, and the enterprising Hill built a trolley system to accommodate prospective lake goers.

The 20th century saw continued expansion throughout the community in terms of population, town services, schools, churches, industry, recreation, and housing, but it also signaled the end of the Slater dominance, with the sale of their mill complexes in the 1920s and 1930s. The Depression of the 1930s was a major economic set back, but the rebound with the start of World War II was remarkable. In the country's wars, Webster has been noted for supplying not only the forces needed to wage battle, but also for the goods to conduct the wars successfully.

In the middle of the 20th century, a number of trends began to develop, namely, a regression in the bustling Main Street activity and a disappearance of industry. Webster's main thoroughfare has had a history of parking space problems ever since automobile usage became commonplace, forcing a number of businesses to relocate in East Webster where parking lots could be established. The other major factor leading to the demise of the Main Street business district was the advent of the out-of-town mall. The disappearance of industry and the loss of jobs have changed the complexion of the area from a blue-collar mill town to a more demographically diverse population. The community is very fortunate that Commerce Insurance, Webster's largest employer, has helped to fill the employment void.

Due to the transitory nature of society in the United States, the concept of "my hometown" seems to be an old-fashioned idea. The hope for Webster is to realize its potential and move forward so that the town's children will be able to reflect and reminisce about the town with the same pride that the authors have encountered during the research of this book.

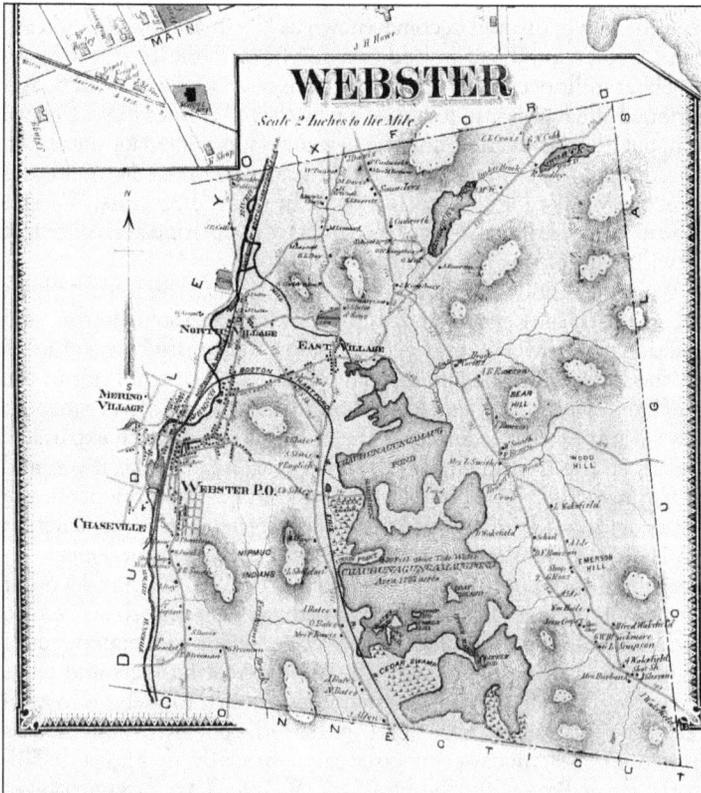

This is an 1870 map of the town of Webster.

One

BUSINESS AND INDUSTRY

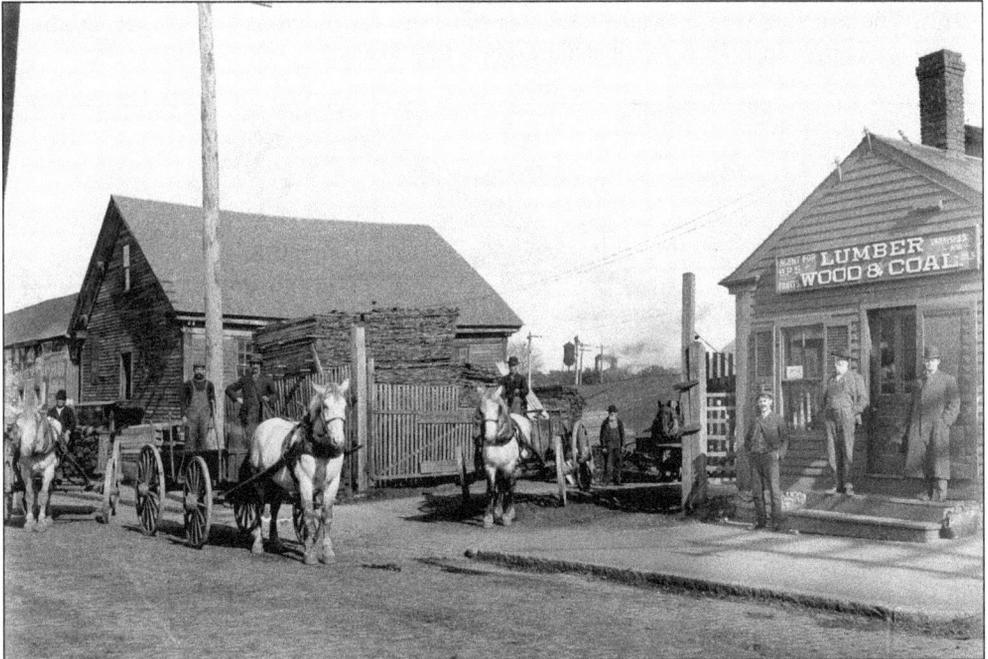

Louis E. Pattison, on his return from the Civil War, started and maintained a very successful coal and lumber business at this Pleasant Street location. The business was positioned perfectly for receiving goods from the railroad, which was literally in its backyard. In the mid-1930s, the business changed ownership, with Horace Trull taking over the operation. (Contributed by Chester C. Corbin Public Library.)

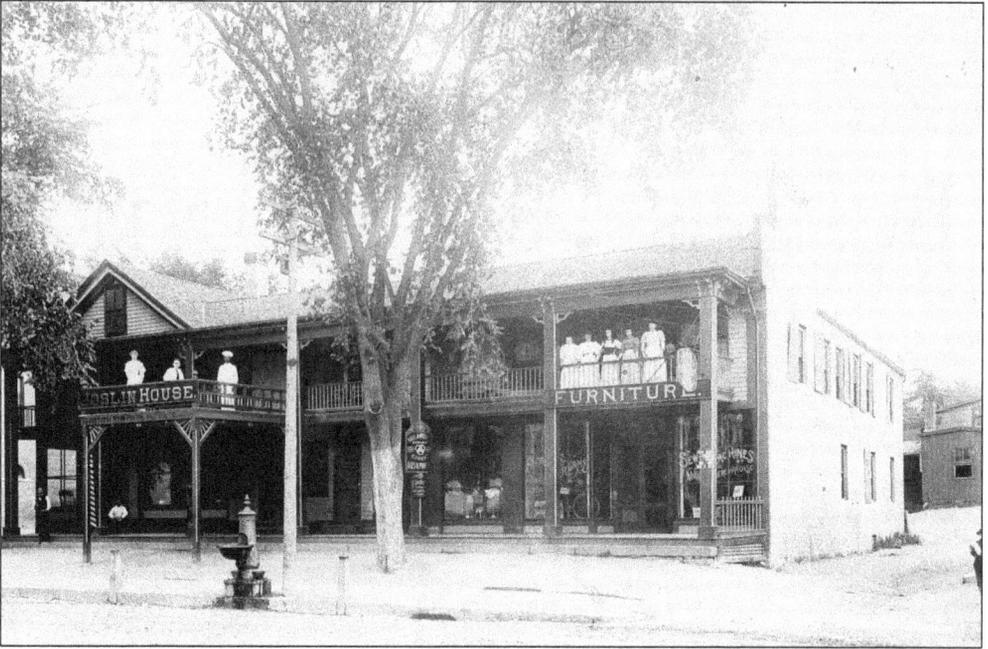

The Joslin House, built in 1844 by Nathan Joslin at the corner of Main and Mechanic Streets, could truly be considered one of the more important structures built in Webster's early history. It served as a hotel and dining facility, hosting many of Webster's most important early social events. The structure was renovated a number of times over the years and was rebuilt after a major fire occurred in 1939. (Contributed by Edward Patenaude.)

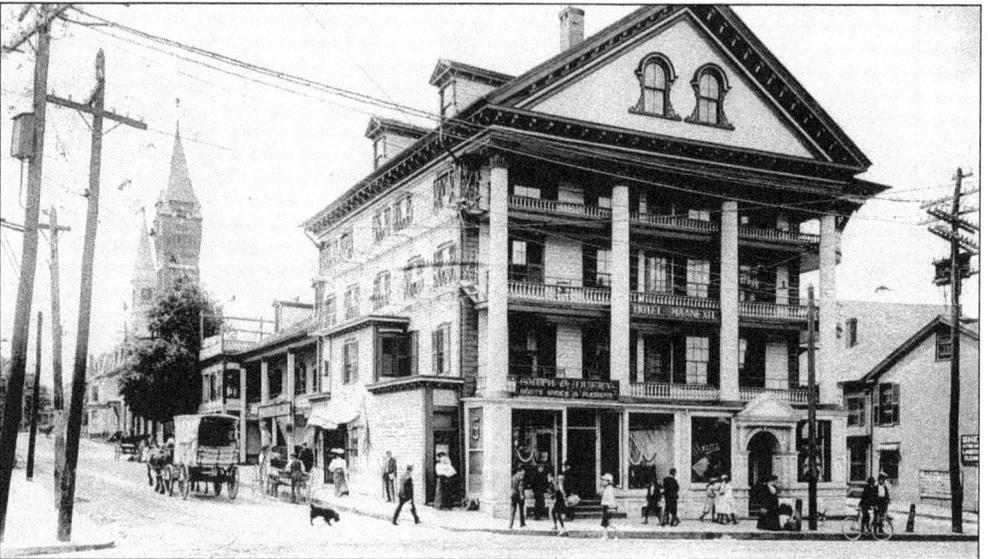

The Hotel Maanexit (originally known as the McQuaid Block) was located at the intersection of Main and School Streets, occupying the site of today's Dunkin Donuts. The wagon pictured here is headed up School Street, with the fire station and Universalist church steeples clearly visible. The hotel was positioned near the railroad, making it an excellent location for travelers arriving in Webster to stay. (Contributed by Webster-Dudley Historical Society.)

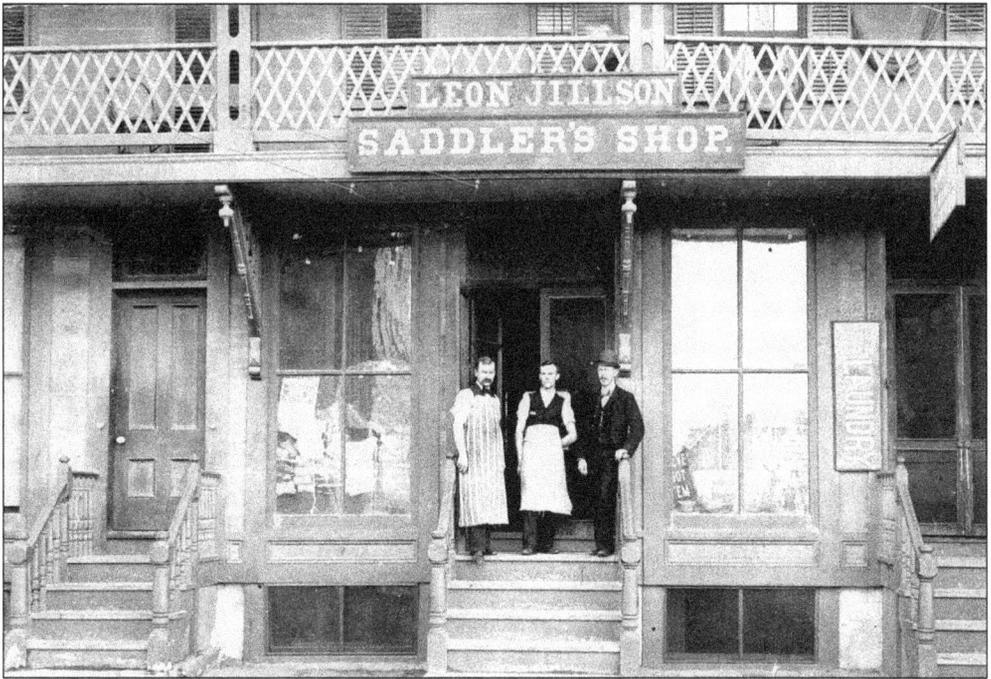

In the 19th century, having a saddler on Main Street was a wise move for a community, and Webster was no exception. Saddles, harnesses, and other equipment for horses could all be taken care of at Leon Jillson Saddler's Shop. (Contributed by Chester C. Corbin Public Library.)

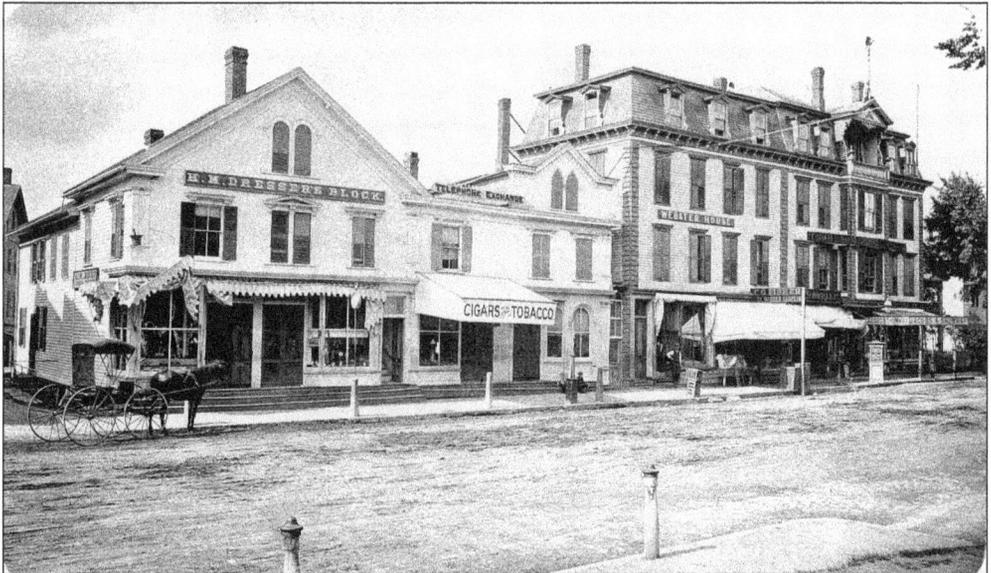

Over the years, the Dresser Block played host to many important Main Street businesses. Webster's first phone exchange was located on the second floor of the building. The beautiful Webster House Hotel was right next door. (Contributed by Webster-Dudley Historical Society.)

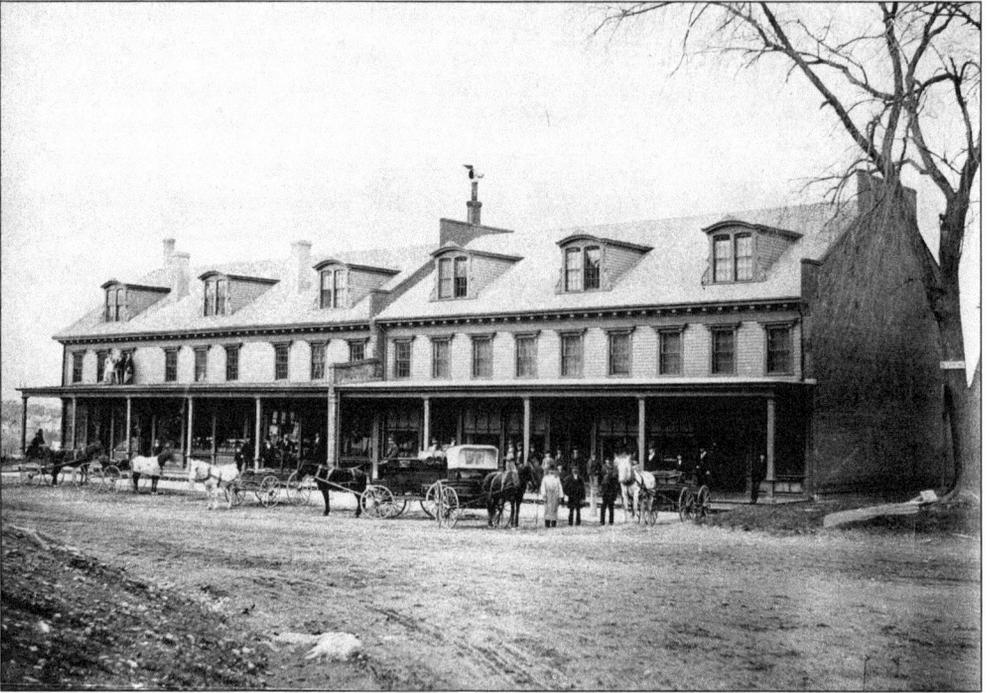

The Slater store was located at the intersection of East, North, and South Main Streets, the present location of the Webster First Federal Credit Union. Slater employees were entitled to special discounts. After the Slater era, the building was used by a number of local businesses before being closed to make way for the new bank. (Contributed by Webster-Dudley Historical Society.)

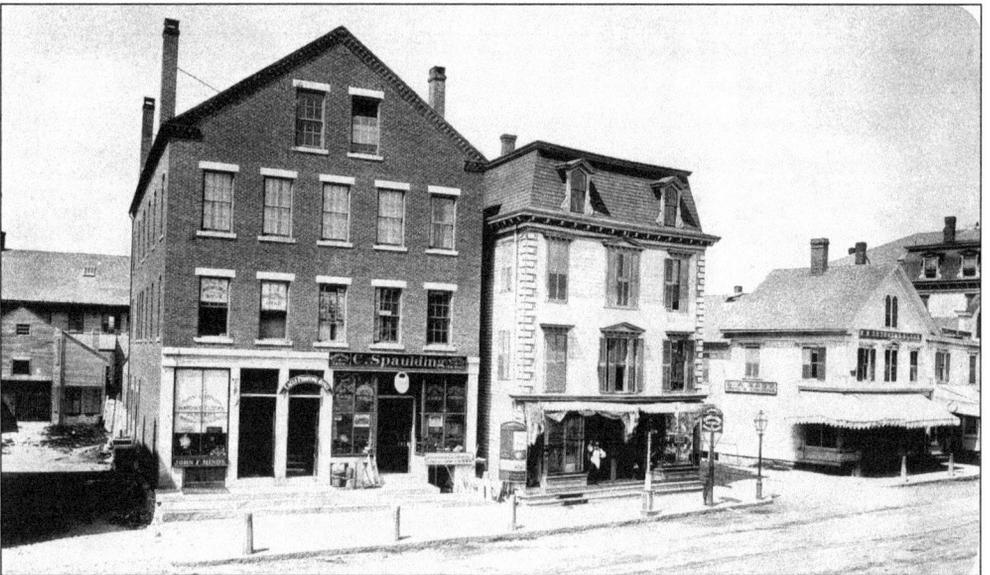

The Spaulding Block, built in 1866, has housed many Webster businesses. At the time this picture was taken, a person could purchase tools from Spaulding's store, go upstairs to have some printing done by Eagle Printers, or go next door to have a watch fixed by John L. Hinds. (Contributed by Webster-Dudley Historical Society.)

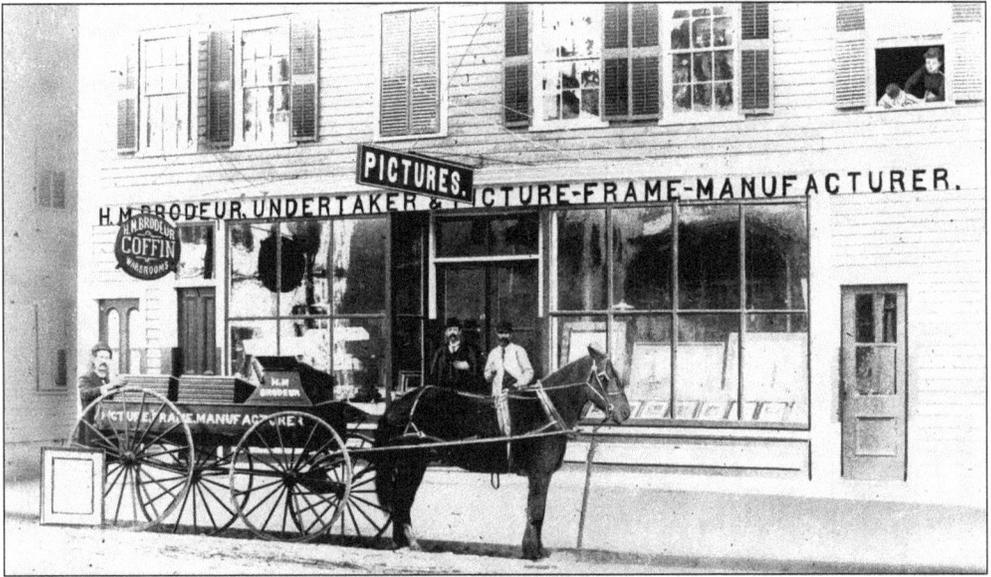

H. M. Brodeur was certainly a flexible businessman. If one needed a picture framed, a religious item for home or church, or the unfortunate need to have someone embalmed, Brodeur could take care of all your needs. In 1887, Brodeur was joined by his brother-in-law, Eldege Paradis. Paradis eventually purchased the business from Brodeur in 1889. (Contributed by Webster-Dudley Historical Society.)

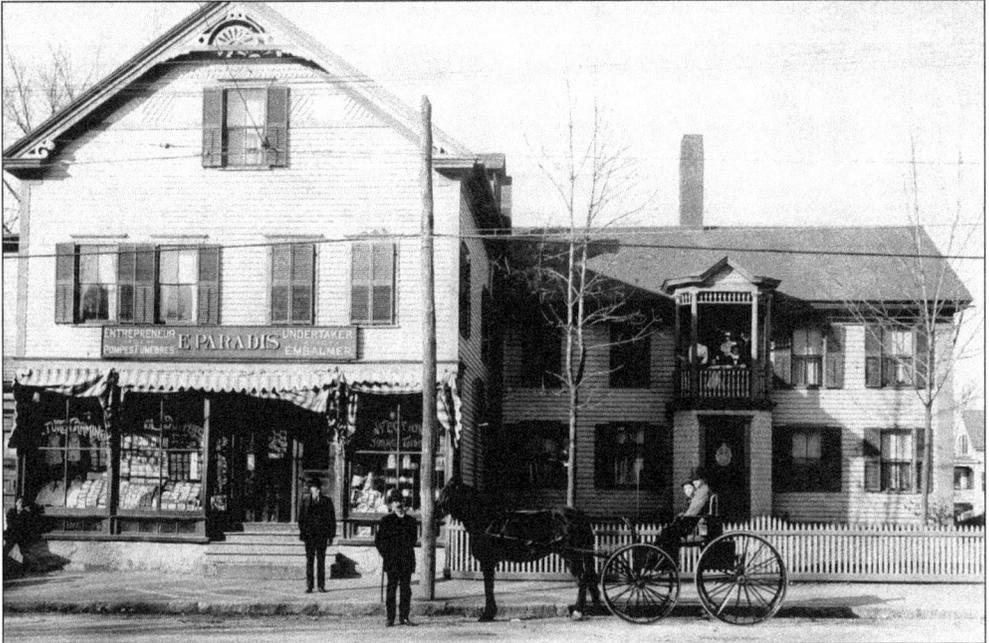

After purchasing the funeral business on Pleasant Street from his brother-in-law, Eldege Paradis moved his business to various locations along East Main Street, including the building pictured here. One particularly noteworthy move was in 1937, when the family acquired the Knolls, a beautiful estate built by H. Nelson Slater, which was used by Paradis for the business and as a residence. (Contributed by Webster-Dudley Historical Society.)

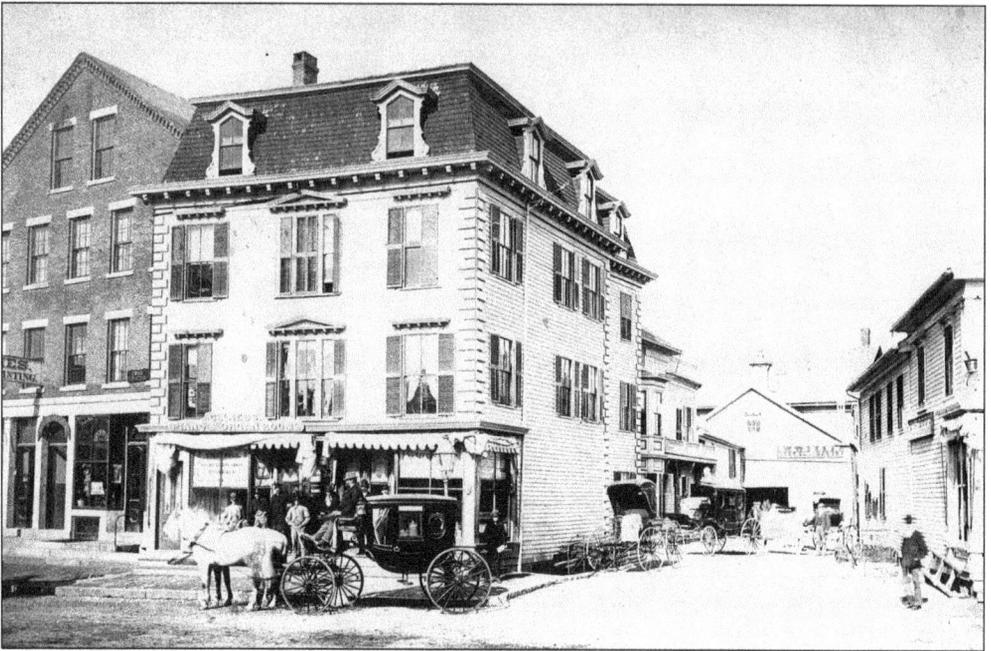

Webster's Main Street catered to those who were musically inclined; proof being the G. Krebbs Music Store, which opened in 1867. The following year, Krebbs organized the Webster Brass Band. David Brown, noted for erecting the town's first gas streetlight in 1867, is shown here driving the handsome horse-drawn cab. (Contributed by Webster-Dudley Historical Society.)

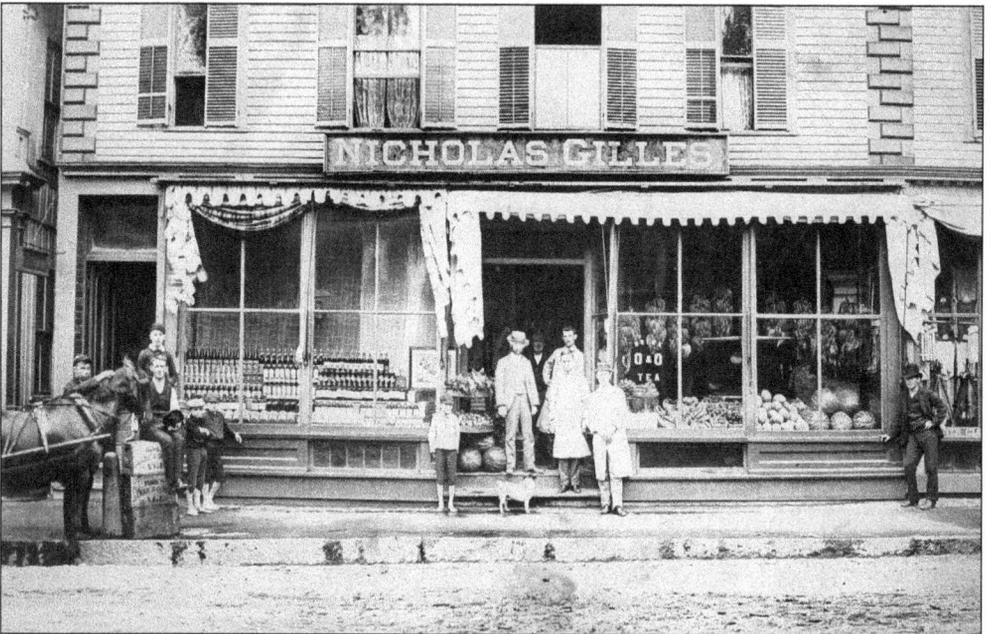

Gilles Block was Webster's largest market and grocery store. It was rebuilt after a serious fire in 1924. An interesting feature is the reservoir that was constructed under the sidewalk for use by the fire department. In the 1890s, the Gilles store advertised "fresh hot rolls ready everyday at 4 p.m." (Contributed by Webster-Dudley Historical Society.)

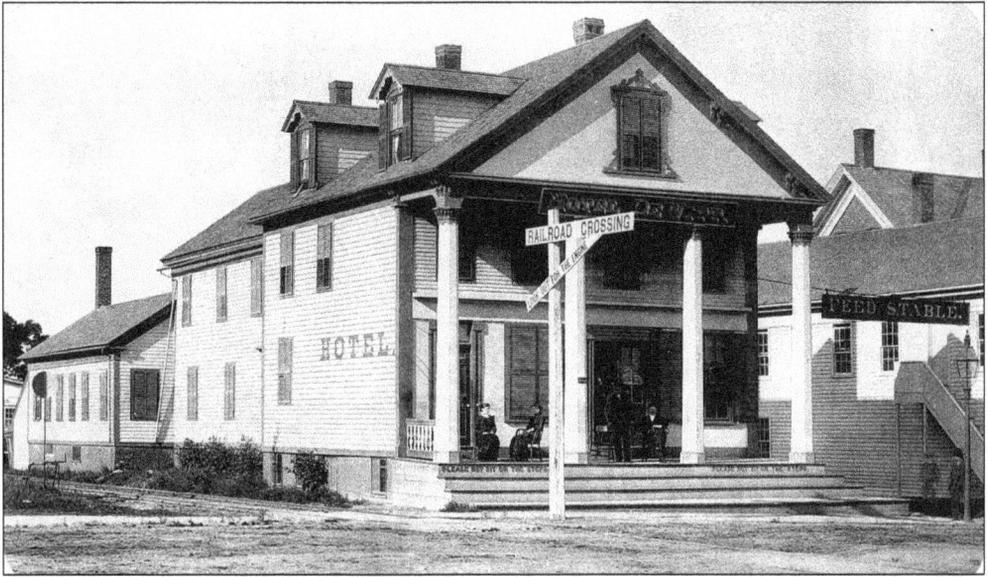

Hotel Dewitt was located on the west side of the Main Street railroad crossing, in close proximity to the train tracks. It was almost possible to touch the train out the window of the rooms on the east side of the building. Passing trains shook the building, disturbing the slumber of many patrons, and, on occasion, sparks from the old steamers would set the building on fire. Little wonder that many visitors chose the Maanexit Hotel. (Contributed by Webster-Dudley Historical Society.)

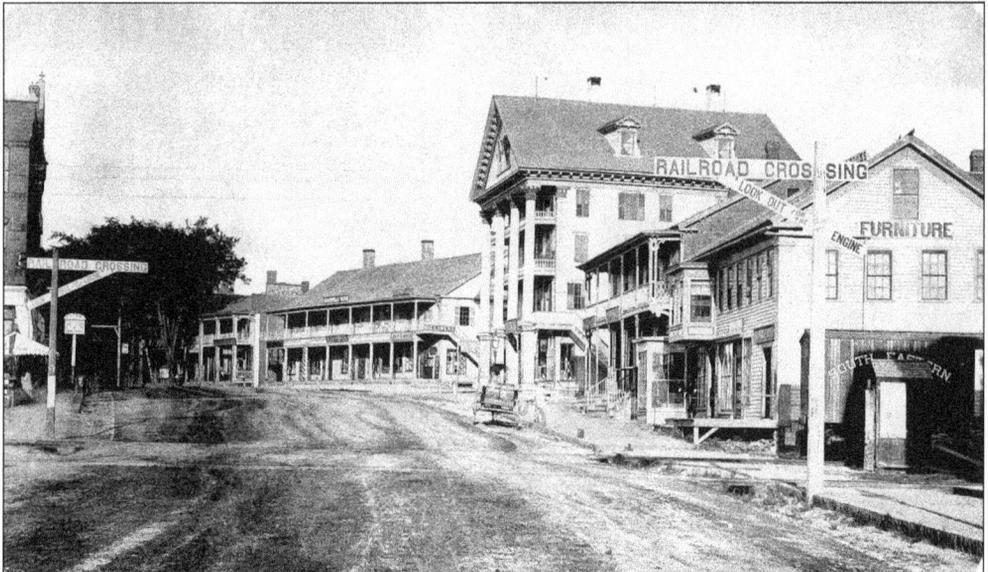

In this 19th century scene, the photographer was standing in front of the Hotel Dewitt, looking in an easterly direction up Main Street. The buildings on the right (south side) of Main Street are as follows: the Stockwell (Manzi) Block, Merchants (Columbia) Block, the McQuaid Block or Maanexit Hotel, Stockwell/Manzi Block, and the Joslin House. The building visible on the left is the Eddy-Times Building. (Contributed by Webster-Dudley Historical Society.)

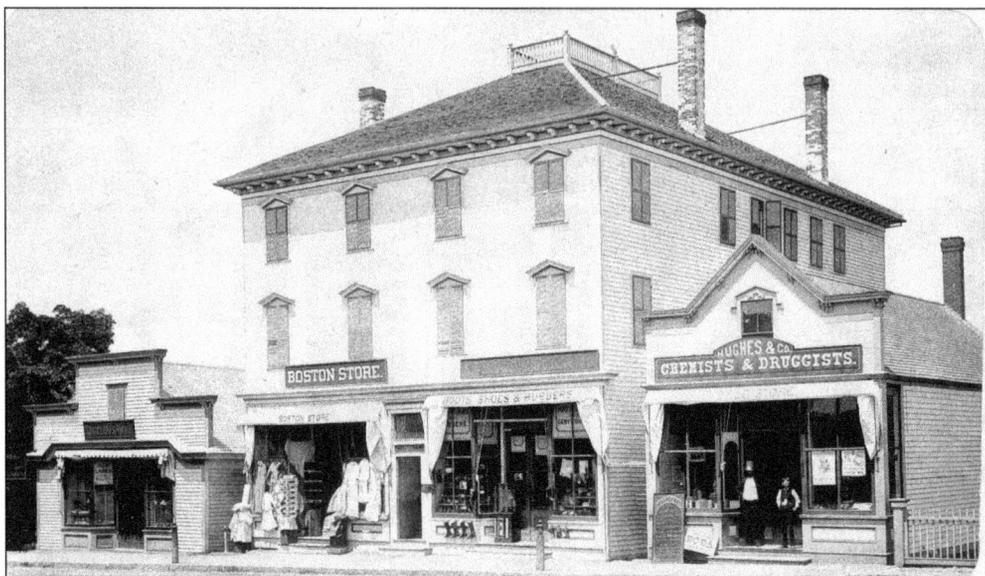

Bigelows Liquor occupied the building shown here on the left in the Burnett Block. The Boston Store, opened in 1889, was considered the top store for ladies clothing in Webster, stocking the latest in styles from the cities. On the right is Hughes Pharmacy, one of Webster's first pharmacies, which was later joined by others, namely, Vernons, Liggetts, Tonyleas, Guays, and Dugans. (Contributed by Webster-Dudley Historical Society.)

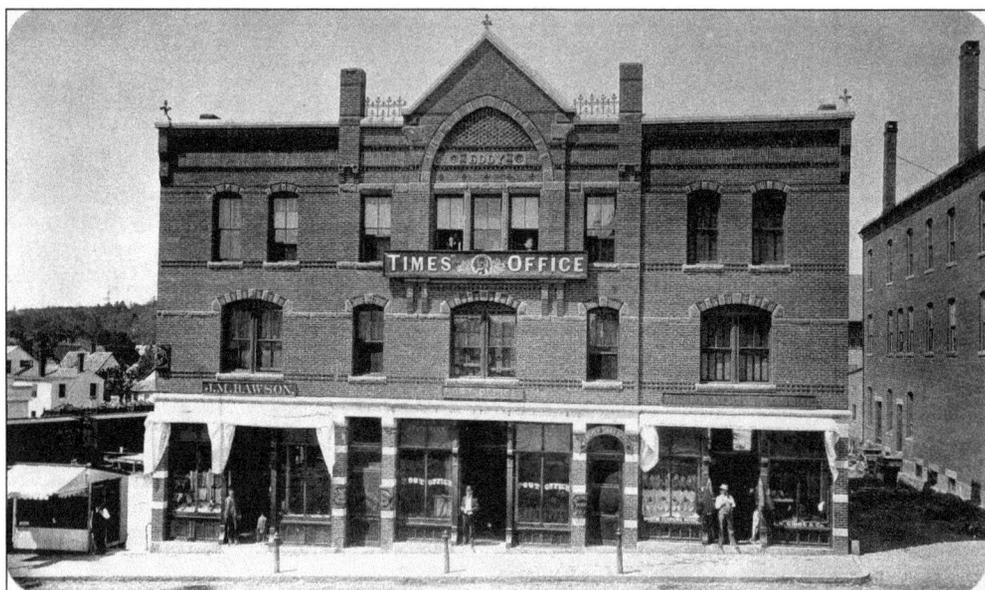

This fine structure, the L. R. Eddy Building, is still in use today. There were actually two Eddy Blocks. The first, at Main and Mechanic Streets, housed the Webster Five Cents Savings Bank and the First National Bank. The second, the building shown here at Davis and Main Streets, was home to the *Webster Times* and the post office. (Contributed by Webster-Dudley Historical Society.)

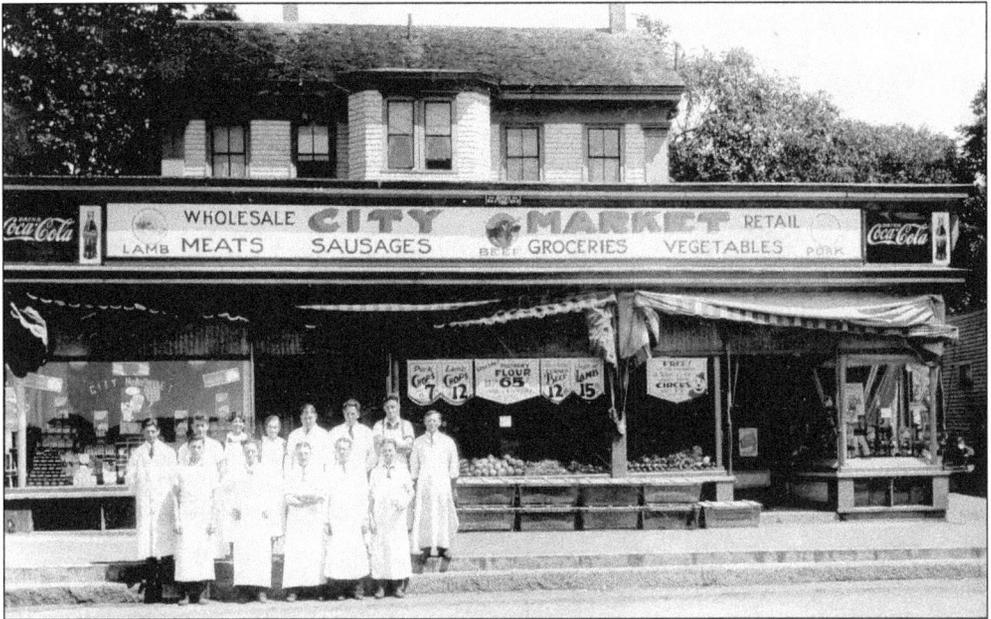

In this photograph, a fine-looking group of employees is out in front of Felix Klys's city market on South Main Street. The property remained in the Klys family for three generations. The building was reportedly used by its first owner, Asher Joslin, as a safe house for slaves in the Underground Railroad system as they traveled north before the Civil War. The building is presently under renovation by the Kochinskas and Boucher families. (Contributed by Al Nowicki.)

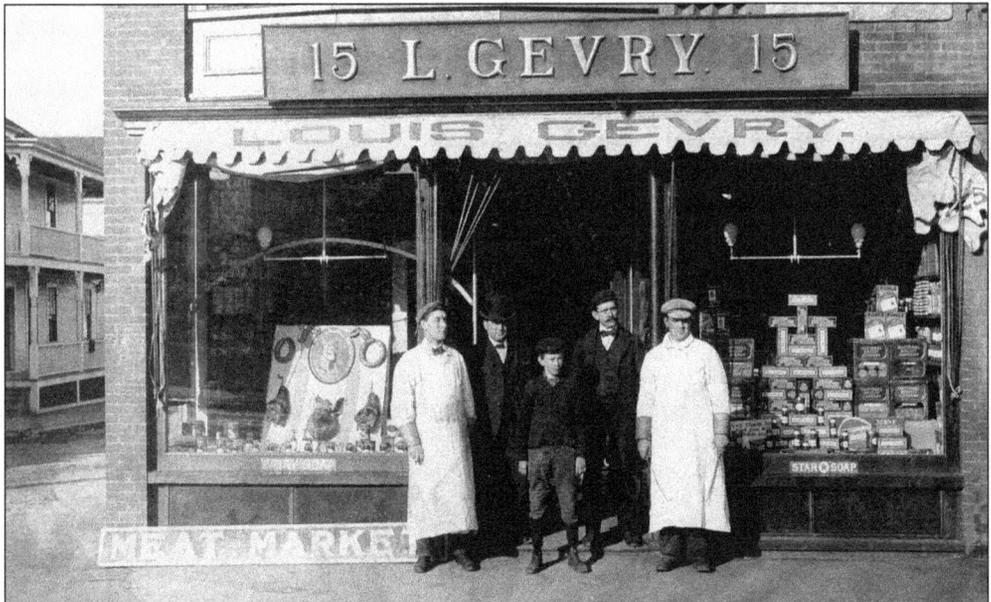

Gevry's Market was located on the corner of Main and Union Streets and was typical of the size of grocery stores of the 1930s. Most of the stores carried a limited supply of goods, forced to do so because of the constraints of their small confines. Like a number of other Webster businesses during the 1930s, the once successful Main Street market could not survive the Depression. (Contributed by Bernard Gevry.)

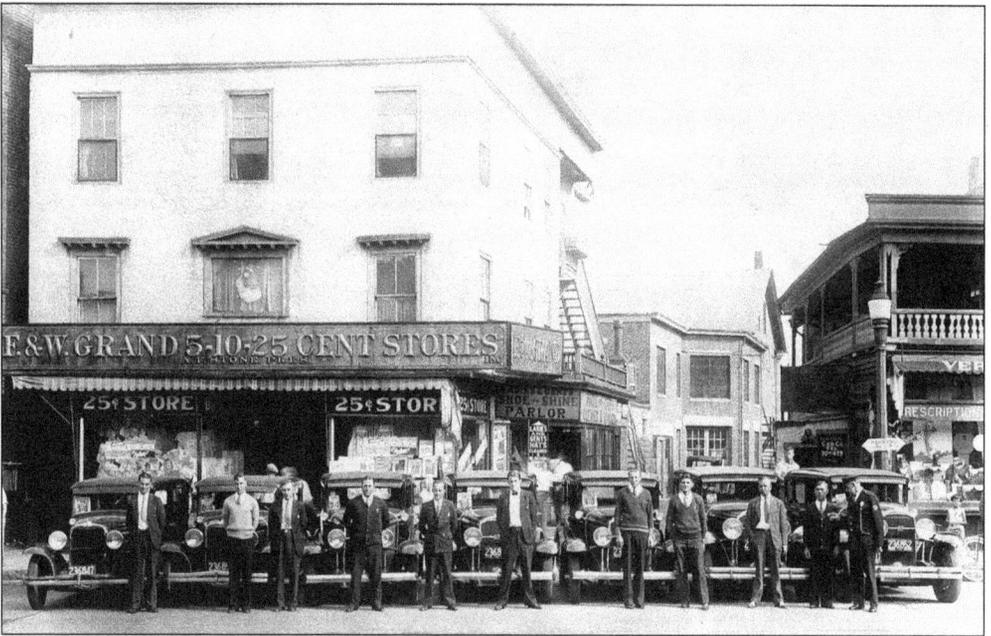

If one needed a ride and had to call a taxi, there would certainly be one available judging from this lineup. The drivers are, from left to right, Al Dutram, Earle Clarke, Frank Zilski, John Jarosz, Ben Pelletier, Ed Streich, Gus Kemnitz, Thomas Gardecki, Herb Johnson, Clem Dutram, police officer John Templemen, and mechanic Paul Ziebel (rear). (Contributed by Richard Gardecki.)

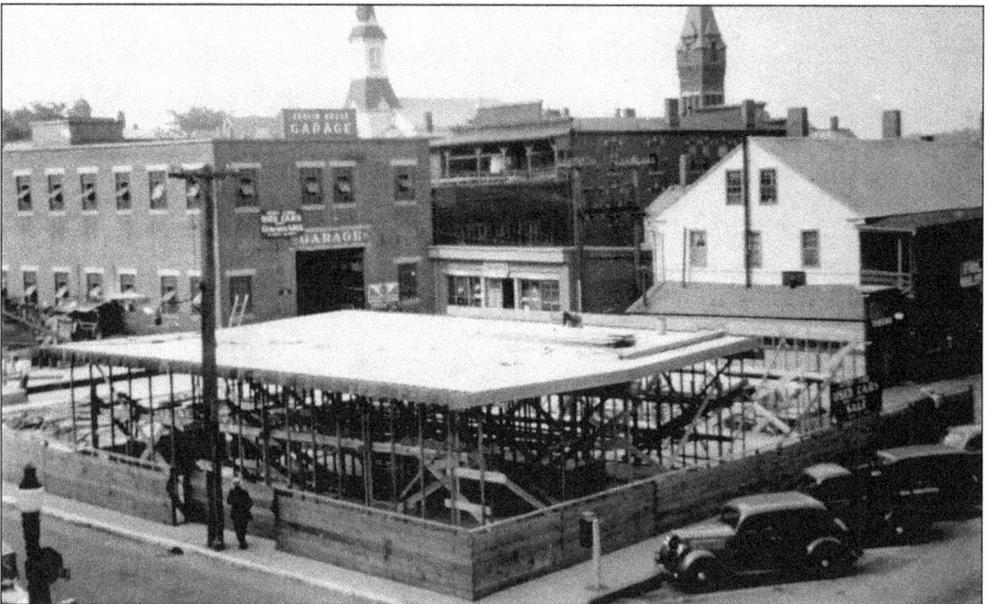

In the spring of 1939, the Joslin House on Main Street experienced a very serious fire. This photograph depicts the rebuilding effort in progress. In the background, a few local landmarks are easily discernible: the Buick garage, located almost directly behind the Joslin House; the white tower of St. Anthony's Church; and the distinctive brown tower of the old Webster Fire Station on School Street. (Reprinted with permission of the *Worcester Telegram and Gazette*.)

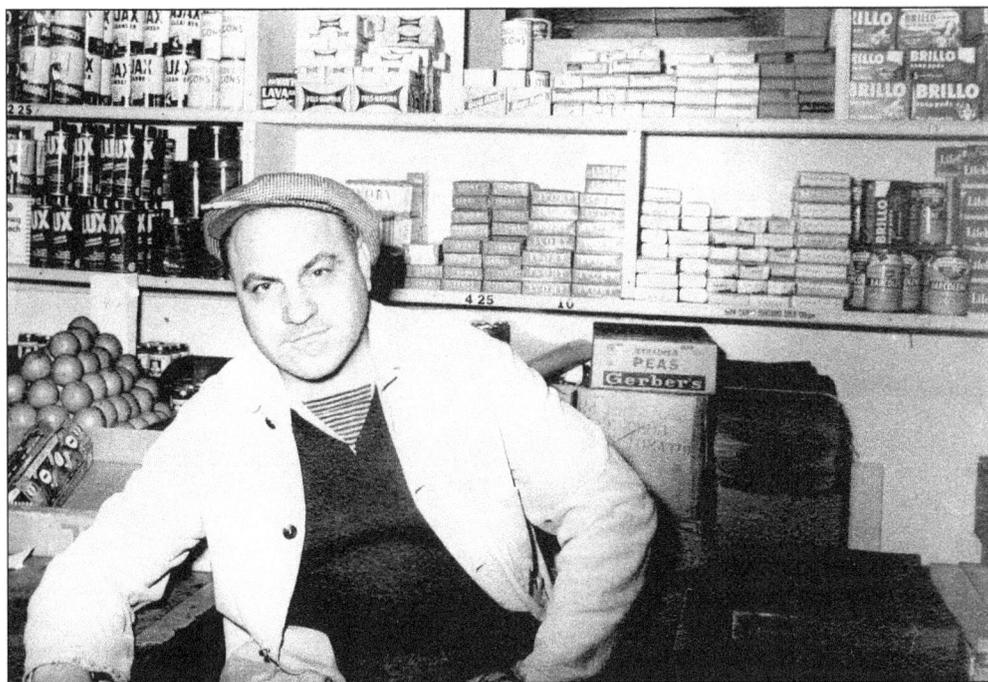

Before the advent of large markets, the neighborhood grocery store was a staple of the American way of life. Webster possessed many of these mom-and-pop operations, which included names such as Kujawski's, Wagner's, Neslusan's, Tomaszek's, Ozaniak's, Dandurand's, Manzi's, Vajcovec's, and Dwyer's. Joe and Josie Mrazik ran a small market on Myrtle Avenue. Joe is pictured here in the soap section of the market in 1954. (Contributed by John J. Mrazik.)

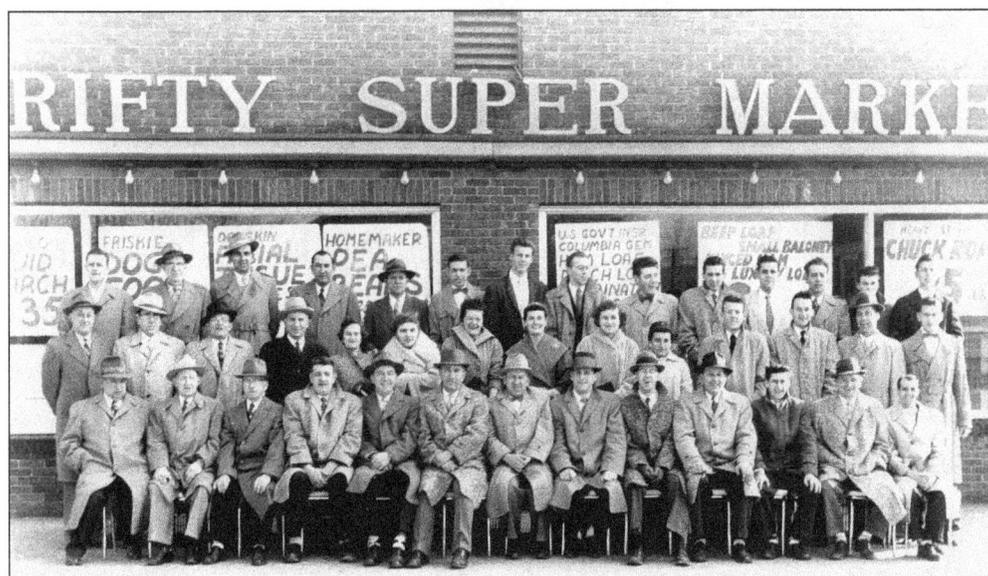

In 1951, Webster experienced the grand opening of its first true supermarket, Thrifty's, which was located at the corner of East Main and Cody Streets. The market dwarfed the many neighborhood markets that were located in Webster with statistics like these: parking for 50 cars, three checkouts, 10-foot frozen food section, and 60-foot meat case. (Contributed by Charles J. Baron.)

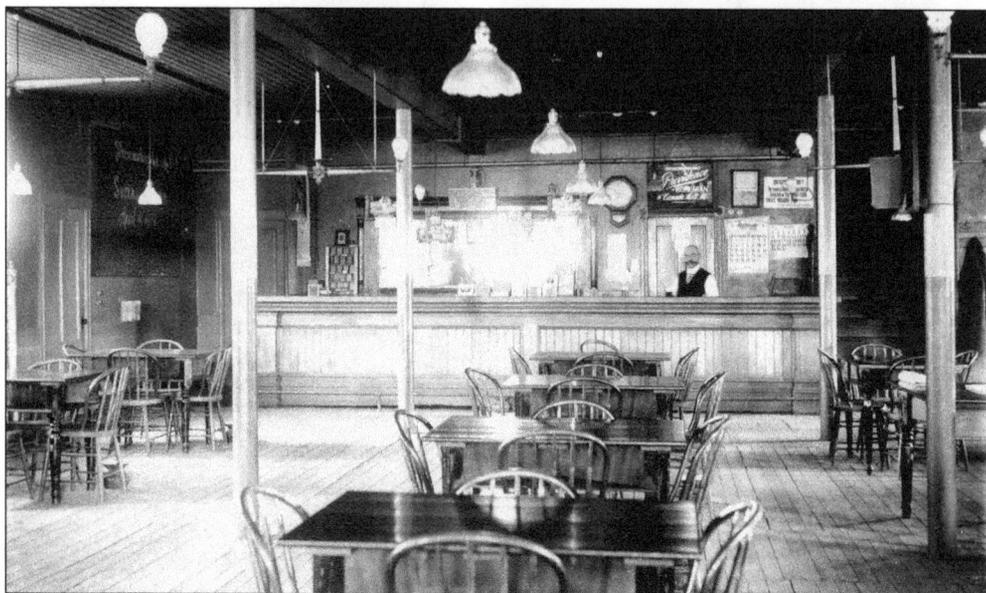

Dedicated on May 17, 1895, Turner Hall was a meeting place for the German fraternal society Turnverein Vorwarts. Located on Houghton Street, Turner Hall was the center of social and political activities for the group, which was one of the best-known organizations in town. The German society sold the building to the Webster-Dudley American Legion Post No. 184 in 1947, and in 1953, the group disbanded. (Contributed by Sylvio Gilbert.)

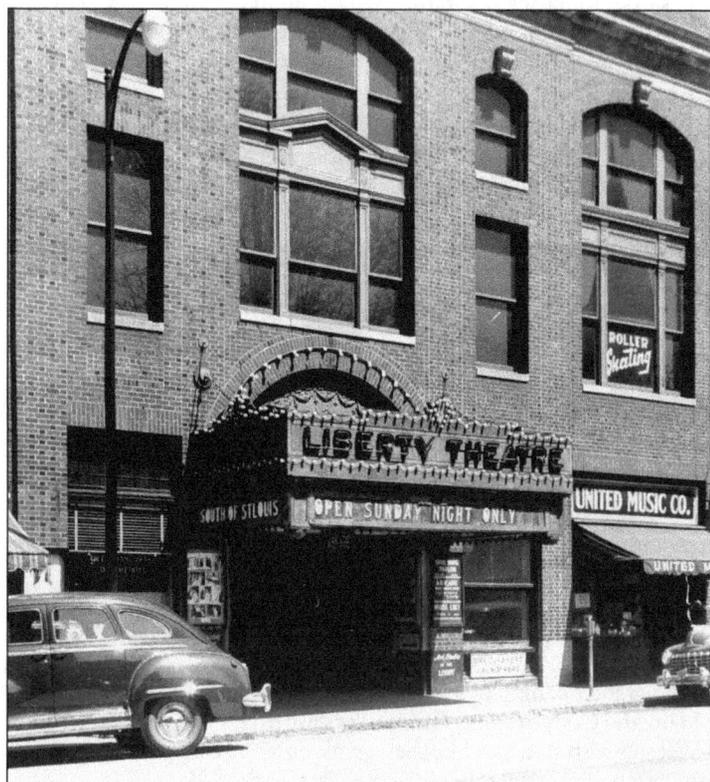

Two Main Street theaters were the State, originally the Steinberg Theatre, and the Liberty, originally the Coster Theatre. The State, located behind the Larcher-Branch Building, was designed to host live stage shows, but the Liberty, located behind the Holden Building, was designed for motion picture use only. The competition of drive-ins and city theaters spelled doom, and the State closed in 1963. (Contributed by Webster-Dudley Historical Society.)

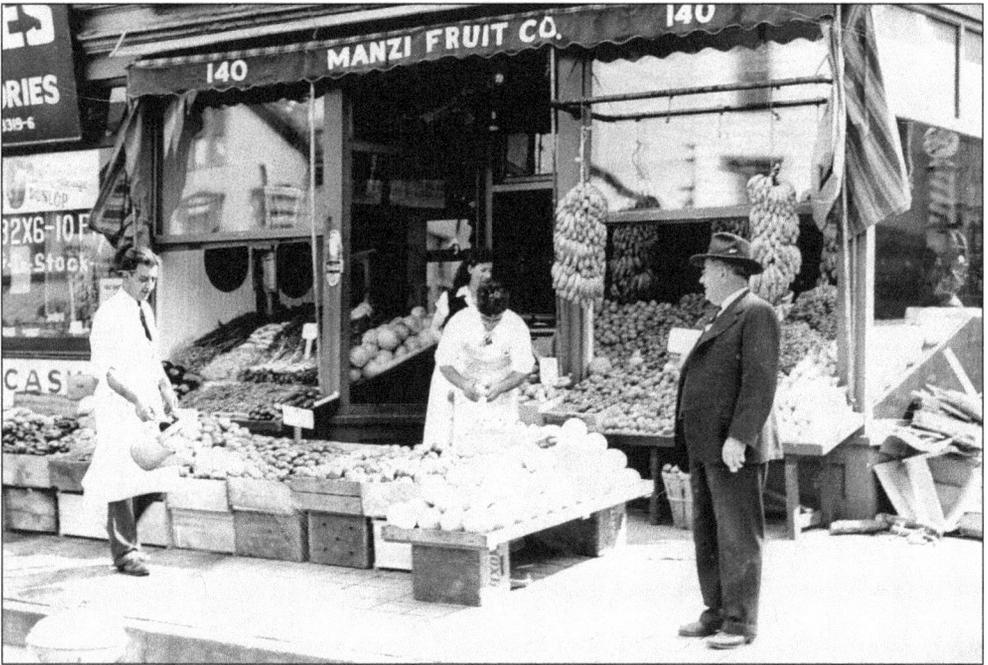

Manzi Fruit Company was a fixture on Main Street for more than 60 years. The fruit and grocery store made home deliveries, and to this day, folks ask about "those grinders." The store was located in the historic Stockwell Block on the corner of School and Main Streets, across the street from the Maanexit Hotel. (Contributed by Jim Manzi.)

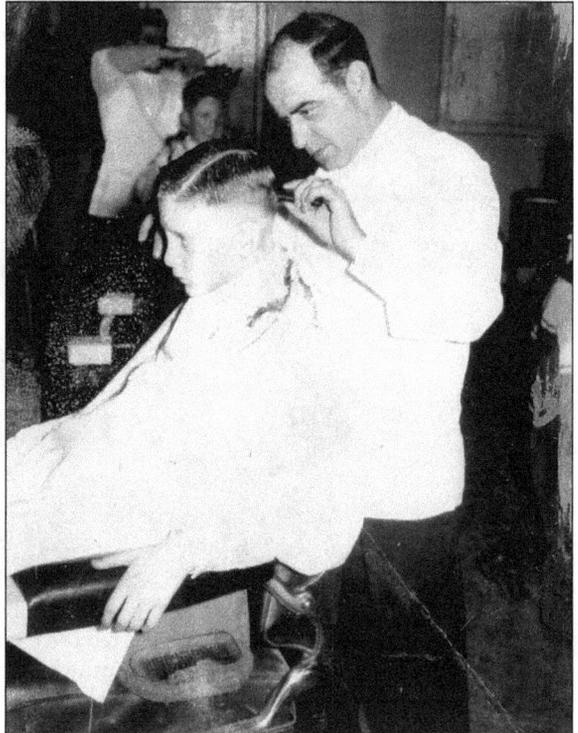

Before seeing a hairstylist became an acceptable activity for men, Webster had a large number of old-fashioned men's barbershops. Pictured here, cutting the hair of a young patron, is Fred Manzi, whose shop has been in continuous service at the same Main Street location since 1930s and is now operated by his son, Freddy. Other barbers who plied their trade in Webster include Chic the Barber, Terry's, Walter's, Artie's, Bazinet's, Curly's, Pio's, and Peewee's. (Contributed by Fred Manzi Jr.)

21

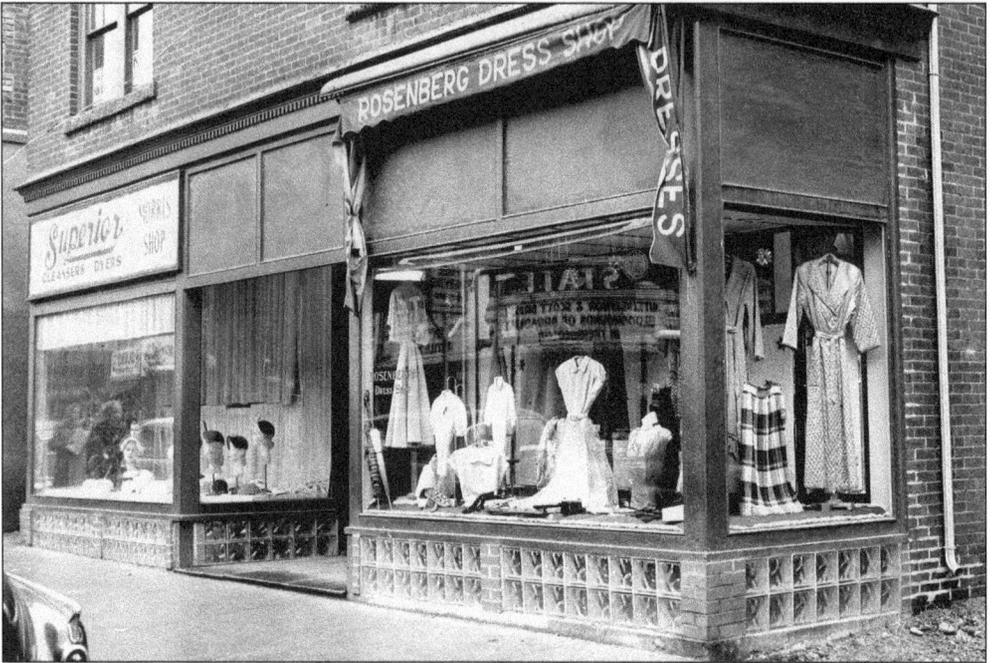

A bustling Main Street was lined with retail stores such as Rosenberg Dress Shop, located in what was called Browns Court in the 1950s. Proprietor Max Rosenberg lived in the Rosener Café block. Other shops included Kulins, Bedards Shoe, Biljacs, Jane Dufaults, Mill End Store, Webster Curtain Shop, and Webster Furniture, which was owned by Sam Cowitz. (Reprinted with permission of the *Worcester Telegram and Gazette*.)

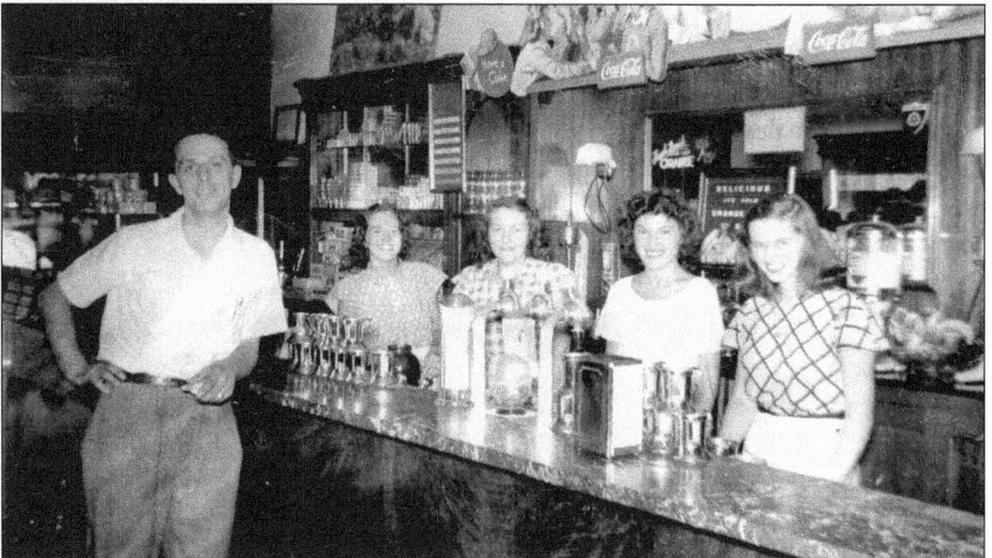

The Stadium Candy Kitchen was started in the 1920s by George Samar. Arthur "Chick" Pappas purchased the store around 1947 and converted the candy kitchen into a popular spot for teens. The Guenthers also owned the establishment, which was located where the post office lot is now. It was torn down along with Vels Jewelers, Johnny Chauvin's Market, and Smith and Duffy's, to make room for the new federal building. (Contributed by Betty Tonna.)

One of the top dining locations over the years has been Ted Morse's Colonial Club on Thompson Road. Many special functions were hosted at the club, and on occasion, some notable dignitaries, such as John F. Kennedy on the campaign trail, were in attendance. Morse was also a great supporter of athletic teams, especially football, and for a number of years, he sponsored the Webster Colonials, a semiprofessional football team. (Contributed by Robert J. Miller.)

McKinstry's large icehouse was located on Webster Lake, near today's Action Marine on Thompson Road. Every winter, the company harvested ice from the lake, selling it to surrounding communities and beyond, including sales to H. P. Hood of Boston. The Hood ice was sent in insulated railcars to Boston via the East Thompson Branch, which ran adjacent to the icehouse. Unfortunately a fire destroyed the building in 1936. (Contributed by Anthony Stefanik.)

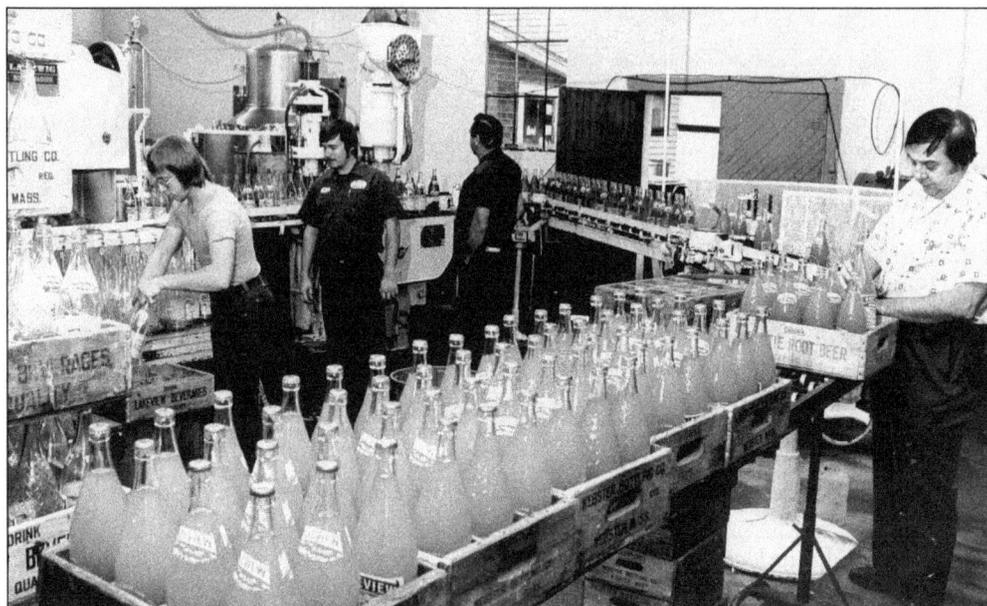

Back in 1919, Alexander A. Starzec started a local beverage business, Lakeview, on Deslauriers Avenue. It was common to see Lakeview trucks scurrying about the community, delivering the distinctive Lakeview bottles in their wooden cases to homes, stores, and restaurants. Shown preparing for the day's delivery in this late-1960s photograph are, from left to right, David Lavallee and Alex, Chet, and Ray Starzec. (Contributed by Annette Starzec.)

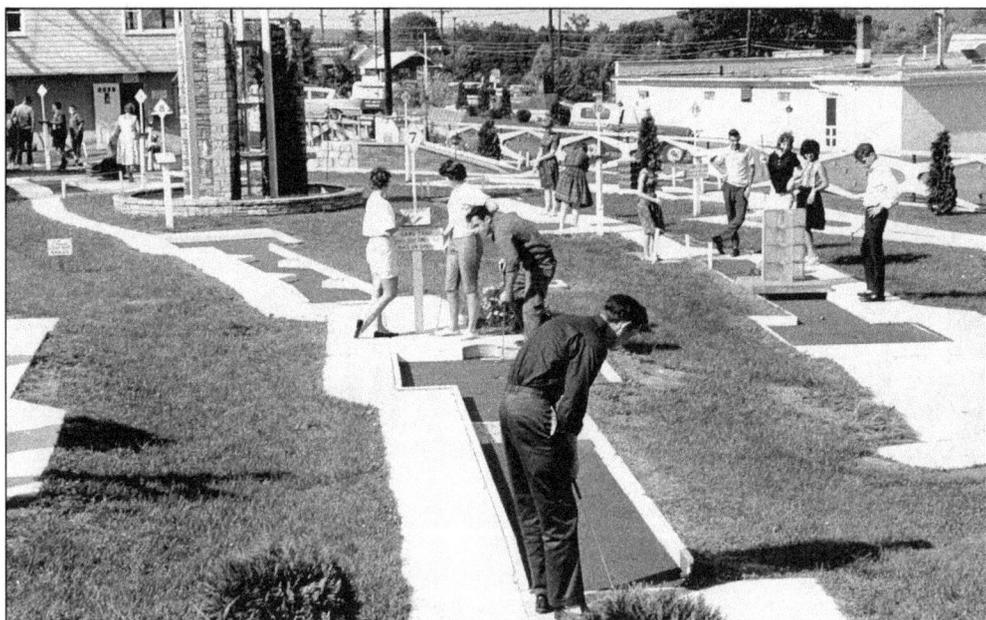

Herman F. Becker opened Nectarland Restaurant in 1956. A 28-station carhop, where meals were delivered to your car, was added in 1958. The addition of an 18-hole miniature golf course made this restaurant on Thompson Road a fun complex. Nectarland closed in 1965, when Dante's Inferno leased the building for a while until a fire put an end to that business. The Wind Tiki Chinese restaurant operates there today. (Contributed by the Becker family.)

24

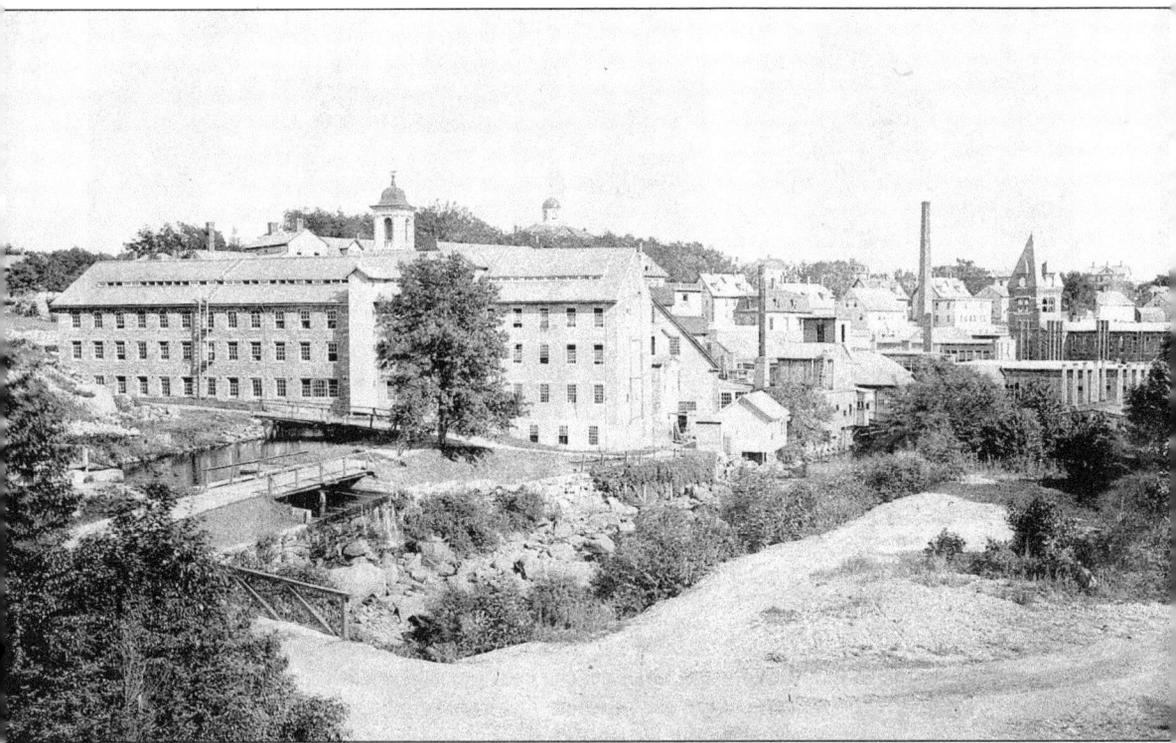

In 1812, Sam Slater built his first mill in Oxford's South Gore, which would become East Webster 20 years later. Slater and his partners established mills in both North and South Webster. Pictured here is the South Village mill complex. All three sites took advantage of the water potential of the lake and river and built dams so that water levels could be kept at a consistent level for mill use throughout the year. Slater sold the south complex in 1923 to American Woolen, the east in 1936 to Cranston Print Works, and the north to B & W Footwear in 1938. Both the north and south facilities were used by a number of businesses in the succeeding years, including Sandler-ette, Bentley Shoe, Webster Sheet Metal, and Williamsberg Greeting Card Corporation. On January 1, 1969, a catastrophic fire destroyed most of the north complex. (Contributed by Webster-Dudley Historical Society.)

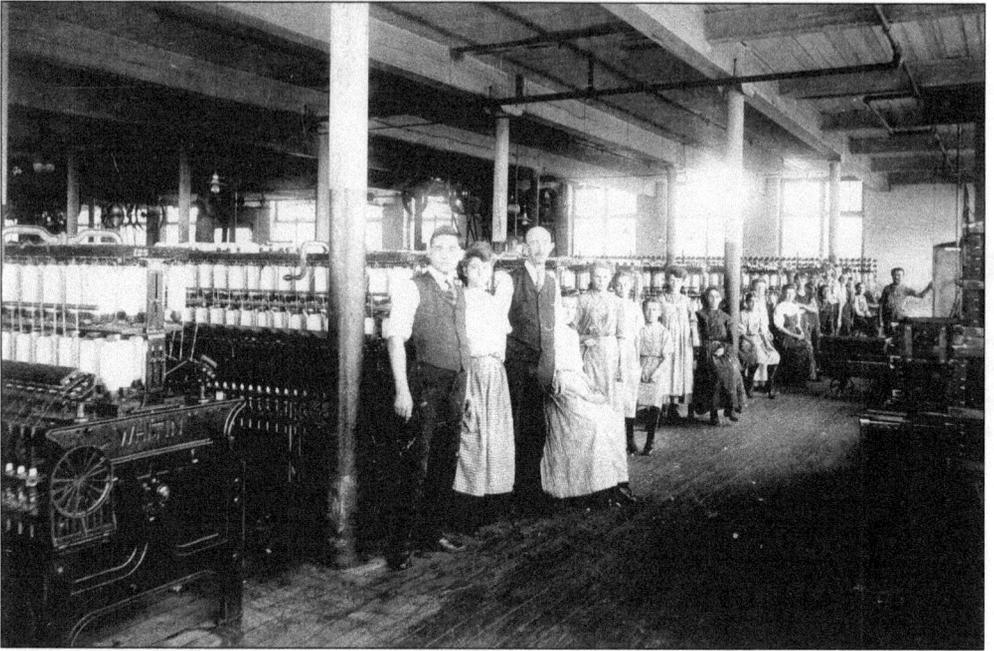

When industry began in 19th-century America, the use of children was a common practice, and Webster was no exception. One of the reasons Slater was attracted to the area was the fact that farm wives and daughters owned home looms and made their own clothing, thereby providing an experienced labor force. (Contributed by Webster-Dudley Historical Society.)

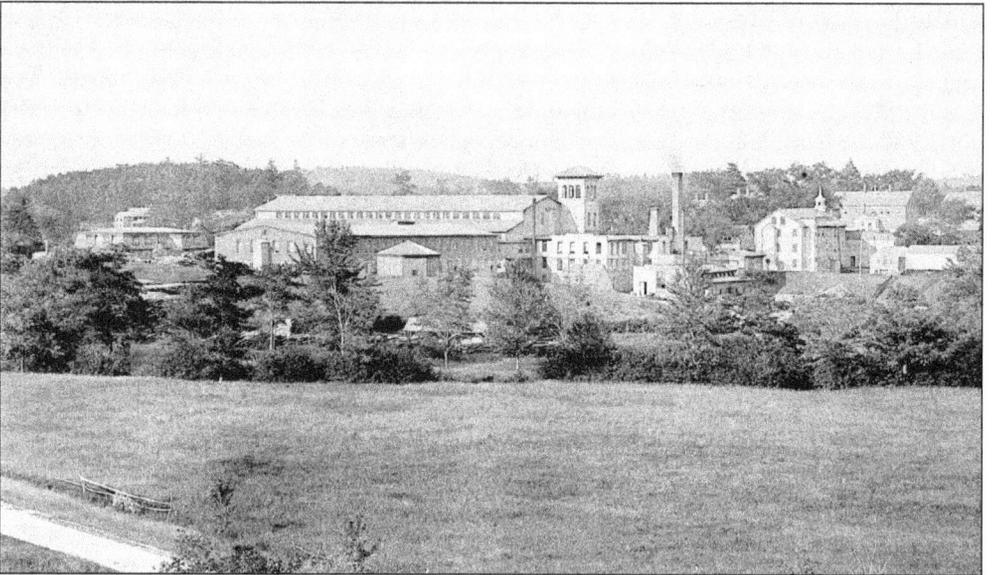

Slater's second mill complex was built in what is referred to as Webster's North Village. Besides the river being an important power source, it was also once considered to function as a canal for transportation. The French River's connection with the Quinebaug, Shetucket, and Thames Rivers would have allowed barges from Worcester to reach an ocean outlet at Long Island Sound, but the development of railroads scuttled this thought. (Contributed by Webster-Dudley Historical Society.)

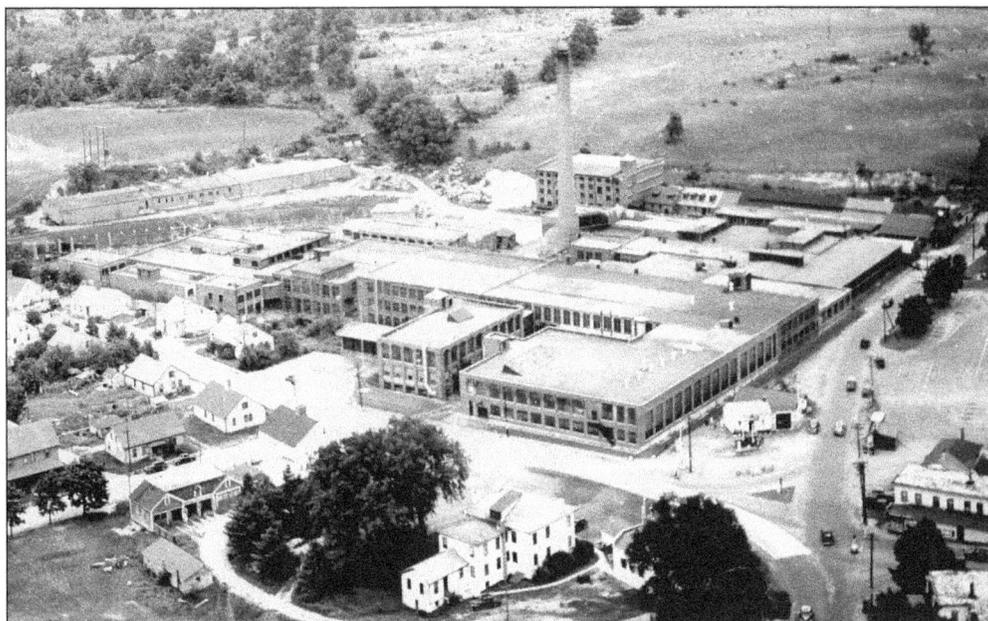

This 1944 picture of Cranston Print Works is interesting on a number of accounts, especially if one were to compare the photograph with what exists today. The many homes that appear in the photograph have disappeared, and the many businesses that exist today, in addition to the Industrial Park, Commerce Insurance, and Route 395, are nowhere to be found. (Contributed by Cranston Print Works.)

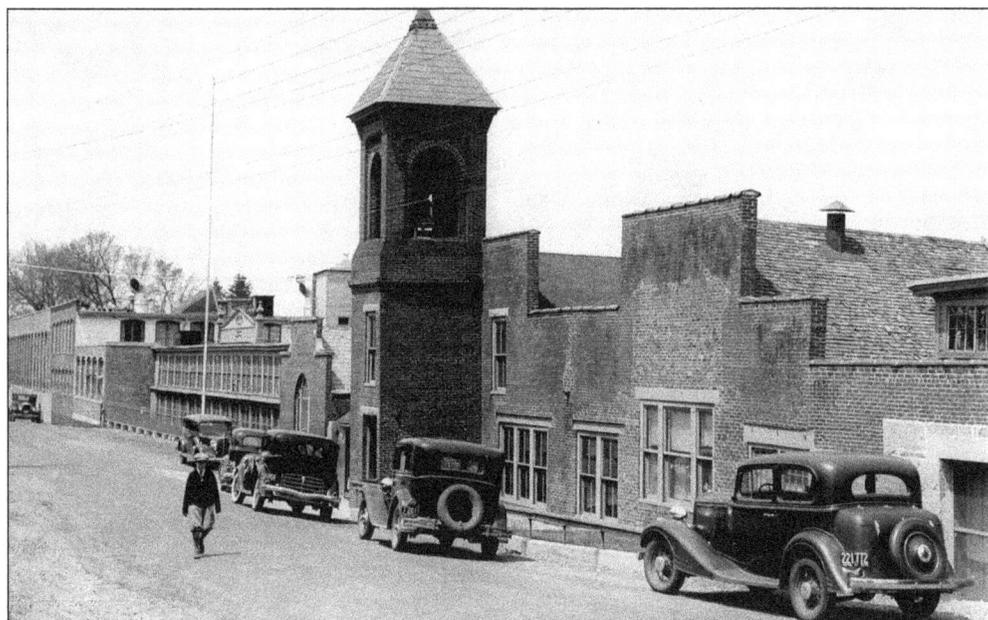

The beautiful tower originally built at the site of Slater's east mill complex is still in place today. The management at Cranston Print Works, which took over the facility from Slater in 1936, had the good sense to save the beautiful structure because of its historical value. Note the knickers the young man walking up Route 16 is wearing. He certainly would have been considered in style. (Contributed by Cranston Print Works.)

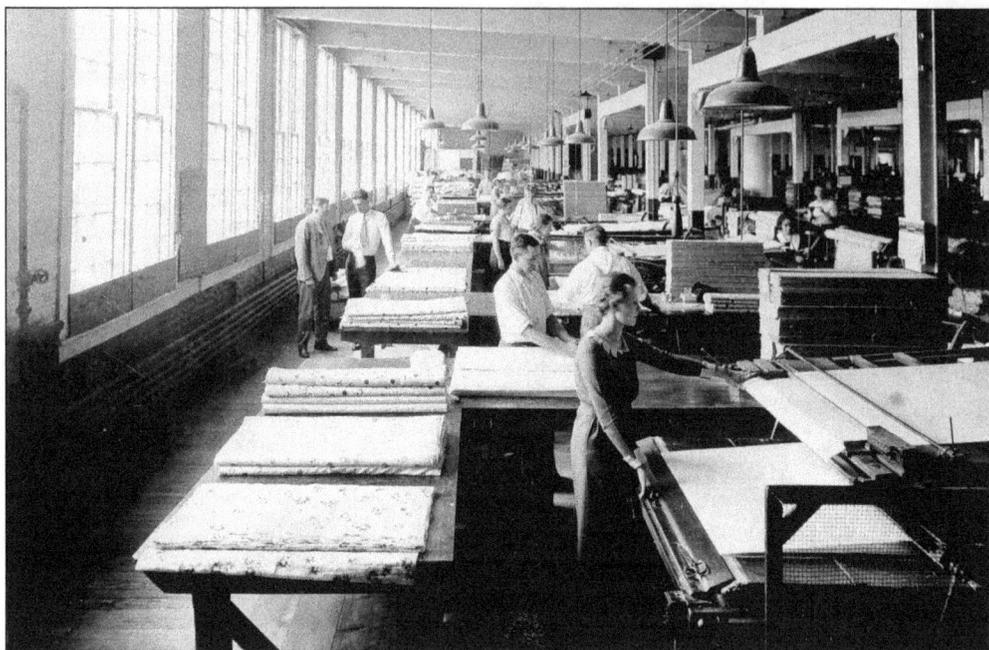

For many years, Cranston Print Works was Webster's largest employer, a distinction now held by Commerce Insurance. Three busy shifts processing cloth at the mill contributed heavily to the town's economy, generating a significant payroll each week. The workers in this picture are busy in the put-up room. (Contributed by Cranston Print Works.)

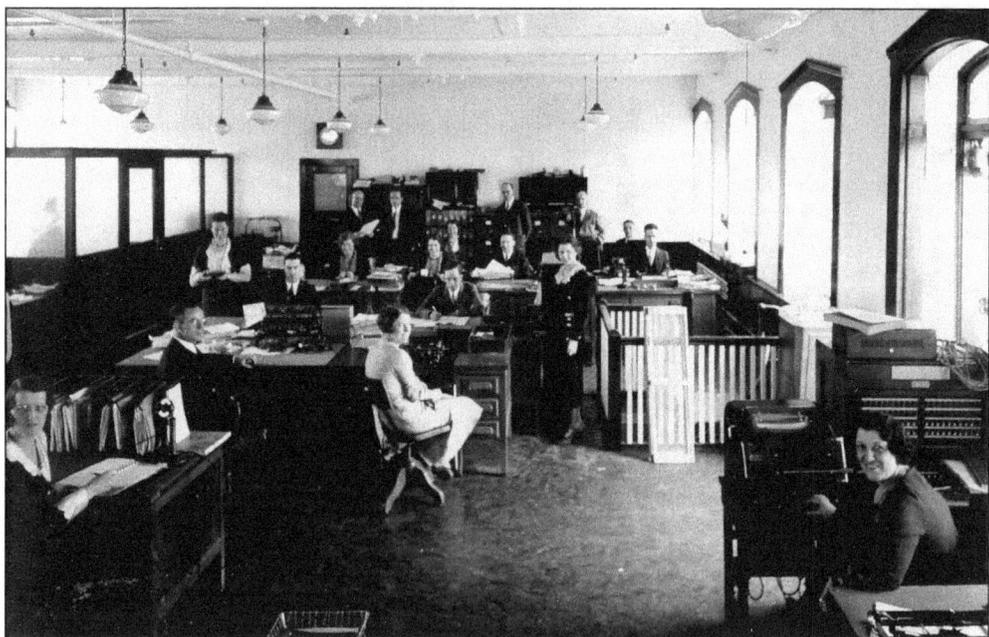

Like many large mills, Cranston Print Works offered a wide range of jobs, from the not so hard to the very hard, and from not so dirty to the very dirty. This 1930s Cranston Print Works scene shows office workers, who always seemed to be the happiest and certainly the cleanest. (Contributed by Cranston Print Works.)

The Bates Shoe Company was established in 1885, when Andrew J. Bates purchased the Humphrey and Burnham shoe factory on Park Street. The Bates Shoe Company became known far and wide for producing excellent shoes that were worn by many quality-conscious customers, including Pres. Dwight Eisenhower, who is shown here trying on a pair of Bates floaters. The plant was taken over by Wolverine Worldwide Shoe Corporation. The Jeffco Company now occupies the Park Street site. (Contributed by Webster-Dudley Historical Society.)

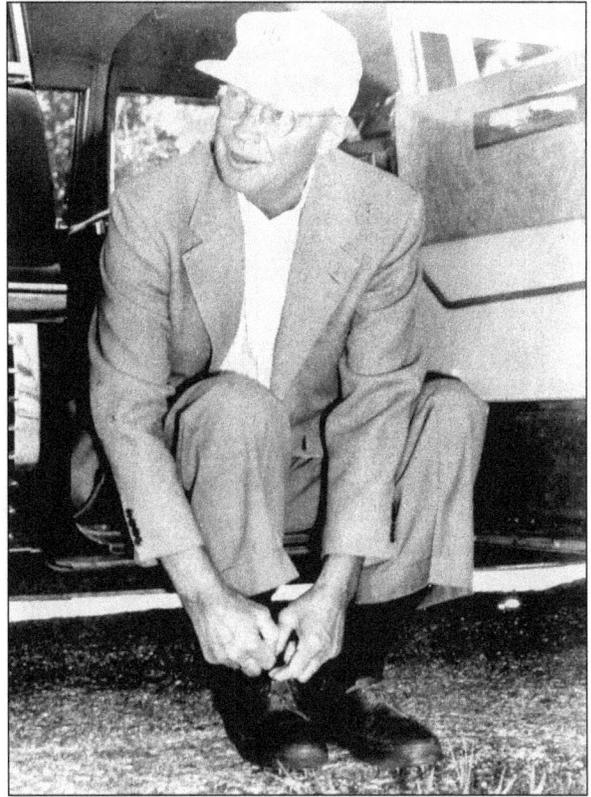

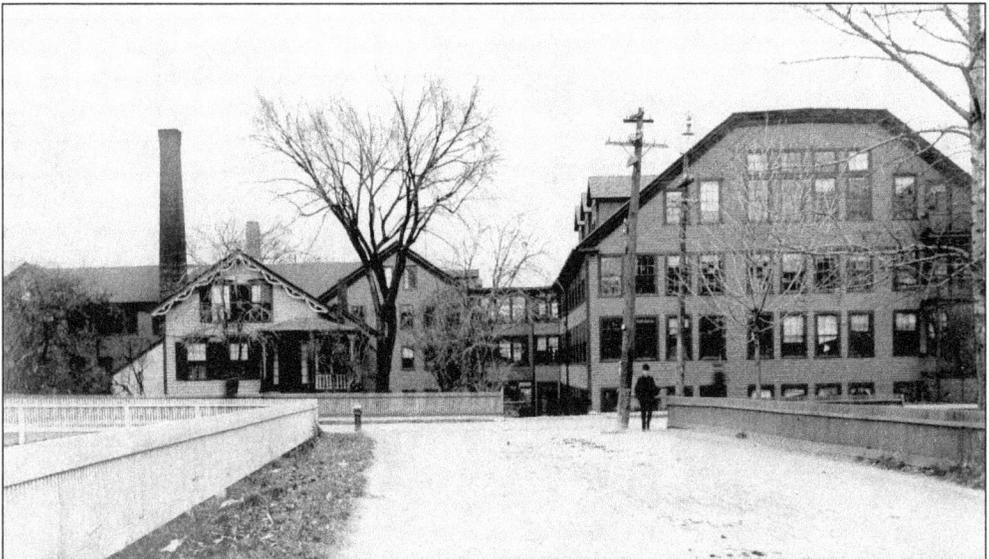

In 1854, B. A. Corbin opened a shoe business in the back of his property on Main Street, and in 1862, Chester C. Corbin joined the business, which later expanded to Negus Street. In 1934, the Webster Shoe Workers Independent Union organized and purchased the factory, leasing it to the Webster Shoe Corporation, which operated until competition from foreign manufacturers took its toll on the local company. (Contributed by Chester C. Corbin Public Library.)

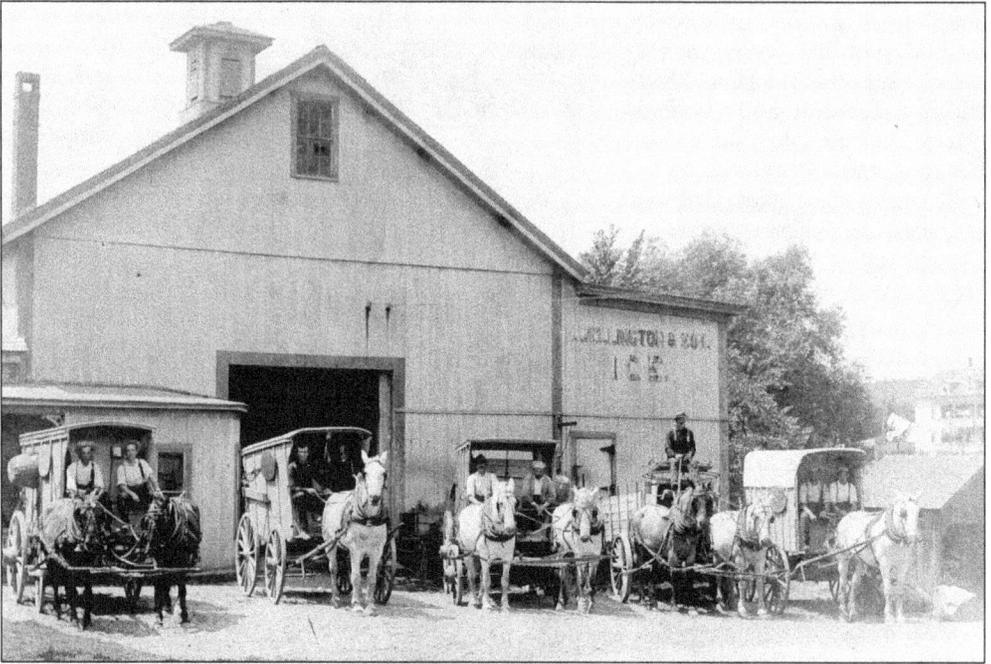

The lake provided local ice companies an opportunity to harvest ice each winter, until the last natural ice was taken from the lake in the mid-1930s. In the early 1950s, it was common to see the ice truck making its deliveries and neighborhood kids jumping on the back of the truck to look for loose chunks of ice. (Contributed by Webster-Dudley Historical Society.)

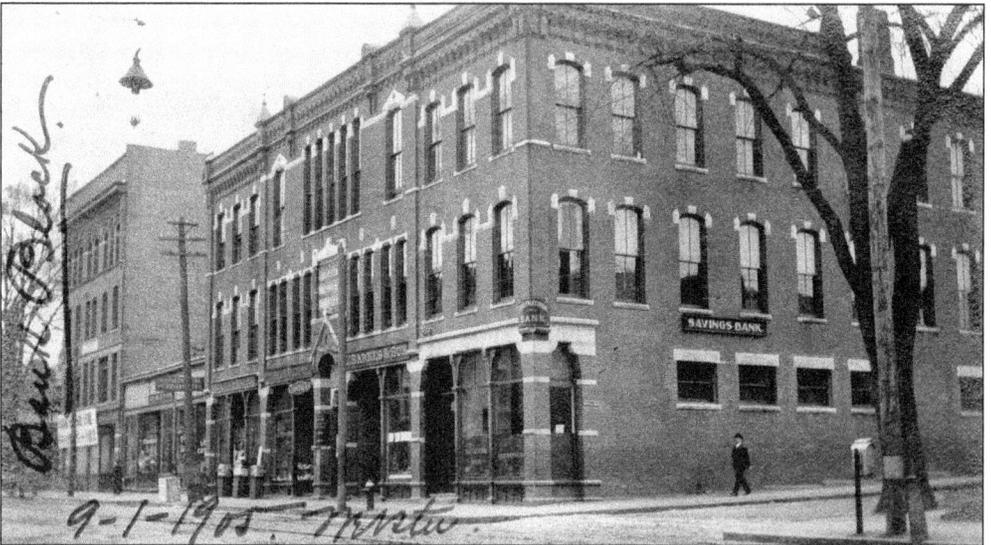

Three of Webster's early banks still remain under local control today: the Webster Five Cent Savings Bank (1868); the Webster Cooperative (1889), now Hometown Bank; and the Webster Credit Union (1928), now Webster First Federal Credit Union. The First National Bank of Webster (1875) and the Webster Five Cent Savings Bank shared the Eddy Block location pictured here at the corner of Main and Mechanic Streets. (Contributed by the Reichenberg family.)

Two

"YOU FISH
ON YOUR SIDE . . ."

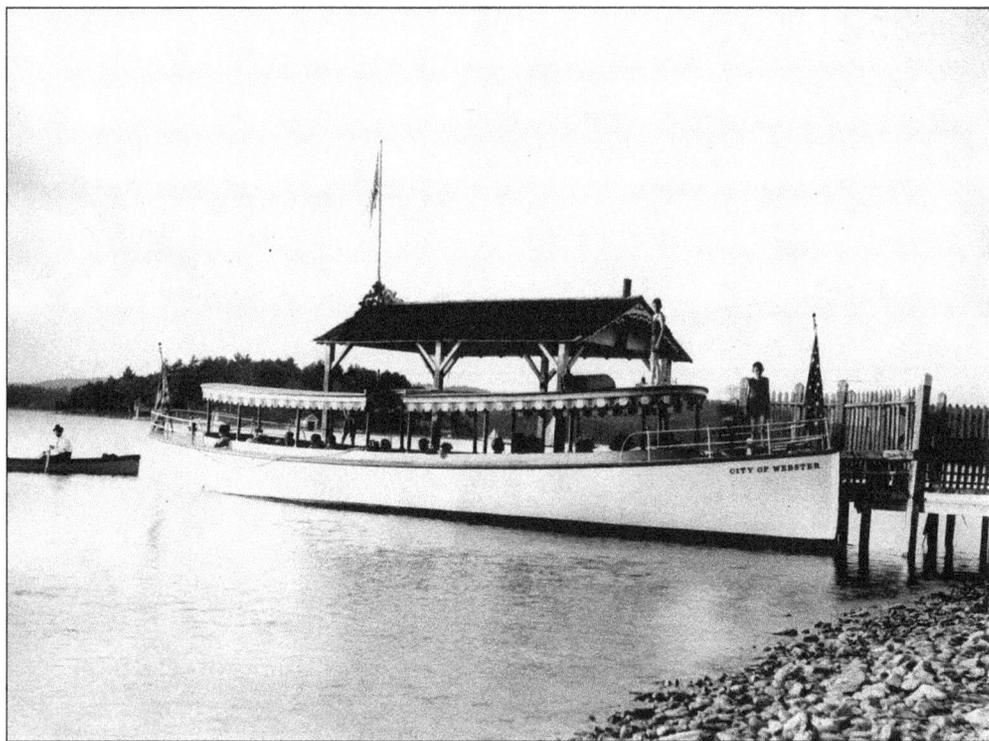

The lake dominates the physical, cultural, and economic landscape of the town. From its early heritage as a Native American praying town and its definitive role in the success of Samuel Slater to the present-day boom of waterfront property, the importance of nature's gift to this community encompasses its past and holds hope for its future. Pictured is the *City of Webster*, the largest of the steam-powered excursion boats that left from Beacon Park and traveled to various resorts on the lake from 1895 to 1935. (Contributed by Sylvio Gilbert.)

Located at Killdeer Island, Sea Scout Point (now named Indian Point) was the starting line for summer weekend sailboat races, which attracted oarsmen and sailors from all over New England. In the early part of the 20th century, competition was among six- and eight-oared sculls, with sailing races becoming popular later. (Contributed by Benjamin Craver.)

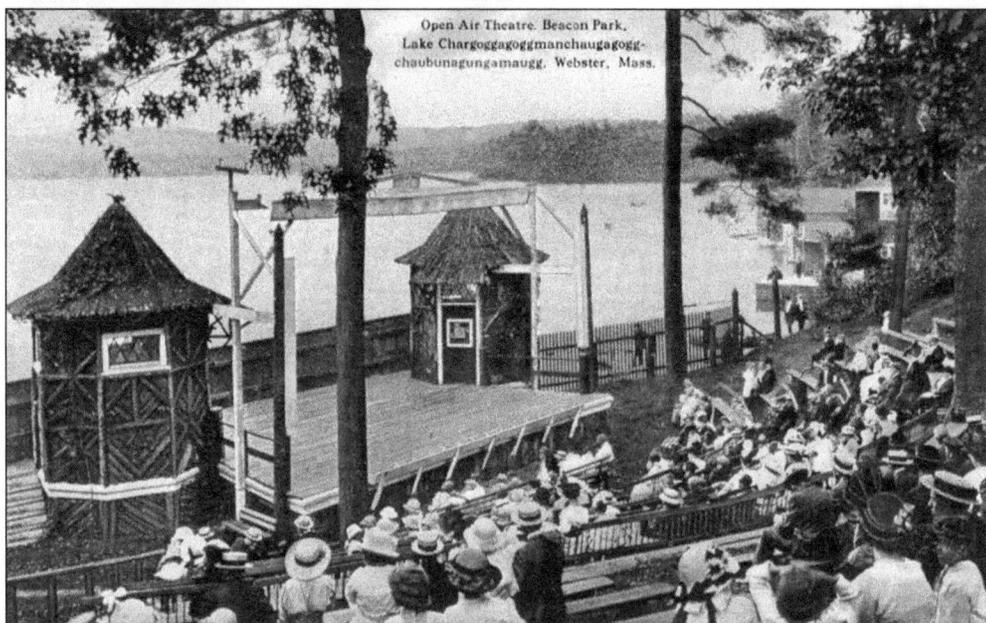

Open Air Theatre. Beacon Park.
Lake Chargoggagoggmanchaugagogg-
chaubunagungamaugg. Webster, Mass.

The Rustic Theater was the site of summer stock productions at Beacon Park. In addition, Edgar S. Hill, and subsequently his son Ralph, presented other entertainment such as a Ferris wheel, merry-go-round, balloon ascensions, high-wire acts, and semiprofessional baseball games. (Contributed by Richard Cazeault.)

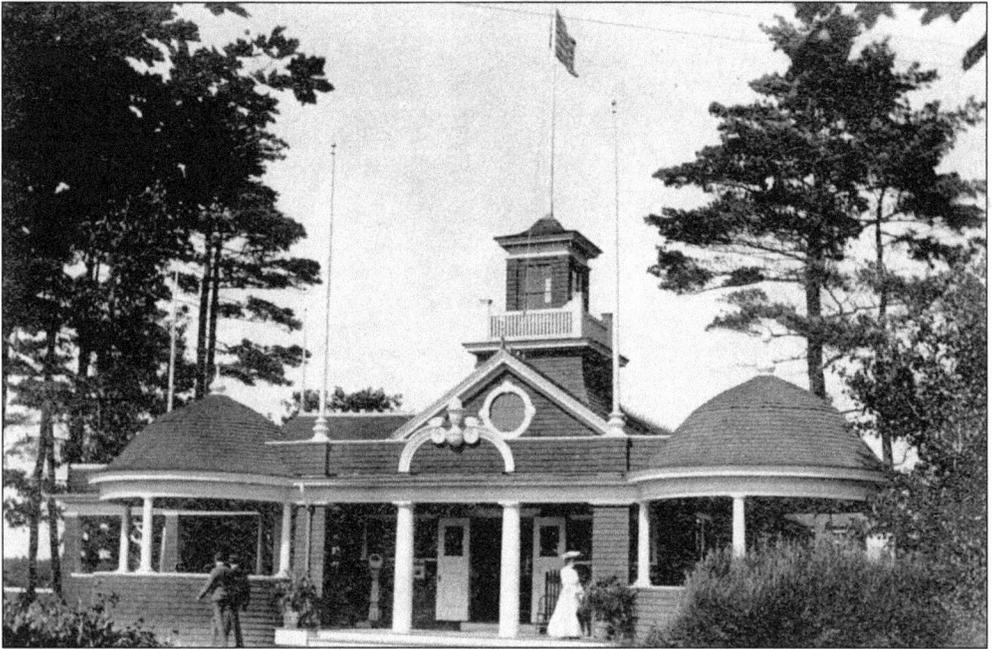

Beacon Park was originally known as Eliot's Shore after John Eliot, who reportedly held prayer meetings there in 1624 to Christianize Native Americans. The Slaters later owned the property, and during the Civil War, the Slater Guards, who were Webster volunteers to the war effort, camped and trained there. In 1874, Fr. James Quan of St. Louis Parish bought the land and, over the next 10 years, erected a roofed dance platform and launched the first steamer. W. Janakowski was owner for the next five years, then the Ancient Order of the Hibernians bought it and promoted outings and competitions with eight-oared racing shells in North Pond. (Contributed by Richard Cazeault and Webster-Dudley Historical Society.)

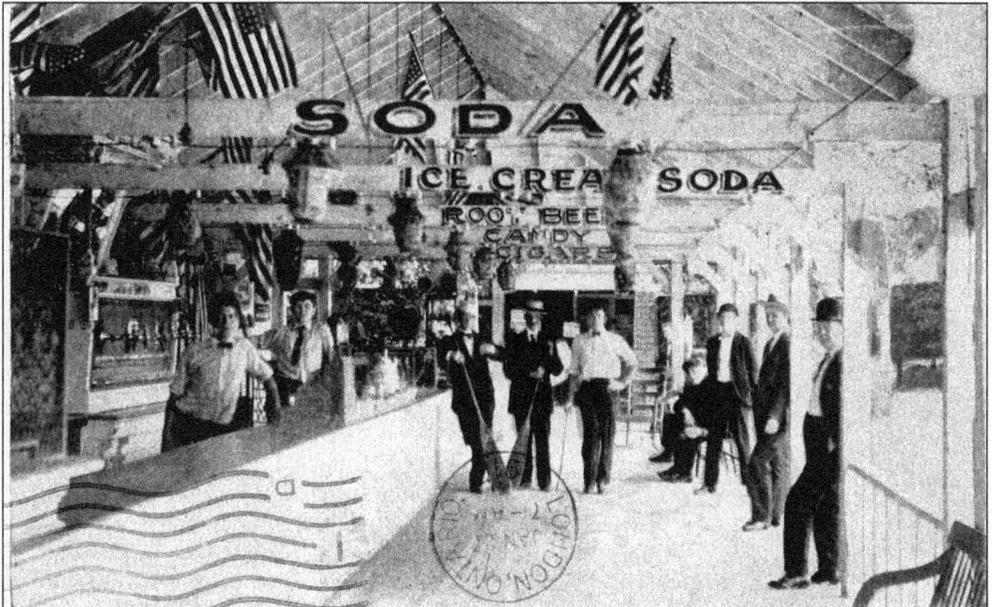

Boardwalk, Beacon Park, Lake Chargoggagogg Manchoggagogg Chaubunagun Gamaugg

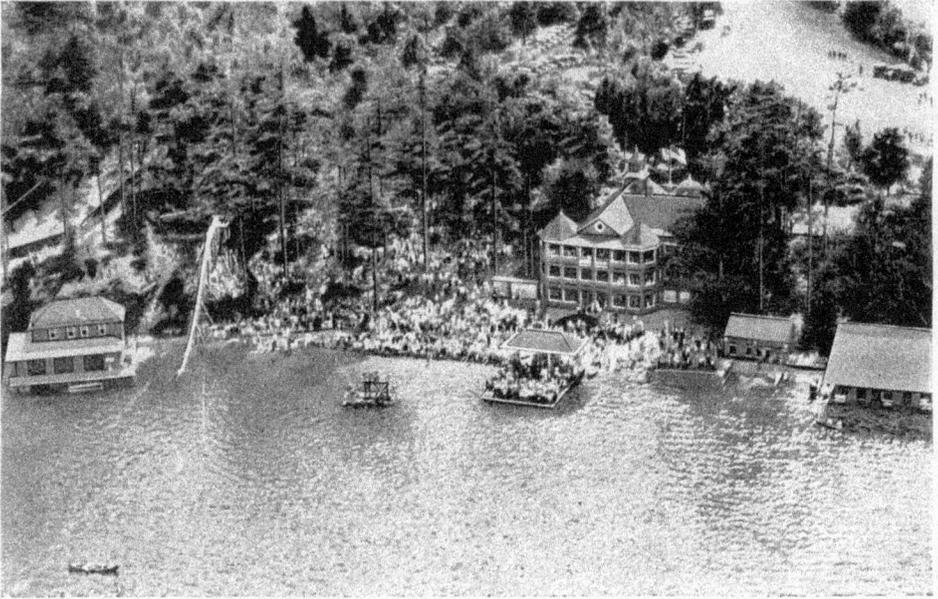

LAKE CHARGOGGAGOGGMANCHAUGAGOGGCHAUBUMAGUNGAMAUGG. WEBSTER. MASS.

The heyday of Eliot's Shore began with the purchase of the property by Edgar Hill in 1895. Hill named the area Beacon Park and built a three-level main hall, outdoor theater, casino offering snacks and souvenirs, and boathouse, which kept canoes for rent. A baseball diamond, tennis court, waterslide, and waiting station for the trolley were later added. (Contributed by Webster-Dudley Historical Society.)

Edgar Hill was undoubtedly the recreation and entertainment king of Webster and was the first to recognize the tremendous potential of the lake, purchasing both Beacon Park and Point Breeze in the late 1890s. In addition to the resorts, the industrious and versatile Hill built a trolley system to convey resort patrons, owned the State and Liberty theaters, operated downtown bowling alleys, and was affiliated with the *Webster Times*. (Contributed by Bruce White.)

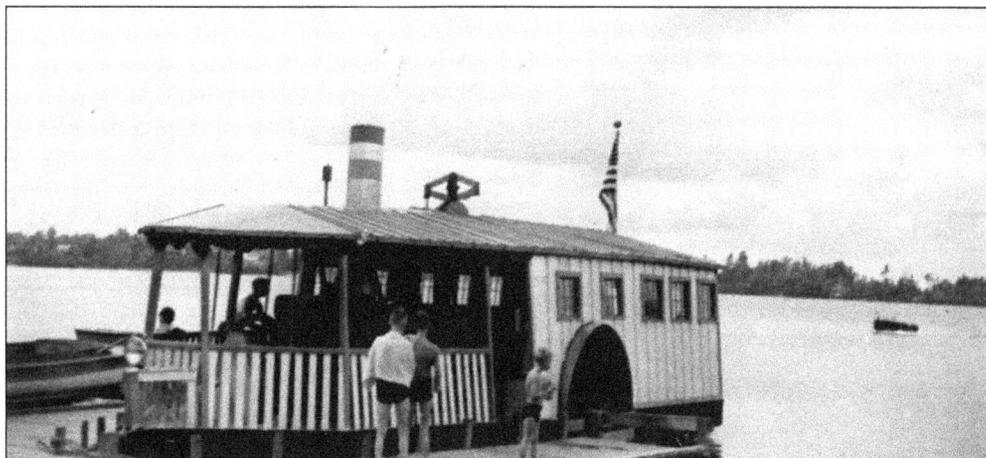

Built after the Great Hurricane of 1938 and operated by Ernest Wallis, the *Showboat* was a side-wheeler that took passengers around the several beaches of the lake. When the *Showboat* was beyond repair, it was dismantled and its deck was used as the original stage at Indian Ranch, which featured early bluegrass acts and a comedian named Joe LaFlip. (Contributed by Jim Manzi.)

The *Hustler* was the oldest and most photographed sailboat on Webster Lake. The official Sea Scout boat for many years, it was built on Goat Island by Lyman R. Eddy in the 1880s. Owners included Carl Wilson in 1937 and "Doc" Prince of Southbridge in the 1960s. Irv Piehler restored and maintained the *Hustler* from Snug Harbor. Final berth was at Watch Hill, Rhode Island. This photograph, taken in 1902, shows Bill Eddy, Charlie Maran, and Carrie Hoyle in calm waters. (Contributed by Webster-Dudley Historical Society.)

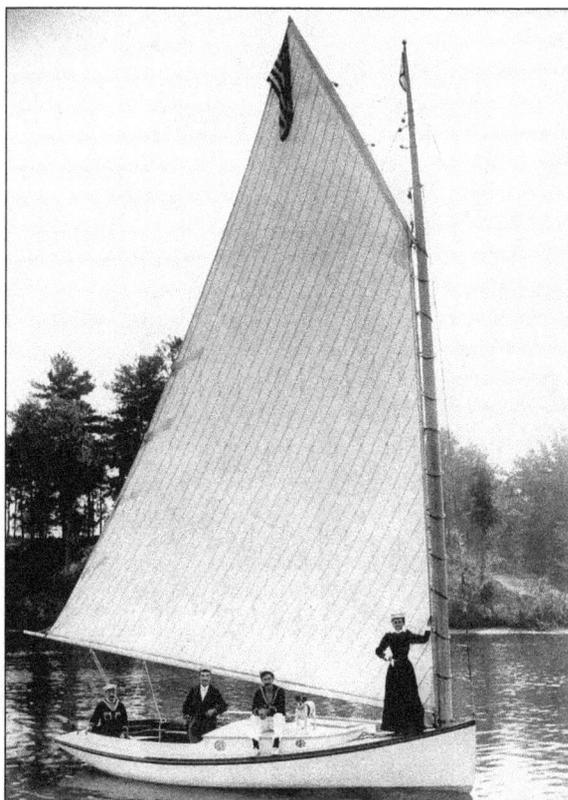

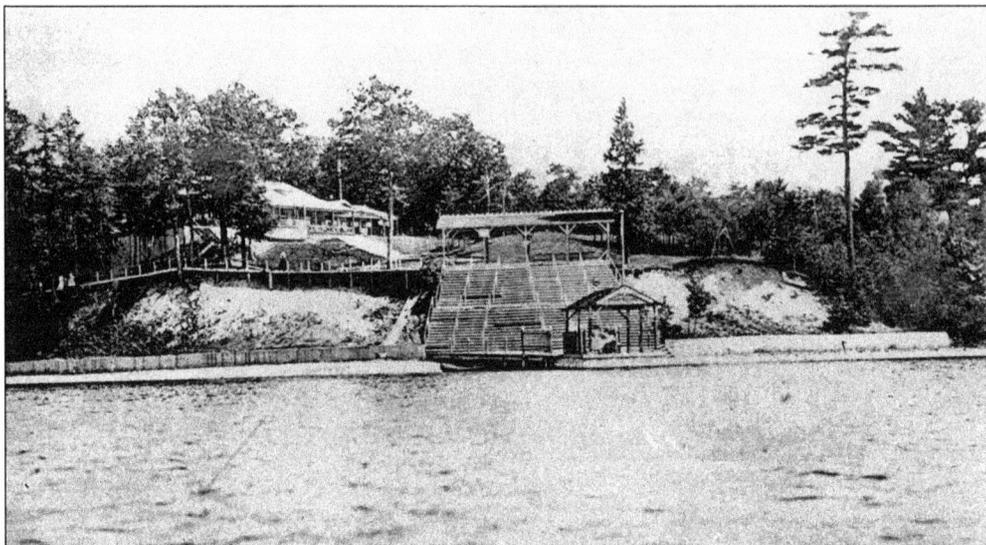

Point Breeze Pavilion was one of the most popular stops on the route of the steamers as they traversed the lake. Again it was Edgar Hill who transformed this beautiful acreage into his dream of bringing the wonders of the lake to thousands of visitors each summer. Hill reportedly swapped his ownership of the Music Hall downtown for the waterfront property at Point Breeze. Always thinking big, Hill constructed a huge dance hall and grand stairway, which was about 20 feet wide and led down the steep embankment to a wharf and landing shed, where the excursion boats dropped off and picked up visitors. The Hills sold Point Breeze to Michael Commons, who in turn sold it to Michael Lilla. The Gawle family later owned and operated Point Breeze for many years and hosted many company outings featuring the famous shore dinner. The Dupont family presently runs the restaurant business at this location. (Contributed by Richard Cazeault and Webster-Dudley Historical Society.)

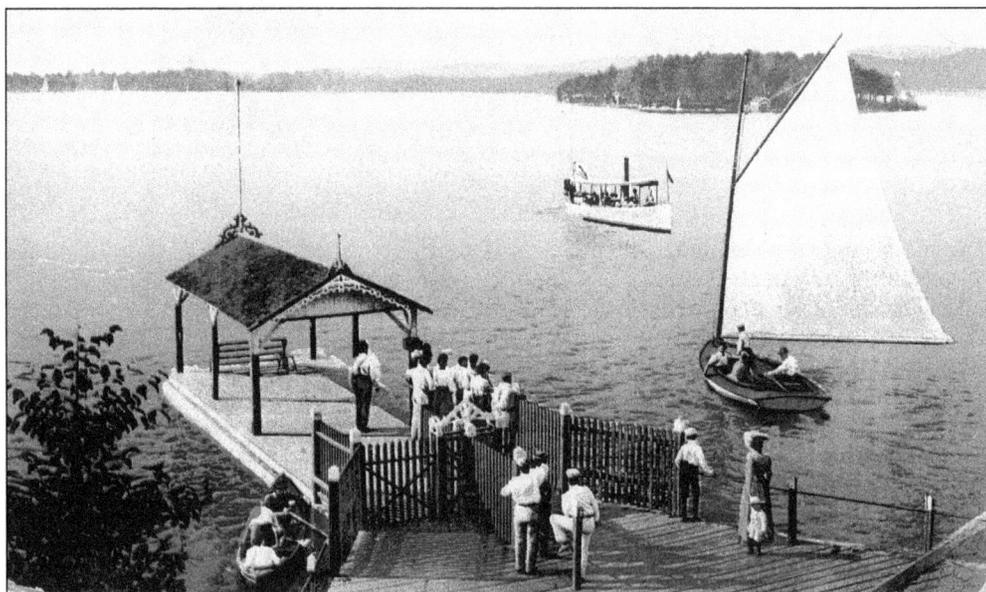

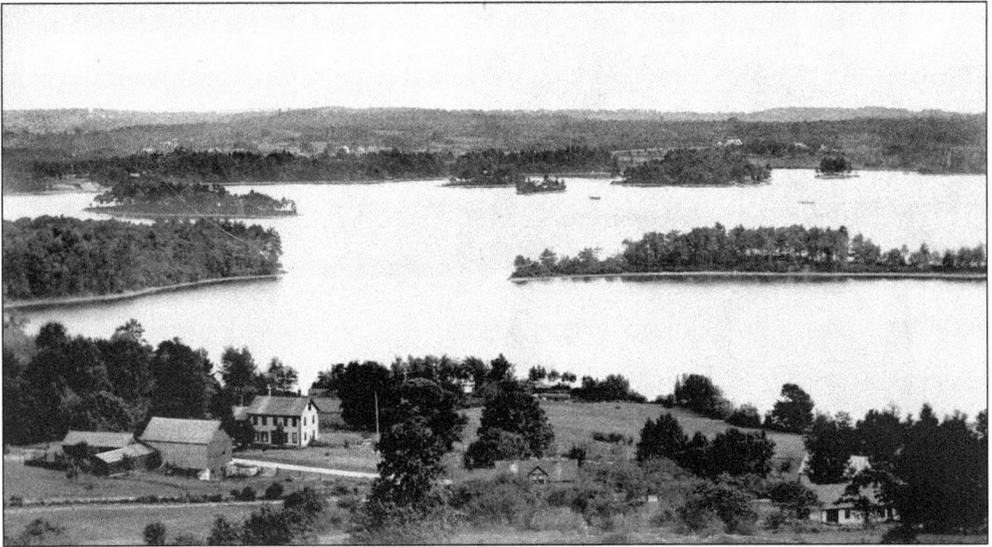

As seen from Upper Gore Road, Webster Lake is made up of three basins connected by two narrow channels. The southern basin, or South Pond, extends to the Connecticut state line and has a shoreline over four miles long. Middle Pond is the largest, with over seven miles of shore and more than one mile across at its widest point. North Pond's shore is over five miles long. The length of the lake is three and a quarter miles, and the surface area is 1,442 acres. Several islands dot the lake, including Long Island (the largest), as well as Checkerberry, Strip, Well, Cobble, and Goat Islands. (Contributed by Webster-Dudley Historical Society.)

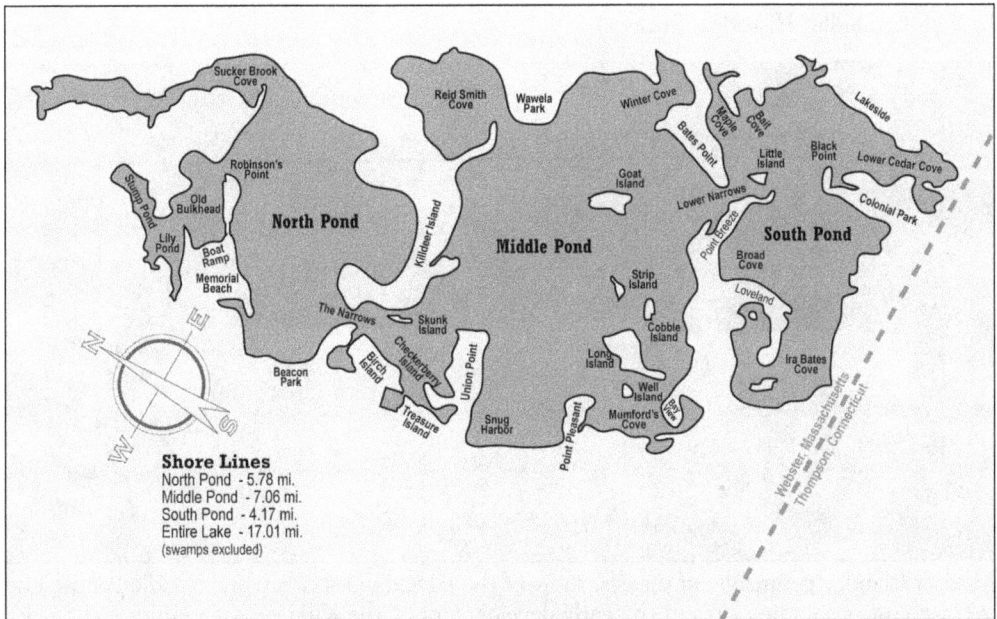

This map depicts Lake Chargoggagoggmanchauggagoggchaubunagungamaugg. Translations include "Boundary Fishing Place" (J. Hammond Trumbull, 1881) and "Body of Water Divided by Islands" (Ives Goddard, 1990). (Contributed by Chad Pepin.)

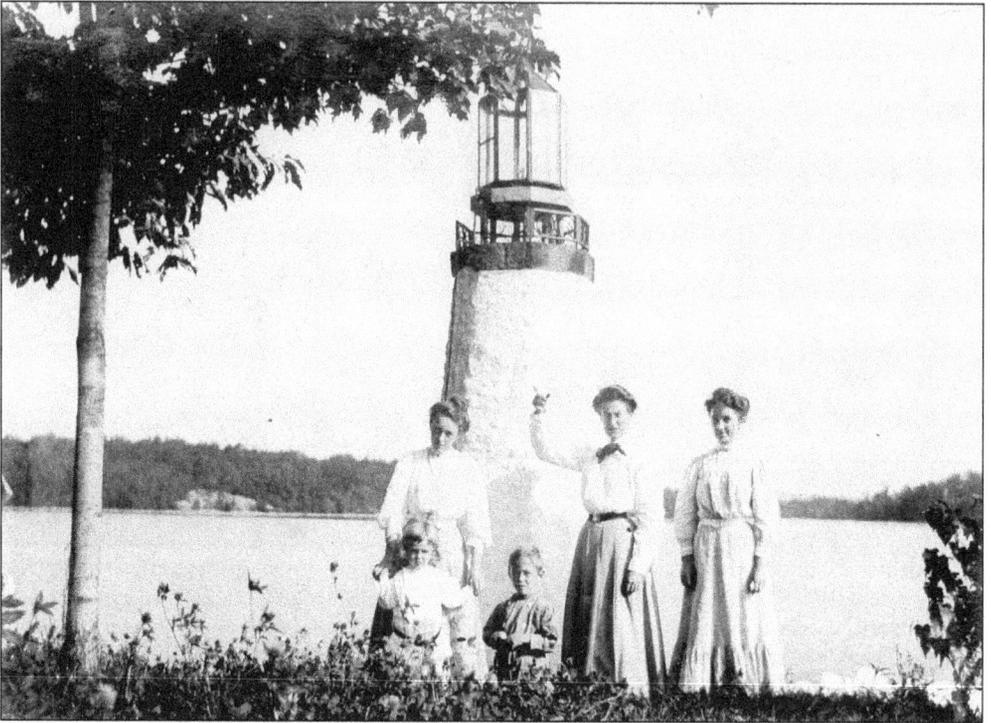

Originally used as farmland, Goat Island housed goats and oxen taken from Wakefield Farm, now Wawela Park. Businessman Lyman Eddy once owned the island, and in the 1930s, it was purchased by the Clausens and the Kents. These gracious ladies pose near the lighthouse that still stands as the landmark for the island, though foliage hides it from water view. (Contributed by Webster-Dudley Historical Society.)

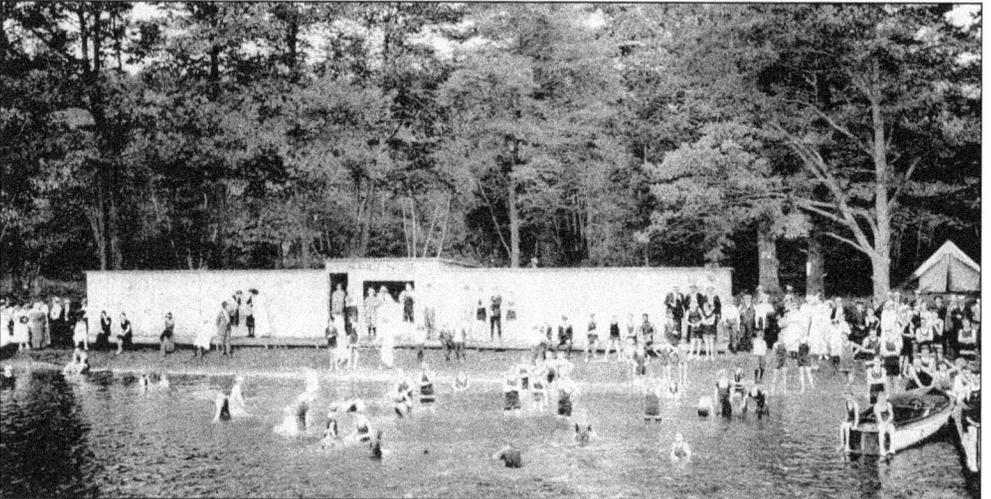

Killdeer Island, a peninsula off the east shore of the lake, divides North and Middle Ponds. The average cost of building sites in the early development of the Killdeer community was $473 a lot. Kelsey D. Purdy was treasurer of the Killdeer Island Development Company and handled the transfer of land from S. Slater and Sons in 1922. Pictured here is the beach at Sandy Shore. (Contributed by Richard Cazeault.)

38

Henry Fielder Bugbee and Maria E. Bugbee (née Mumford), otherwise known as Pa and Ma Bugbee, were the perennial hosts for visitors to Webster Lake. They rented summer cottages and rowboats at Point Pleasant, beginning in 1895. They hosted shore dinners at the Point Pleasant house and operated a small variety store on Thompson Road, which was later operated by Frank Steutermann. Henry Bugbee died in 1931, followed by Maria Bugbee in 1935. (Contributed by Webster-Dudley Historical Society.)

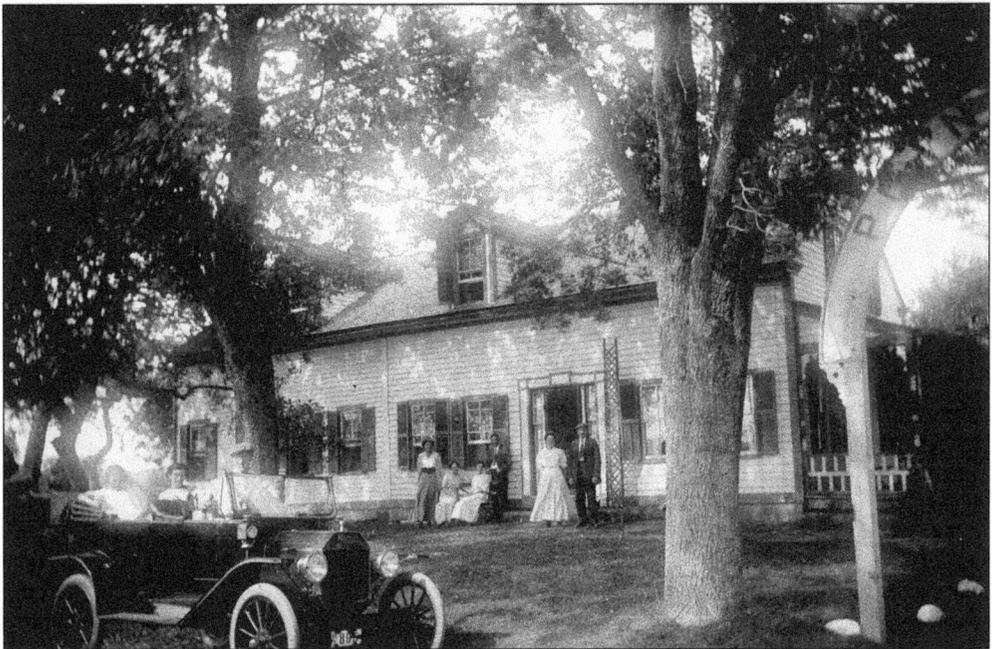

Elegant summer days were spent at the Point Pleasant house at the corner of Point Pleasant and Thompson Roads. Henry and Maria Bugbee were hosts to lake visitors, maintaining and supplying cottages there for many years. (Contributed by Webster-Dudley Historical Society.)

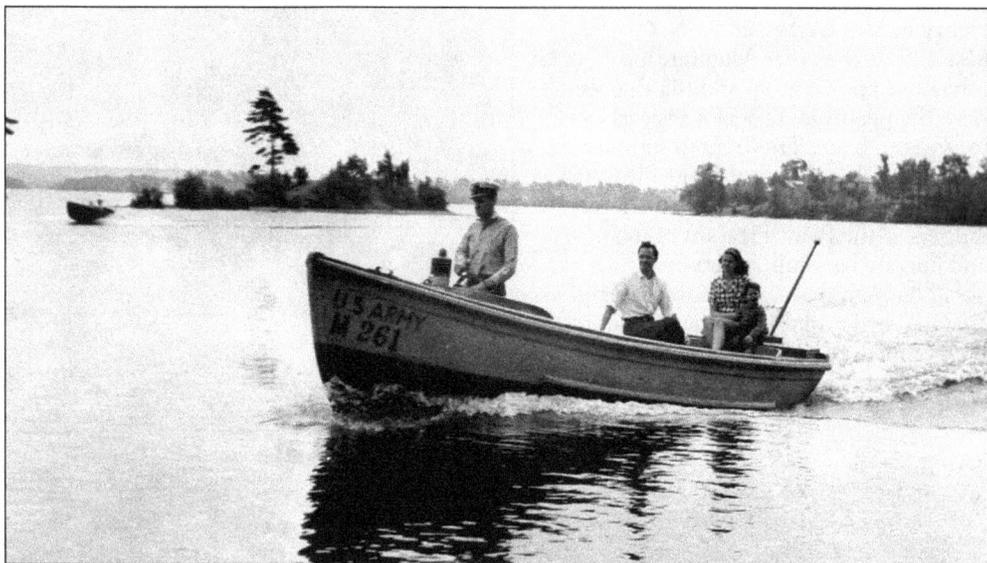

Shown here around 1950, skipper H. Craigin Bartlett steers his boat past Cobble Island toward Point Breeze with passengers Edwin Daniels, Jane Bartlett Howland, and David Daniels. The Bartlett family is a direct descendent of the Slaters. (Contributed by Ethelinda Bartlett Montfort.)

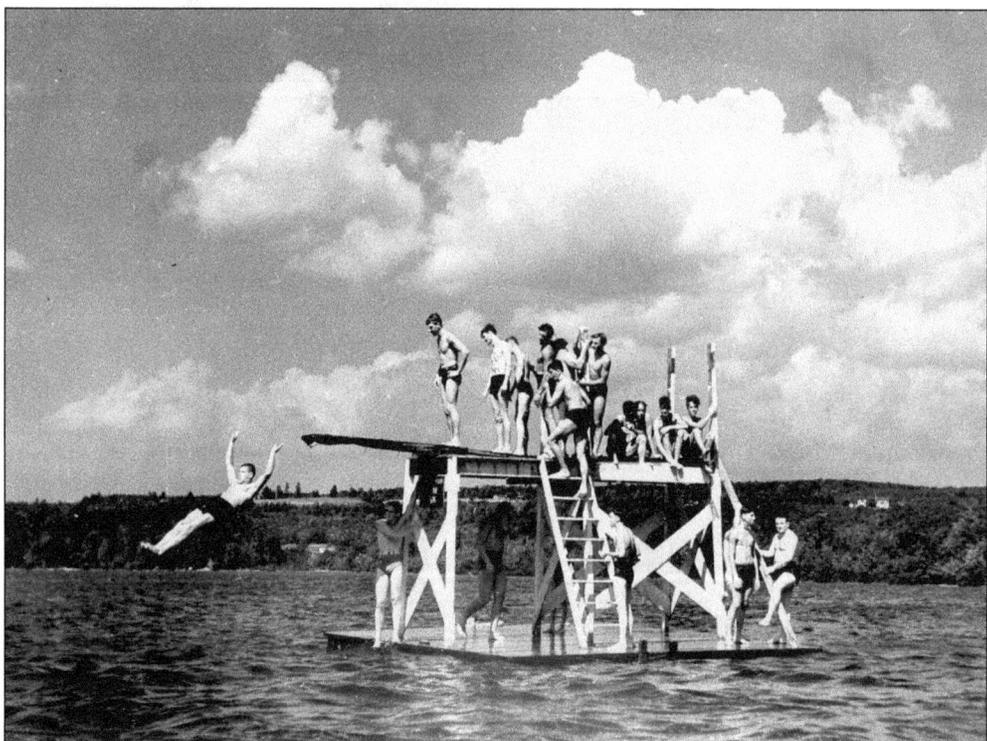

Diving rafts at the lake were a great place to spend a sunny summer afternoon. The one pictured here around 1960 is at Point Breeze, and another with a tower was located at Colonial Park. (Contributed by the *Webster Times*.)

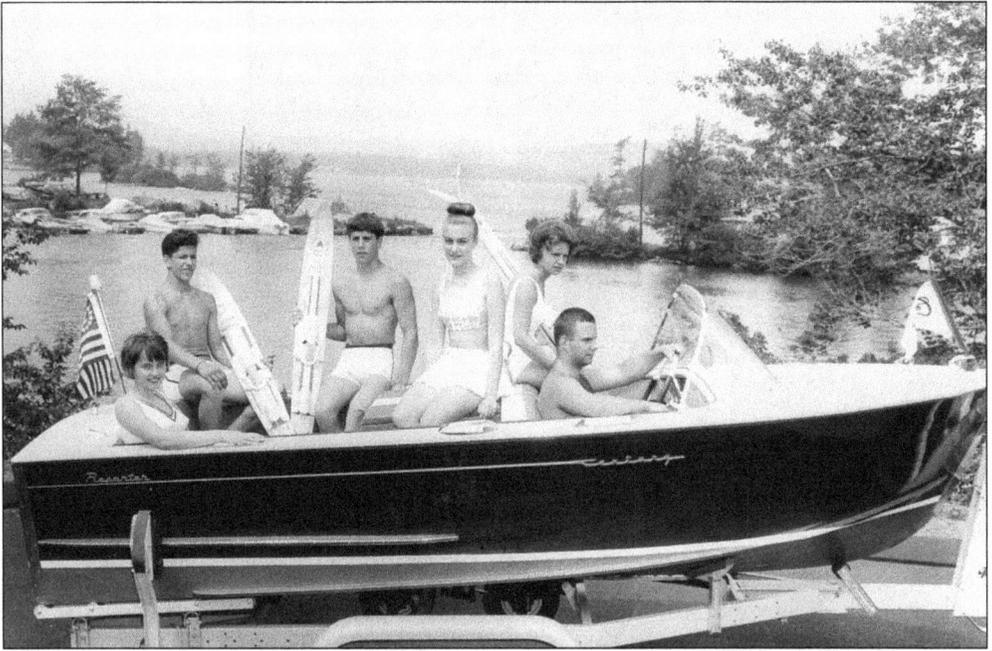

The National Water Ski Championship Tournament was held in 1964 and attracted tens of thousands of people to Webster Lake for four days in August. The Nipmuc Water Ski Club sponsored the event, which was covered by ABC's *Wide World of Sports*. The judges' stand was on Spectator Point and the competition held in Ben's Cove, later renamed Nipmuc Cove, at Memorial Beach. Posing for a promotional photograph in Marina Cove are, from left to right, Nipmuc Ski Club members Judy Blair, Gene Brisbois, John Gawle, Patty Guerin, Judy Small, and Irvin Piehler. (Contributed by Gerard Bernier.)

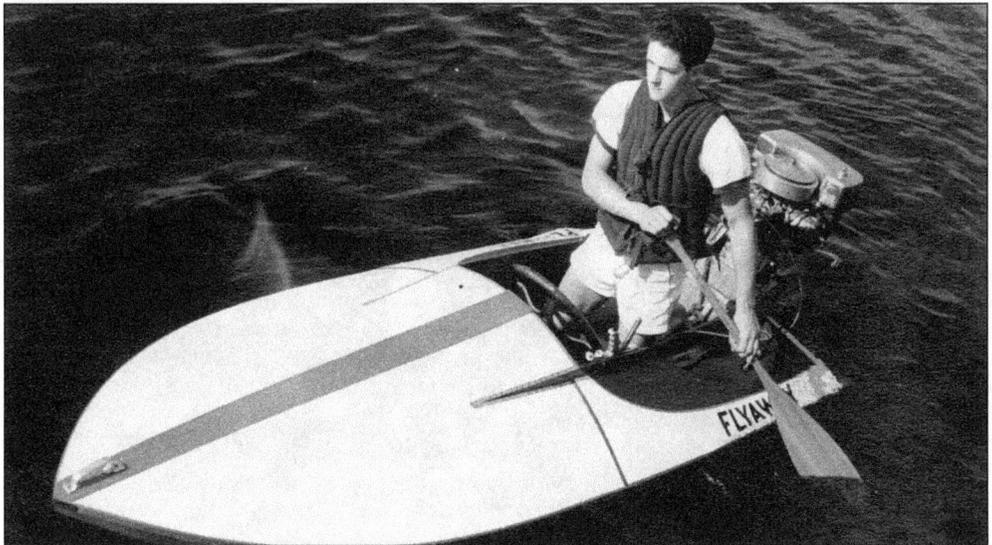

Jules Paradis is shown here on the hydroplane racing boat, the *Flyaway*, in the mid-1930s. The boat's motor only propelled forward, no neutral or reverse, thus requiring a paddle. Jules's father, Clarence A. Paradis, was also a participant in racing this boat on the lake. (Contributed by the Paradis family.)

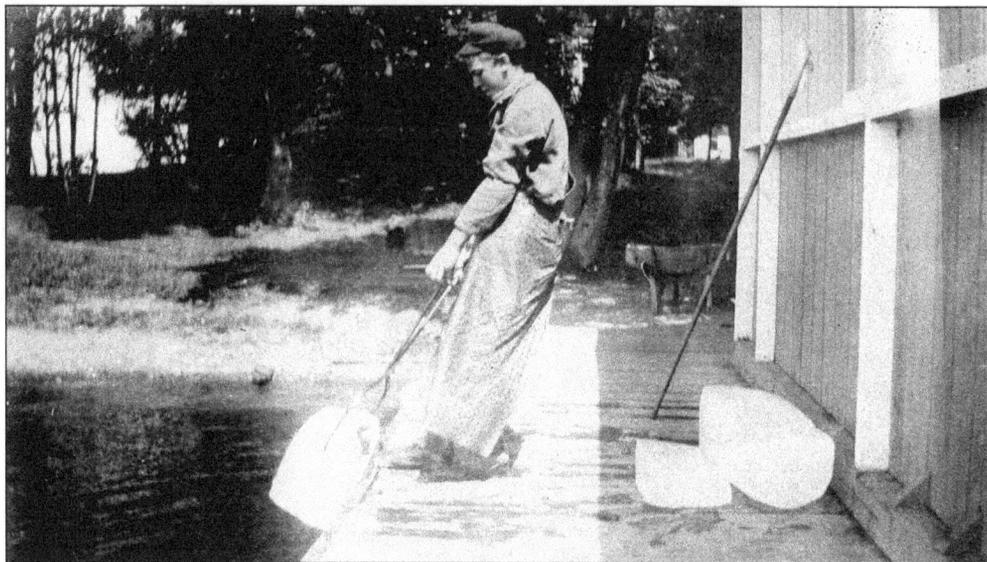

Each winter, a number of ice companies would harvest ice from Webster Lake and store thousands of blocks in the icehouse to sell to local businesses and other communities throughout the year. This young man uses ice tongs to rinse sawdust off the blocks of ice for the day's deliveries. (Contributed by Ethelinda Bartlett Montfort.)

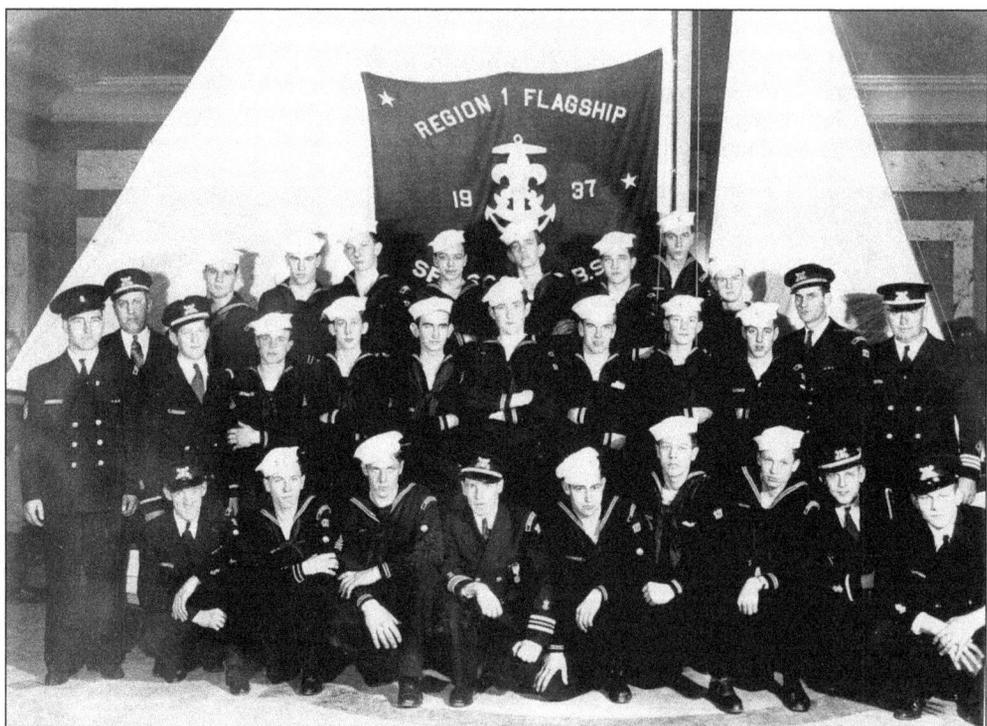

Webster Sea Scouts played an important role at the lake every summer. They maintained a life-service station, conducted boat races, and were in charge of a fleet of rowboats and powerboats, including the Sea Scout ship, SS *Clarence Kozlay*. Skipper Richard T. Wales was in charge in the mid-1930s. (Contributed by Ethelinda Bartlett Montfort.)

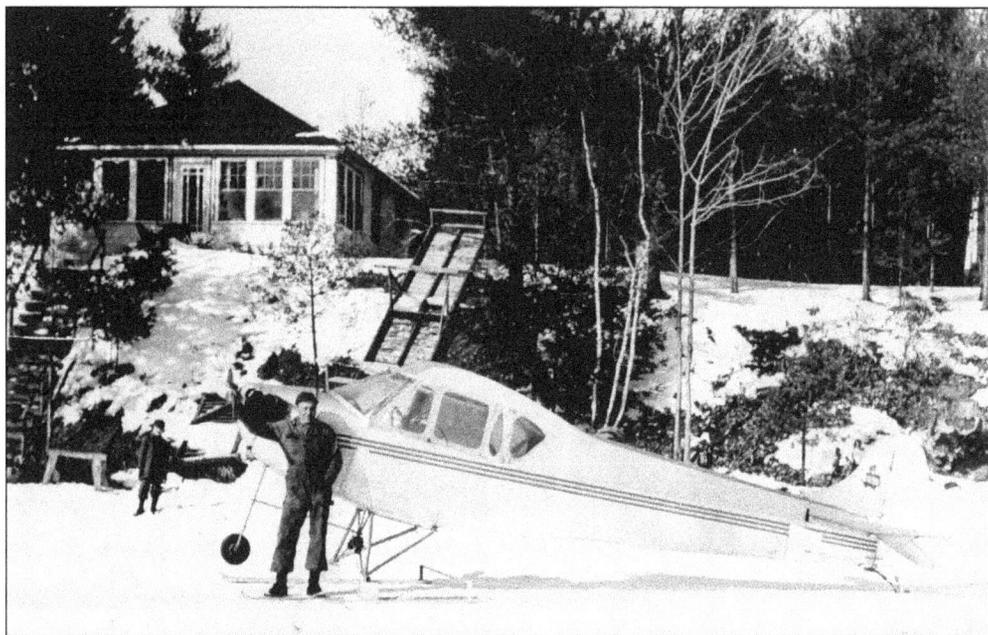

Pictured here in 1945, Joseph Valentinetti is poised and ready to go in his ice plane at Union Point. It was not unusual for enthusiasts to remove the wings for a smooth and speedy ride around the lake. Valentinetti's young friend, Joey Janeczek, looks on. (Contributed by Richard Cazeault.)

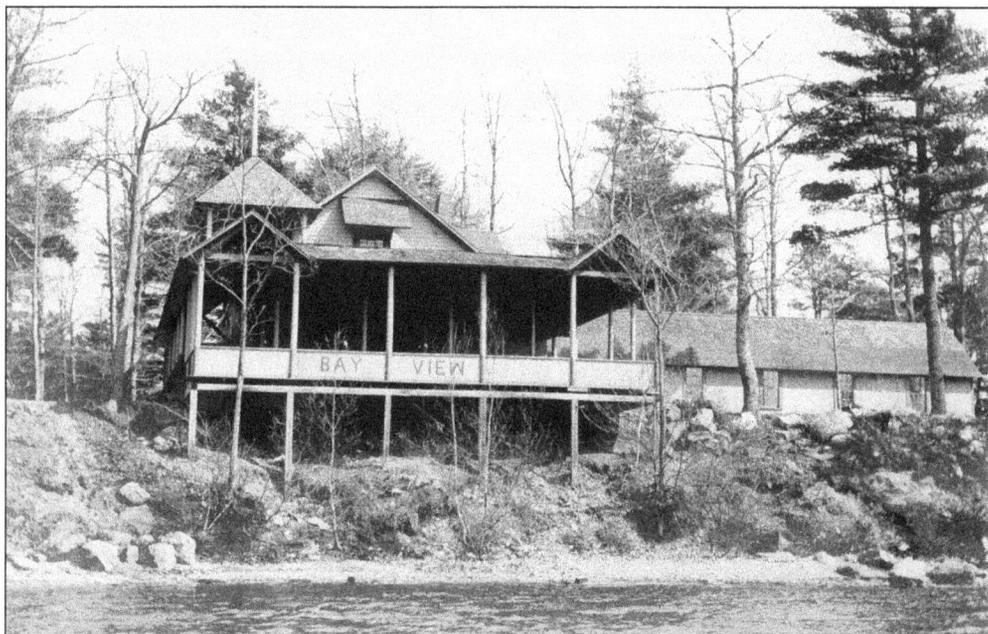

Built in the 1890s by Andrew J. Bates, founder of Bates Shoe Company, Bayview is located off Point Breeze on Webster Lake. It was connected to the Bates home on Thompson Road (later Webster District Hospital) by a footpath for the Bates children to travel back and forth on. Most well-known as Monsey Camp, a summer camp for children, it was owned and operated by Lillian Monsey and Helen Hanley from 1942 to 1965. (Contributed by the Reichenberg family.)

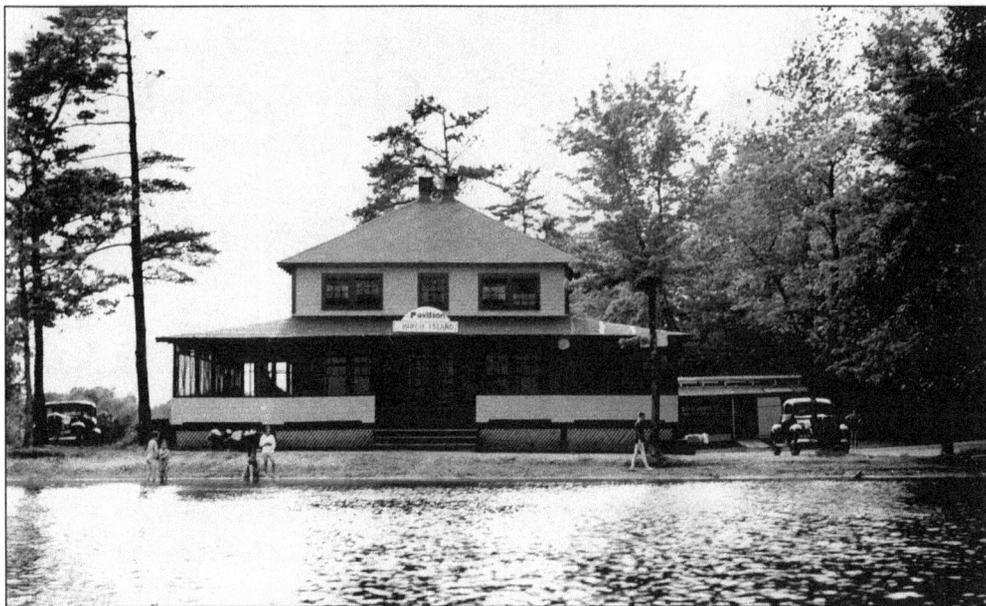

The Birch Island Pavilion, present site of Waterfront Mary's, was run by James J. Dwyer from 1937 until 1960, when the property was sold to Mary Dow. The pavilion was a popular spot for snacking and bathing. Swimming was considered dangerous in the early days, and most folks just waded by the shore and splashed around to cool off, thus the term bathing. (Contributed by Richard Girardin.)

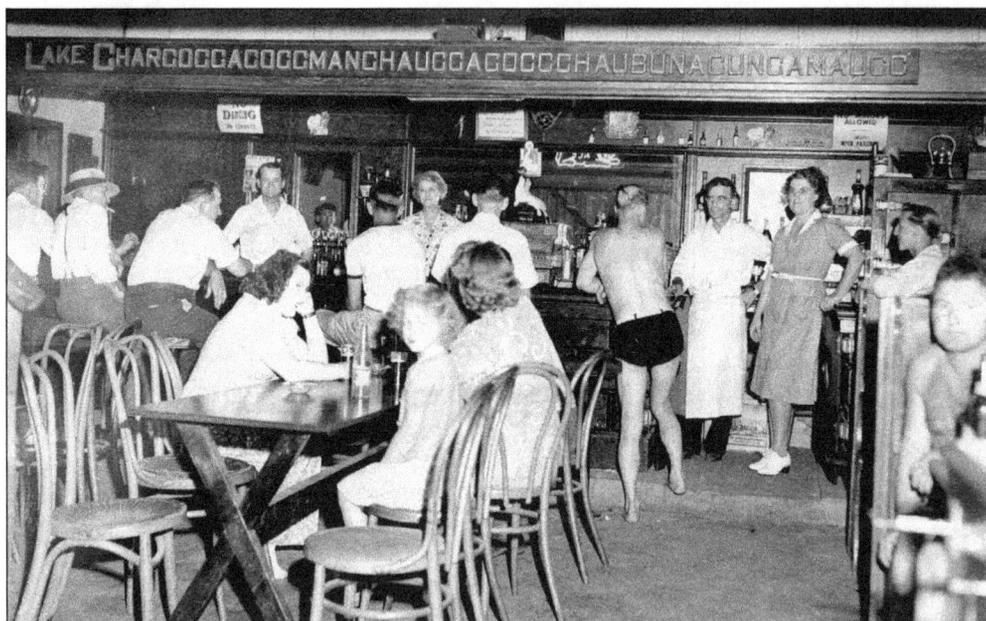

For more than 50 years, the Dugout at Colonial Park was a favorite at the lake for socializing and grabbing a bite to eat after a long day on the water. The place was dug out of the side of Indian Inn Banking. Emil and Bertha Fritzsche owned the restaurant, which closed in 1964. Pictured behind the bar are, from left to right, Merrick Hart, Bertha Fritzsche, Emil Fritzsche, and the Fritzsches' daughter, Bertha. (Contributed by Sylvio Gilbert.)

Mohegan Ballroom was located on Thompson Road, at the modern site of the Goodyear Tire Company. The club was a popular spot for dancing to swing bands of the era. A tremendous fire destroyed the building on the afternoon of October 6, 1938. In the 1950s, the location was used for several years as an ice-skating rink and eventually sold to Gauthier Tire. (Contributed by the Reichenberg family.)

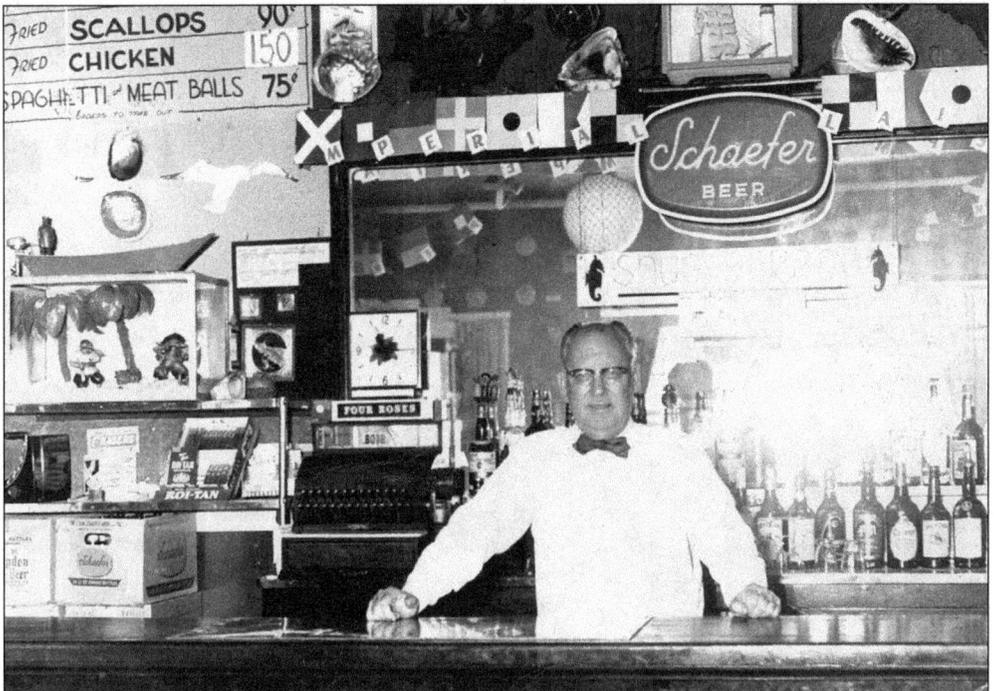

Built in the 1920s by the Piehlers, Snug Harbor was a year-round waterfront restaurant located on Union Point at the corner of Thompson Road. The state took the land for the construction of Route 52 (now Interstate 395) in 1974. The Nipmuc Ski Club held their meetings here in the late 1950s and early 1960s. Pictured is Herman Piehler at the bar of his establishment around 1940. (Contributed by Irvin Piehler.)

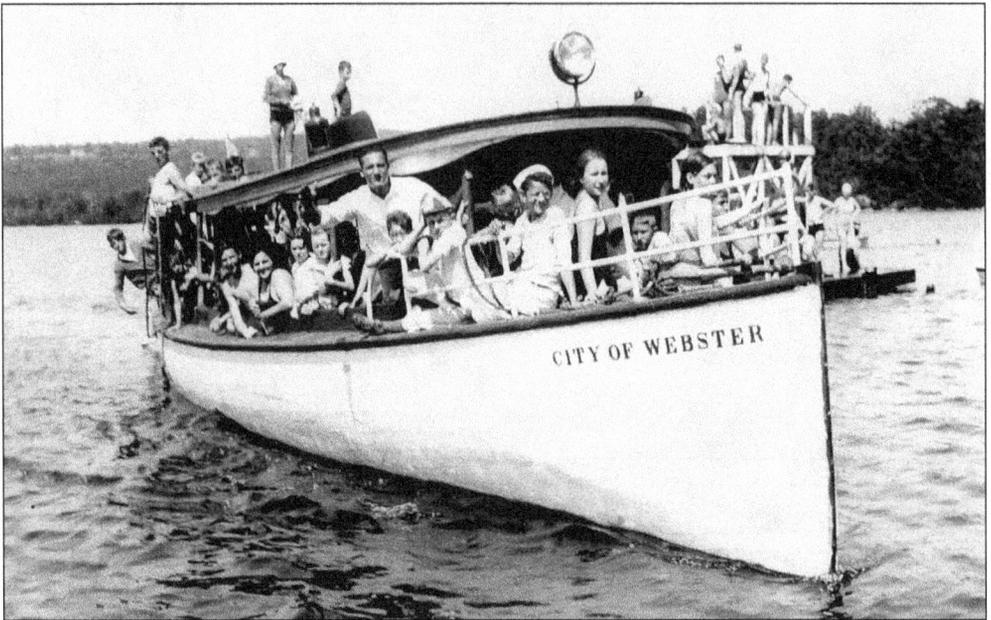

This rare photograph shows the vintage excursion boat *City of Webster* toward the end of its run in the 1930s. The steamers were utilized by people living on or visiting the islands or Wawela Park for transportation back to town or to the shows at Beacon Park. When folks wanted the boat to stop for a passenger, a red flag was placed on their landing in the daytime, or a red lantern was put out at night. (Contributed by Bennett J. Smith.)

Thanks to a campaign spearheaded by *Webster Times* editor Larry Daly and supported by town servicemen writing letters from war zones all over the world, the Memorial Beach at Second Island became town owned in 1946 and was dedicated to the veterans of World War II. $65,000 was appropriated to construct a locker house with a concession stand, build a road, and landscape the acreage leading to this prime piece of waterfront. (Contributed by Gerard Bernier.)

Three

PLANES, TRAINS, AND AUTOMOBILES

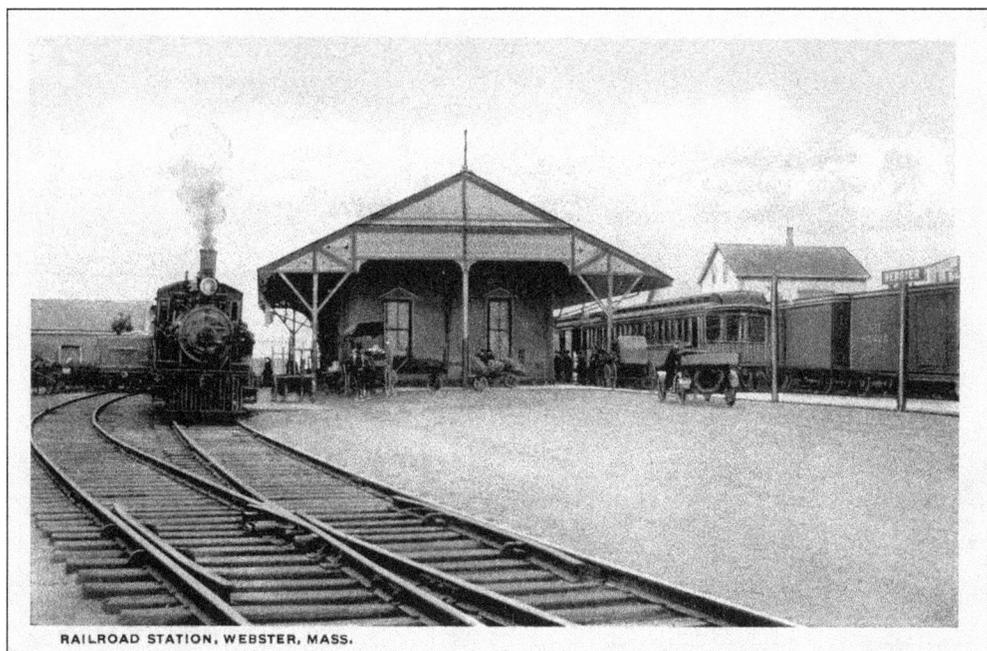

RAILROAD STATION, WEBSTER, MASS.

The Webster Depot, typically a very busy place, looks rather quiet in this early-20th-century scene. The depot, which was built in 1872, was located approximately 80 yards north of the Main Street crossing. The tracks on the right were built by the Norwich and Worcester Railroad in 1840, and the tracks to the left were originally laid by the Boston, Hartford and Erie in the mid-1860s. Eventually the New York, New Haven and Hartford would control this entire track. (Contributed by Jeffrey Stefanik.)

Before the advent of electronic gates, the railroad gates on Main Street were lowered manually with a crank mechanism. With many trains passing each day, it was necessary to have railroad gatekeepers on duty 24 hours a day. The little gatekeepers' shack protected the workers from the elements and housed a potbellied stove that would outdo any modern-day sauna. Elsie Reich, a New Haven Railroad employee, is pictured here on duty at the Main Street crossing in this late-1940s photograph. (Contributed by John J. Mrazik.)

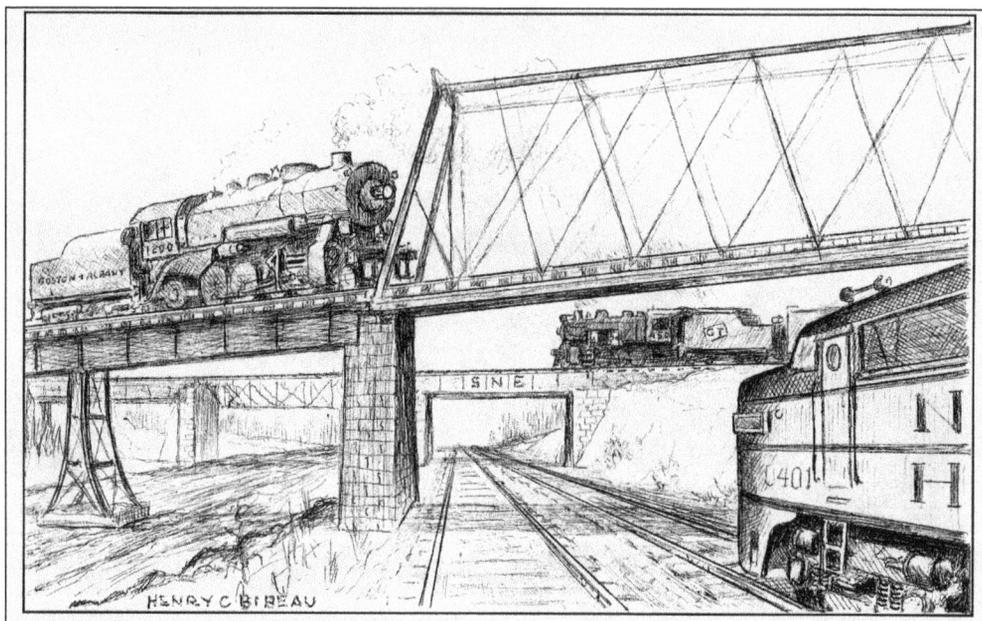

This sketch of North Webster illustrates the way it might have been if the *Titanic* had not sunk and Charles Hays, president of the Southern New England Railroad, or Grand Trunk, had survived. In this late-1940s scene, a New Haven freight heads toward Worcester, a Boston and Albany Railroad locomotive is returning from Cranston Print Works, and on the imagined far bridge, a Grand Trunk freight out of Providence is headed for Palmer, Massachusetts. (Contributed by Henry Bibeau.)

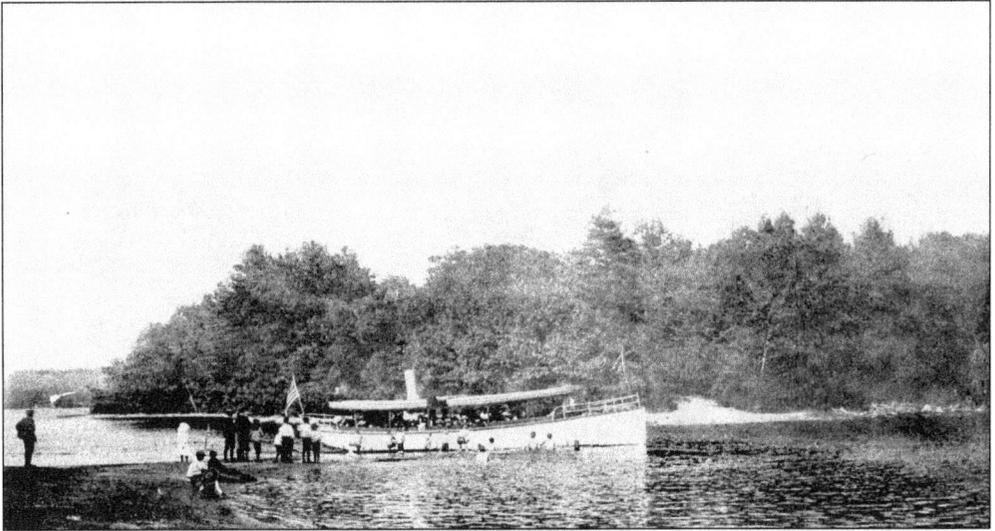

Webster Lake, located approximately halfway between Boston and Hartford, was originally on a Native American path. Many early colonials found this an advantageous route, connecting Boston and the Connecticut River. The Great Trail, or Old Connecticut Path, crossed the lake from Killdeer Island to Birch Island at what is known as the Narrows. (Contributed by Richard Cazeault.)

This southbound train is crossing Marina Cove, near today's Action Marine. The original Boston, Hartford and Erie track connected Southbridge, Webster, and East Thompson to where connections could be made to Boston, Providence, and New York. The line crossed the French River, North and East Main Streets, and Thompson Road. It then followed the lake's west shore before heading to East Thompson, the site of the great wreck of 1891. This line was abandoned in 1937. (Contributed by Webster-Dudley Historical Society.)

49

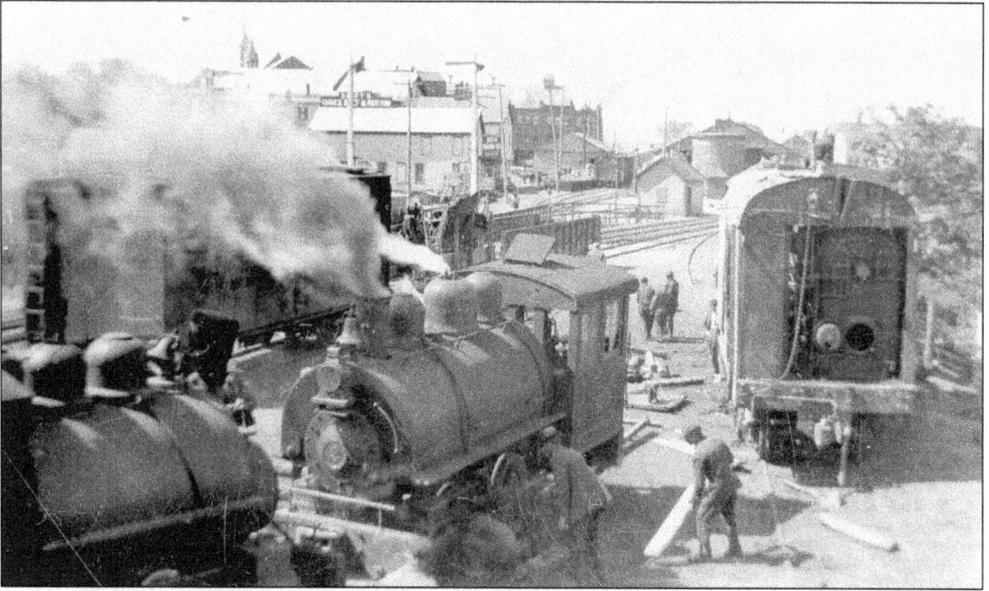

Former Panama Canal equipment, being off-loaded at the Webster rail yard in 1912, would be used in the construction of the Southern New England Railroad. Charles Hays, who directed the effort to build the railroad from Palmer to Providence, drowned on the *Titanic*. Despite Hay's death, work on the new railroad began, but the project would never be completed. Traces of the ill-fated venture can still be found throughout the area today. (From the Russell Joslin collection.)

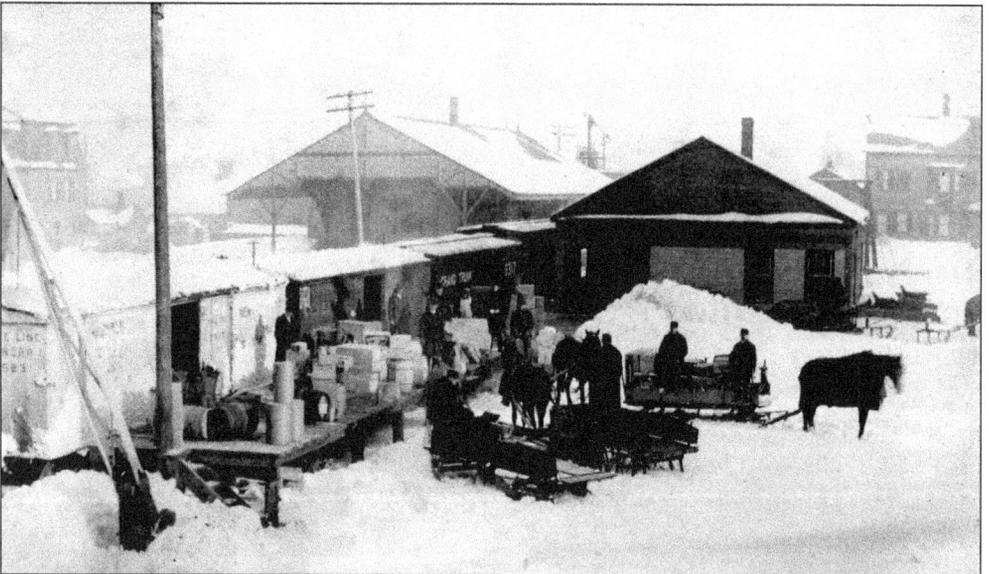

The Norwich and Worcester branch of the New Haven Railroad was an extremely busy rail line. Goods from northern New England would be shipped on this line, along with the products from the hundreds of mills along the French, Quinebaug, Shetucket, and Thames Rivers. More than 90 percent of products would arrive in Webster by rail, as is shown in this very early photograph from the 1890s. The freight depot area pictured here near Davis Street was always bustling with activity. (Contributed by Webster-Dudley Historical Society.)

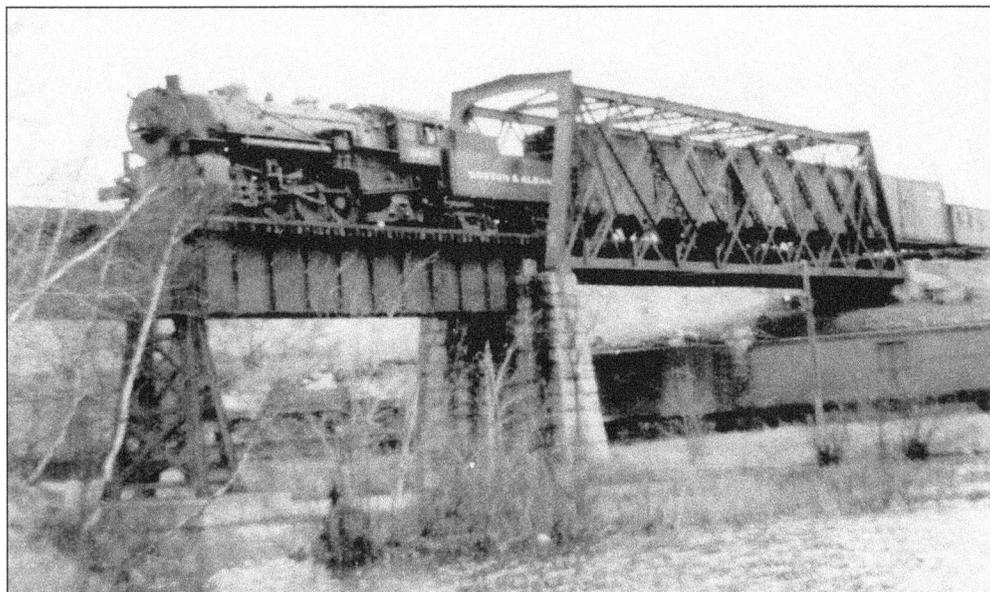

This Boston and Albany train is returning from Cranston Print Works. The Providence, Webster, and Springfield Spite Line was built in the 1880s at the direction of Horatio Slater, who was displeased with the railroad service at the time. The railroad ran from the Boston and Albany main line in Auburn to Dudley, near Calvary Cemetery, with one branch veering eastward toward the East Mills and one southward to the North Mills and Jericho station. (Photograph by William Radcliffe, from the David Jodoin collection.)

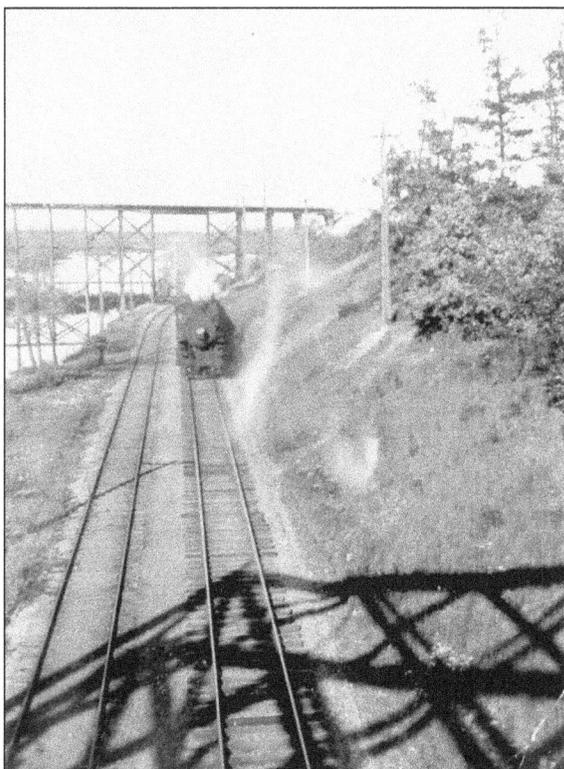

This photograph was taken from the Providence, Webster and Springfield truss bridge in North Webster, which still stands today. The southbound steamer below belonged to the New Haven Railroad. What makes this picture so unique is the view of one end of the 1,052-foot Grand Trunk railroad wooden trestle, which crossed the French River and two other railroads. Though the bridge was dismantled in the mid-1930s, its stone piers still remain. (From the John Faber collection.)

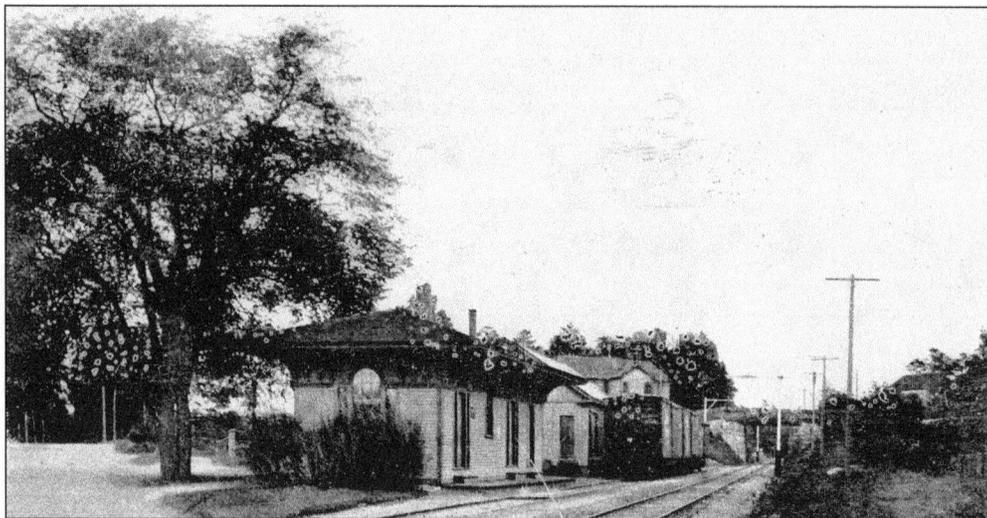

The East Main station was located near the intersection of East Main and Cody Streets, the present site of CAP Auto Parts. The New York, New Haven, and Hartford tracks crossed East Main Street diagonally, then headed off to the lake area. The station was located on a secondary line that connected Southbridge and East Thompson via Webster. It was never a very busy line, and the last passenger train made its final stop in August 1930. Freight service ended in 1937. (Contributed by Michael Branniff.)

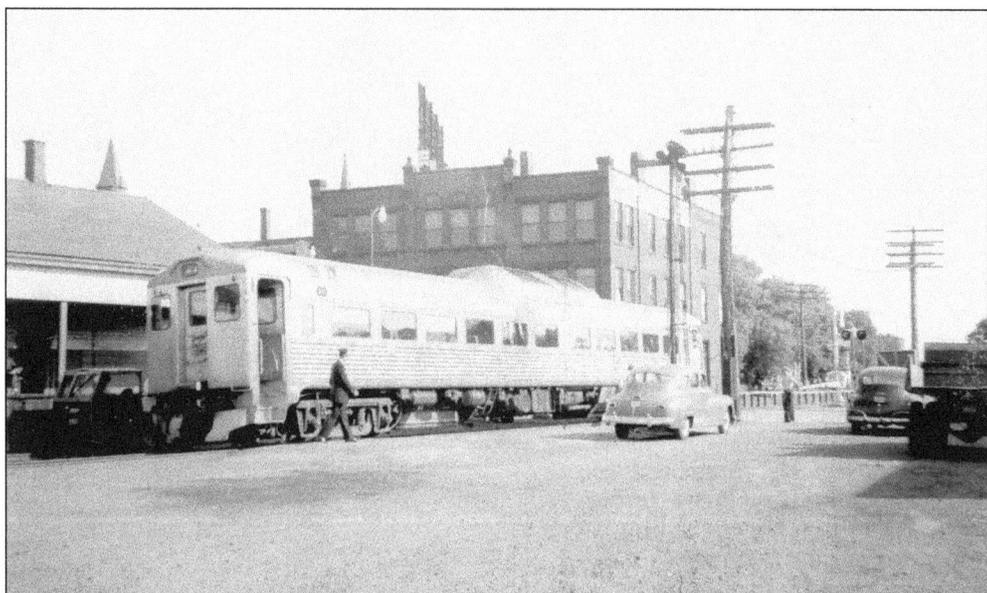

Passenger rail service in Webster would remain popular into the 1920s, but the advent of the auto age would end America's heavy reliance on rail passenger service. The famous boat trains and other rail services would end, with only the late-night State of Maine Express continuing Webster stops until 1946. In 1952, the New Haven Railroad resumed passenger service, utilizing Budd cars between Worcester and New London. The Penn Central Railroad ended the service in 1971. (Photograph by William Radcliffe, from the David Jodoin collection.)

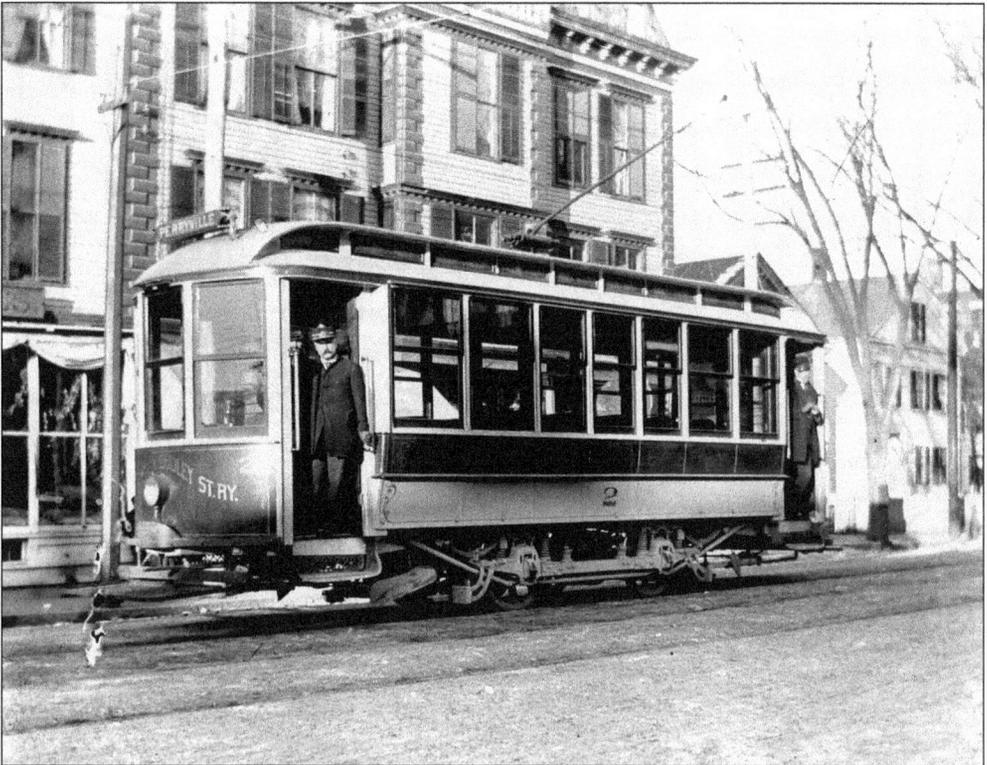

In the late 1890s, Edgar Hill, owner of Beacon Park, headed up a group to build a trolley line in Webster. Hill realized that a fast and convenient source of transportation from the main railroad depot to his resort would enhance his business position, thus the creation of the Webster and Dudley Street Railway. The use of the word Dudley is interesting because the line never did reach that location. (From the Russell Joslin collection.)

The trolley lines of Webster traversed Main, South Main, East Main, Slater, Lake, and School Streets. Connecting lines north to Worcester and south to Connecticut made for a very convenient and economic mode of travel. This original transfer ticket indicates the trolley's various stops. (Contributed by Richard Gardecki.)

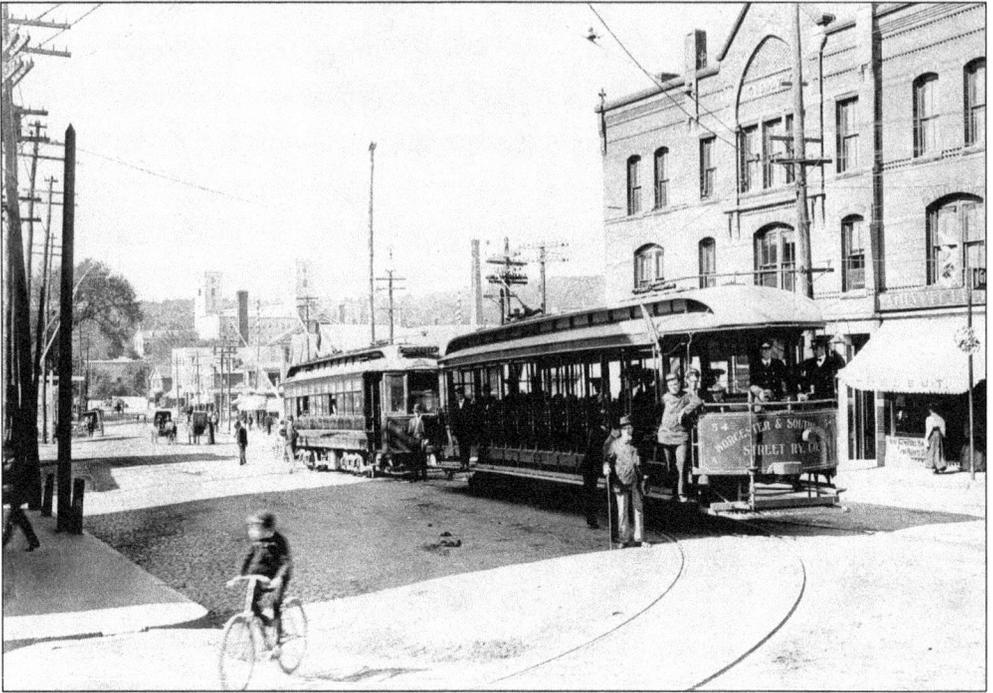

If one looks carefully at the front of this trolley car located at the intersection of Main and School Streets, it clearly reads Worcester and Southbridge Street Railway. Equipment between the various street railways was often interchanged. The tracks to the left would run the entire length of School Street, and the tracks to the right would continue up Main Street. (Contributed by Chester C. Corbin Public Library.)

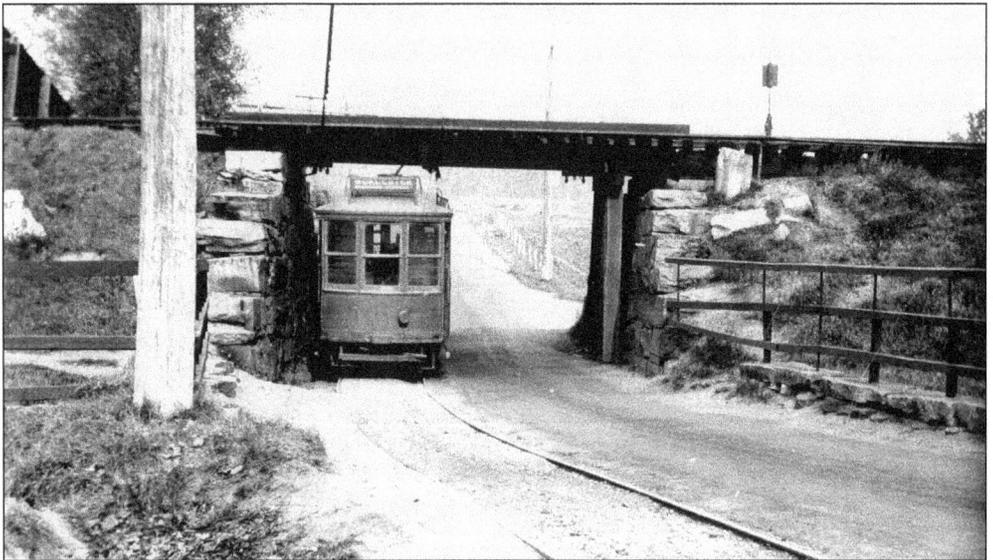

This trolley is on present-day Route 12 and is passing under the railroad trestle that ran to the East Mills, today's Cranston Print Works. This line would continue on to Oxford, Auburn, and Worcester. The location is not far from where a fatal head-on trolley collision occurred in front of the Knolls on East Main Street on July 4, 1900. (Contributed by Robert Antos.)

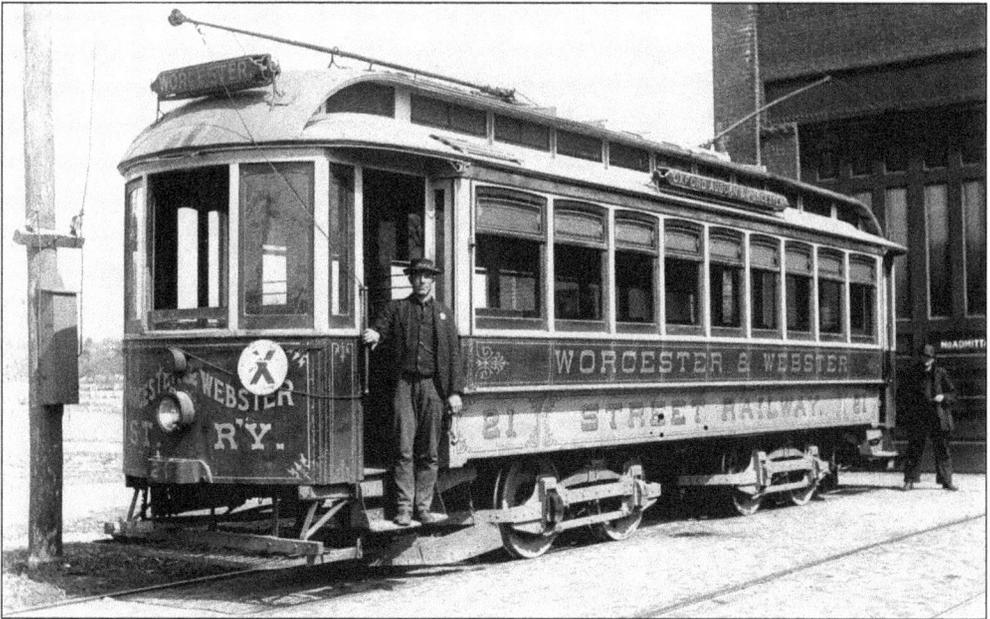

Two trolley structures still in existence today are the trolley barn on Lake Street, now an auto restoration business, and the trolley power station on Perryville Road, now connected with an excavating company. The Worcester and Webster provided frequent service via Oxford and Auburn. (From the Russell Joslin collection.)

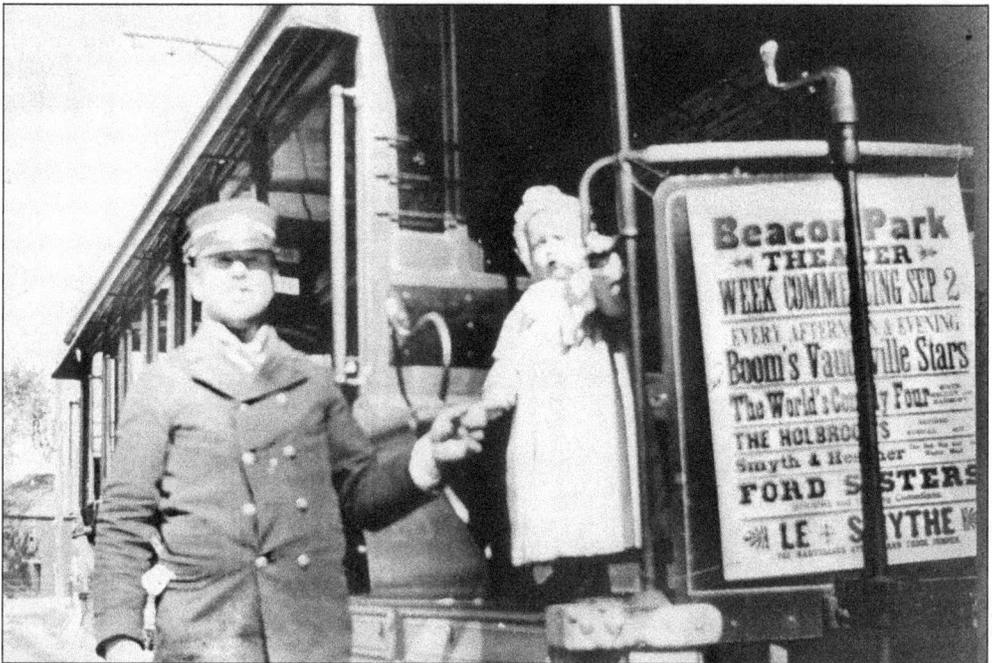

The conductor is assisting a young patron on the Webster and Dudley Street Railway trolley, perhaps headed for Beacon Park. The advertisement on the front of the car indicates that there was no shortage of activity taking place at the amusement center at the lake. (Contributed by Webster-Dudley Historical Society.)

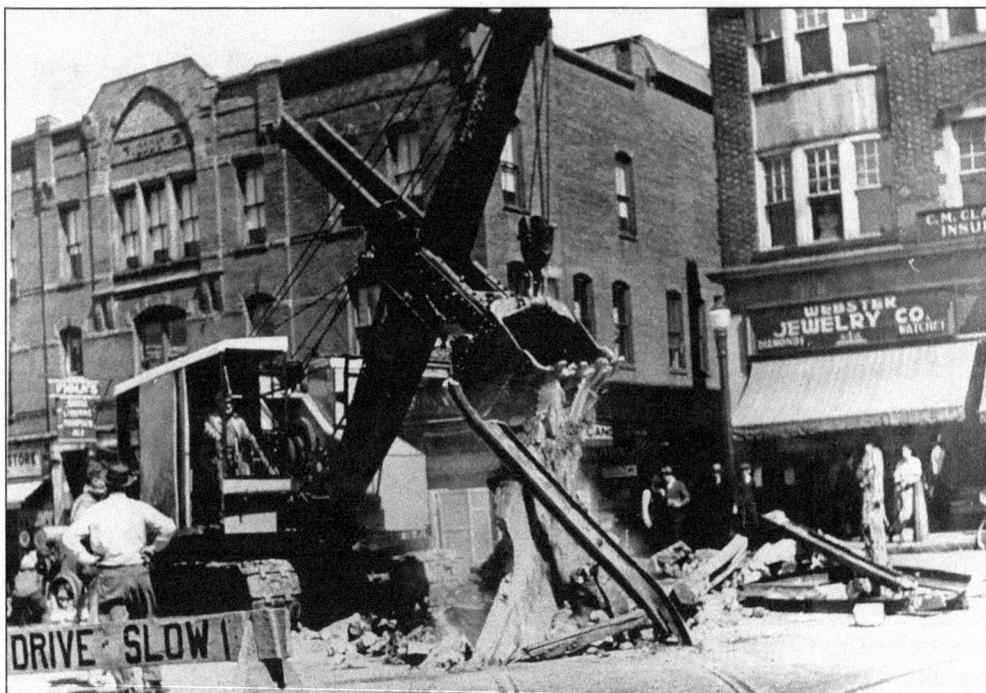

By the mid-1920s, trolley ridership would drop dramatically. The automobile played a major role in the demise of the system. Service reliability and track conditions between 1926 and 1927 would become intolerable, and service would effectively end, with bus service replacing the trolleys. This late-1930s scene depicts the trolley rail being removed from Main Street. (Contributed by Bennett J. Smith.)

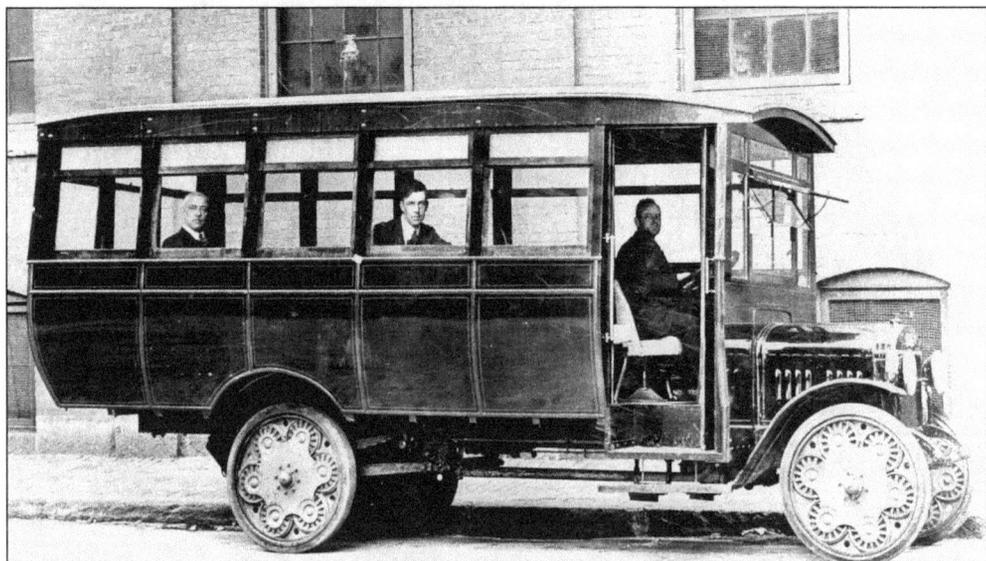

This photograph from 1919 shows one of the earliest buses that ran between Worcester and Webster. The driver of the bus is Wilfred J. Boutillette. Note the unusual wheels, which were a component of the planetary drive system that enabled the outside wheel to turn faster than the inside. This is the type of bus that replaced trolleys in the mid-1920s. (Contributed by Alfred E. Beland.)

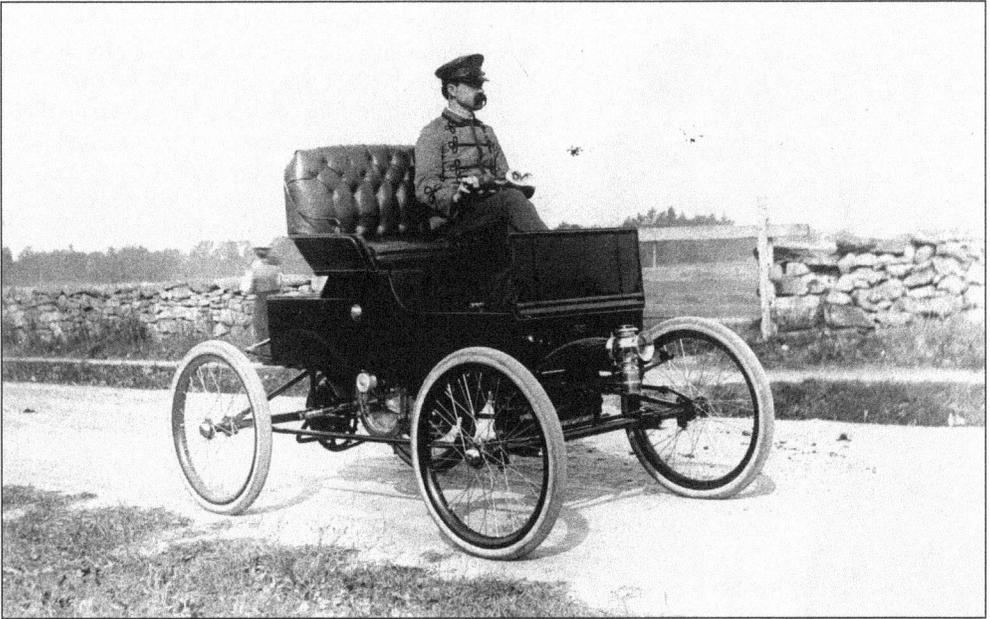

The development of the internal combustion engine changed the face of America, with Webster's first automobiles appearing at the beginning of the 20th century. The early vehicles experienced rough riding on Webster's dirt roads and streets, and poor driving conditions continued despite the advent of paved roads in the 1920s. Pictured here is Emil Roemer, who was reportedly one of Webster's first car owners. (Contributed by Webster-Dudley Historical Society.)

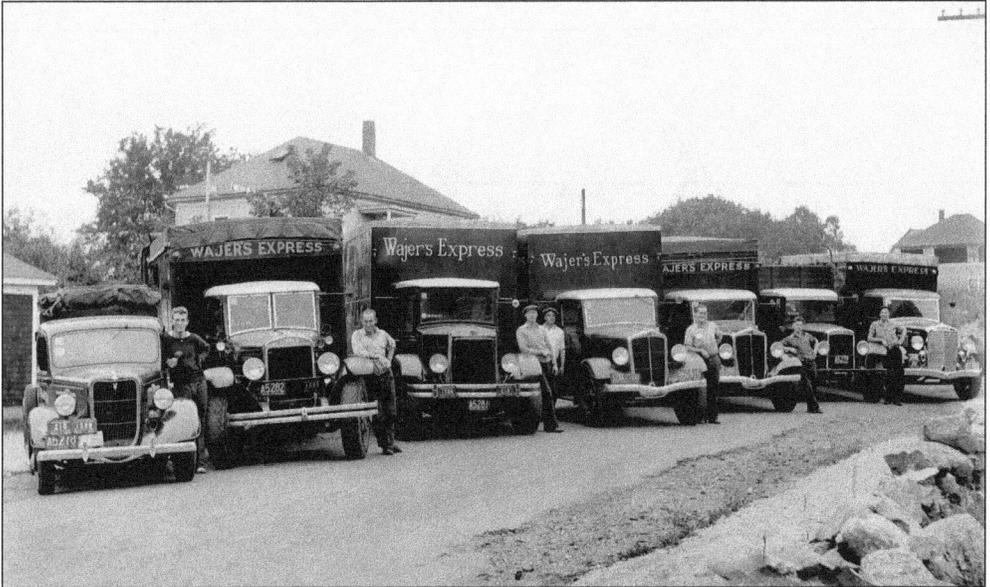

Paul Wajer started a trucking company in 1918 that would become a significant mover of goods in New England. With the advent of better roads, trucking companies played a vital role in America's transport system. Route 12 was the primary north and south thoroughfare until the completion of Route 52 (Interstate 395) provided a great stimulus to the local economy. By 1935, the express company grew to a fleet of seven trucks. (Contributed by Paul Wajer.)

Webster's first pilot, Felix Brisbois, met his demise in a crash in Oxford in October 1928. In the 1930s, it was not uncommon to see German airships passing over Webster on their way to the North Atlantic. During World War II, the Aircraft Warning Service kept watch over Webster's skies 24 hours a day, noting the time and positions of all overhead aircraft. The organization's lookout station still stands today and is located at the southwest corner of Memorial Athletic Field. (Contributed by Webster-Dudley Historical Society.)

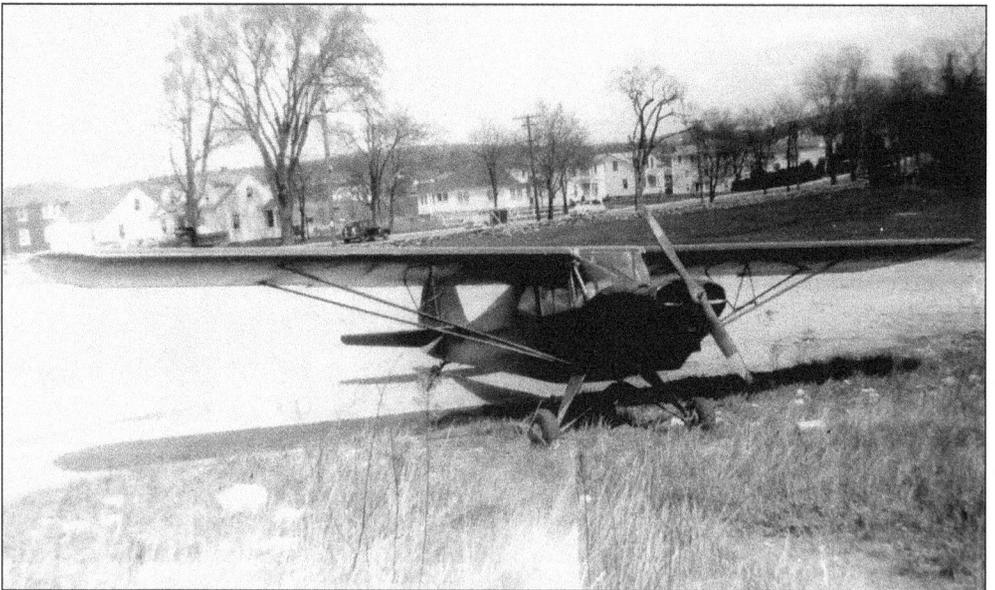

Webster never had a formal airport, but landings and takeoffs were not uncommon. In the wintertime, Webster Lake provided an excellent landing strip for local flyers. Another convenient landing location was the east side of Hillside and Second Island Roads. If one looks carefully, East Main Street is visible in the background. (Contributed by Alice Kitka.)

Four

SCHOOL DAYS

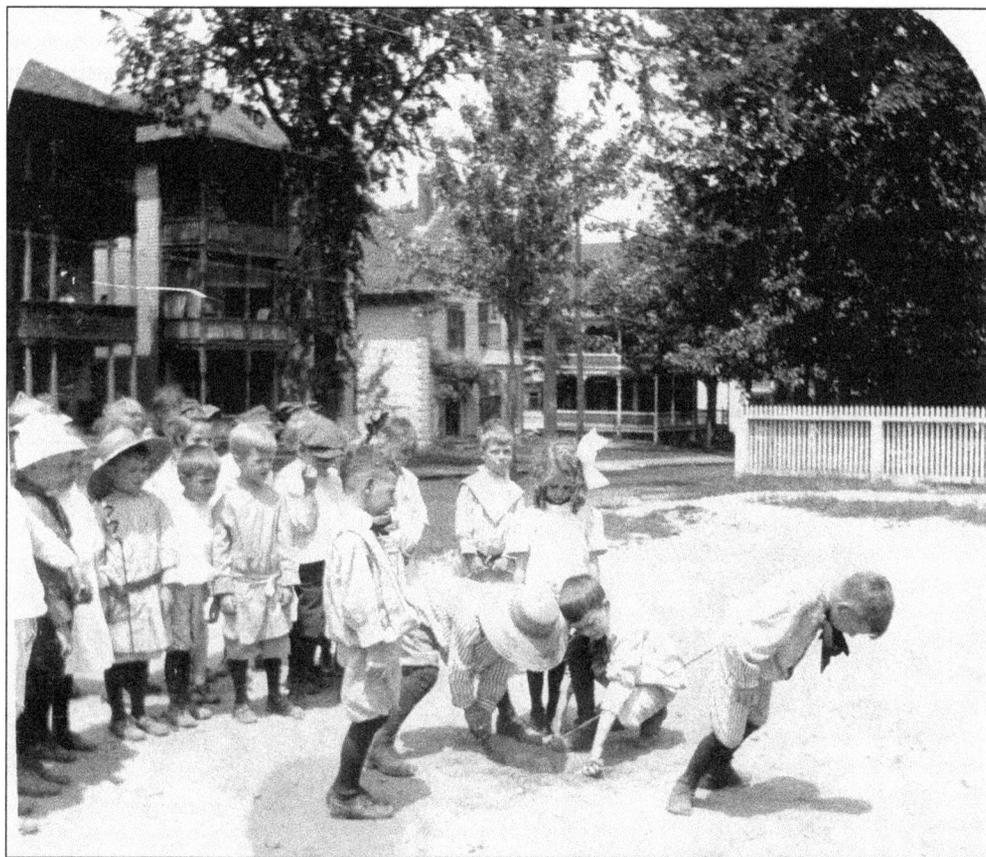

One of the universal truths about kids and school is that everyone cannot wait for recess. In this *c.* 1900 photograph, children at recess at Fenner Hill School, otherwise known as Little Red Schoolhouse, on School Street wait in anticipation for their classmate to pull a large object from the play yard. (Contributed by Jim Manzi.)

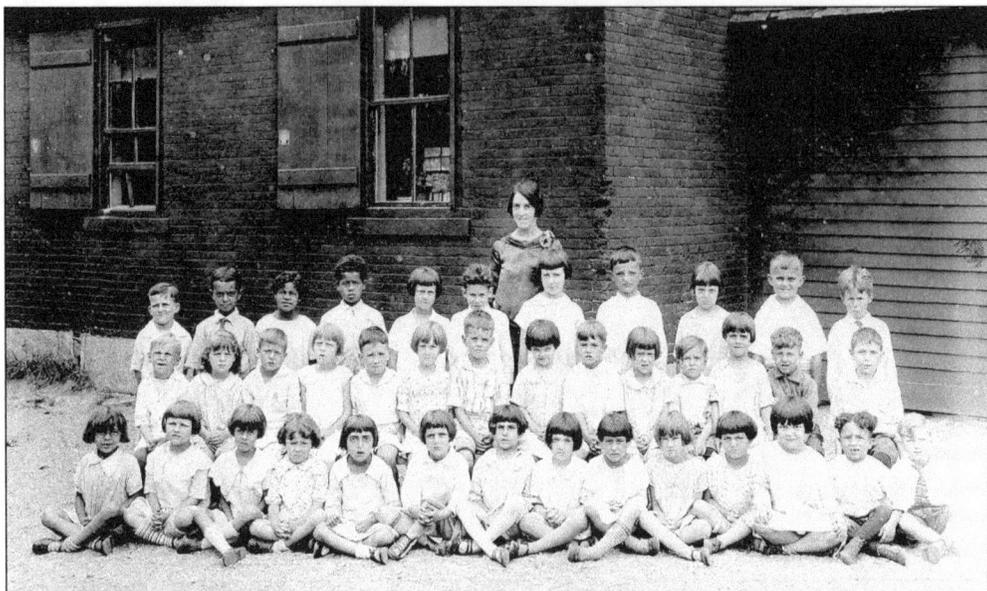

The Little Red Schoolhouse, or Fenner Hill School, located at the intersection of Hill and School Streets, was built in 1835 and was Webster's first school building project after incorporating in 1832. The town purchased the one-eighth acre of land for $7, and the cost of construction was less than $500. The school would last a century, closing in 1935. The building, which is on the National Register of Historic Places, houses the Webster-Dudley Historical Society. (Contributed by Webster-Dudley Historical Society.)

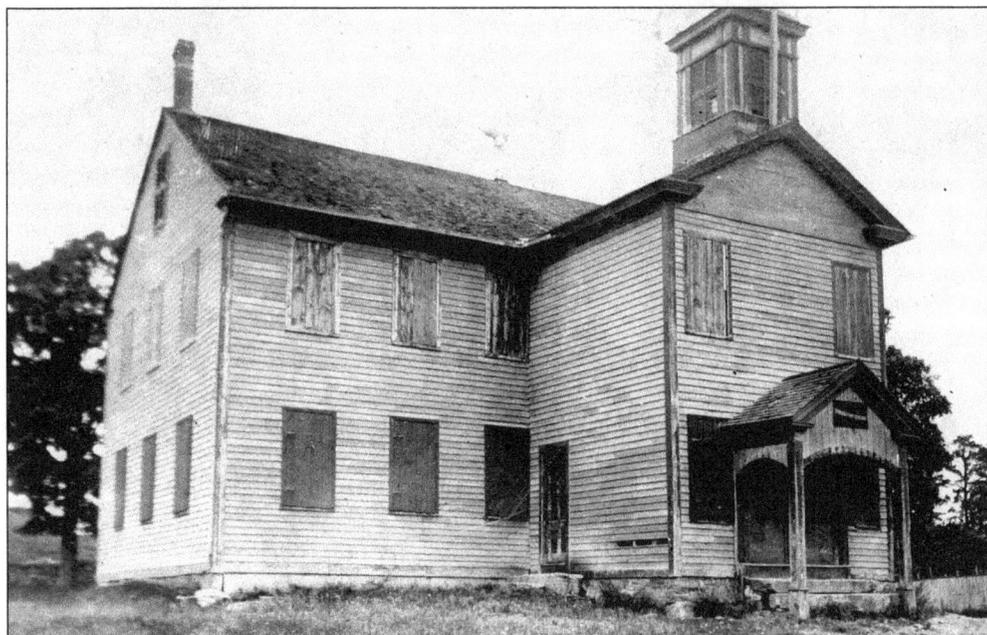

While the first school built by the newly chartered town of Webster was the Fenner Hill School in 1835, construction of the Center School began that same year but was not completed until 1836. This school was located just off East Main Street near what is now Park Avenue. Center School burned to the ground in 1915. (Contributed by Webster-Dudley Historical Society.)

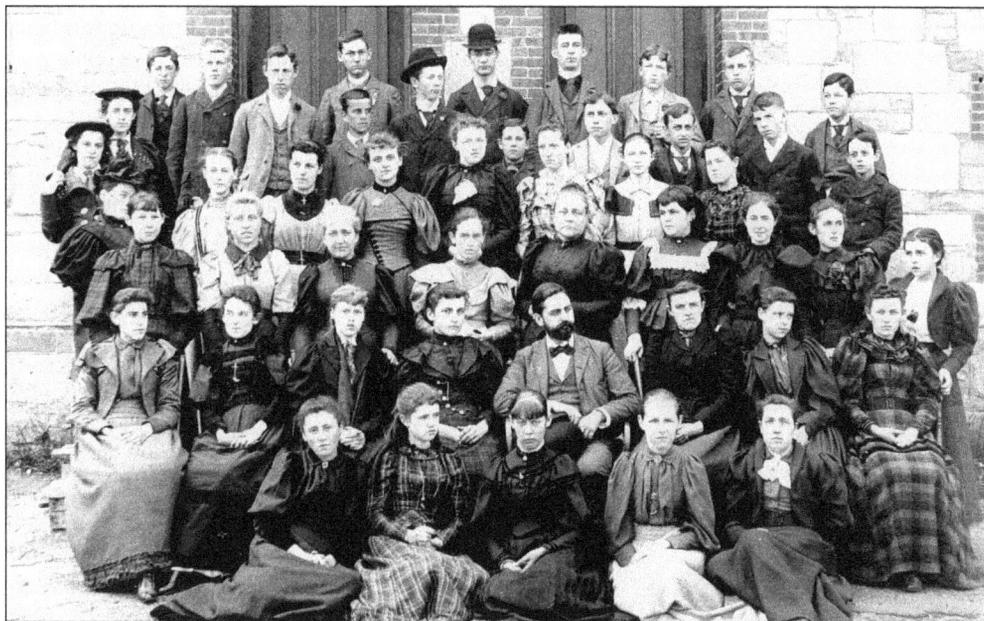

The Webster High School classes of 1894–1897 pose on the front steps of the Rock Castle School. The high school's class sizes would increase markedly due not only to the growth of Webster's population, but also labor law changes, which went into effect in the 1920s and 1930s, increasing the working age and keeping more children in school. (Contributed by Chester C. Corbin Public Library.)

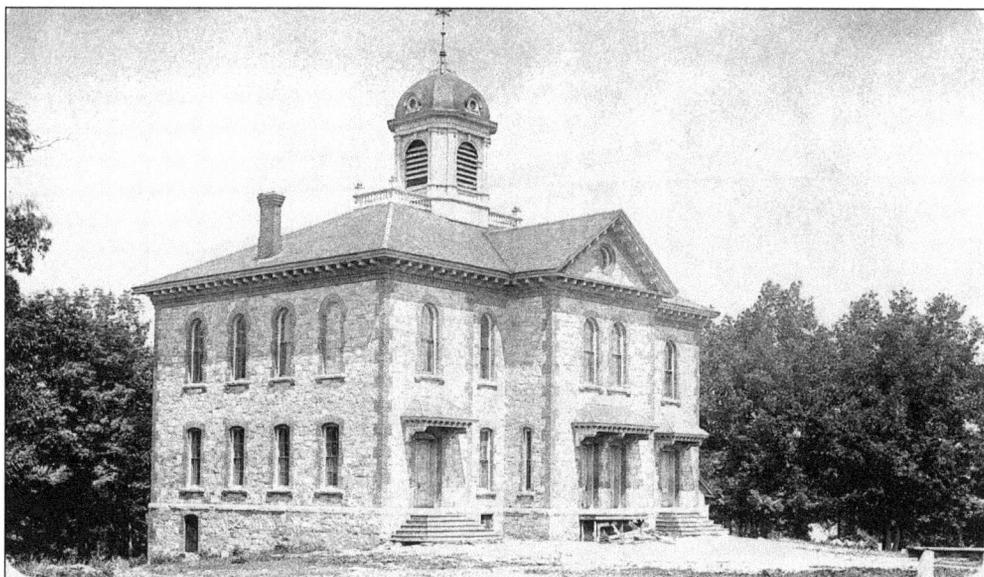

Webster High School, also known as the Rock Castle School, was built in 1871 on land purchased from S. Slater and Sons in the South Village. It was used as a high school until 1905, when the new high school on Negus Street was built. Used as an elementary school until 1930, it was reopened in 1948 as the vocational annex to Bartlett High School and used as a trade school until 1972. (Contributed by Webster-Dudley Historical Society.)

In 1881, a wooden two-story structure was built on Prospect Street, where, in 1913, Thompson School would be built. The early Prospect Street School was a one-room school that accommodated 64 pupils. When it was razed in 1912, the boards, foundation stones, and even the privies were sold at auction. (Contributed by Webster-Dudley Historical Society.)

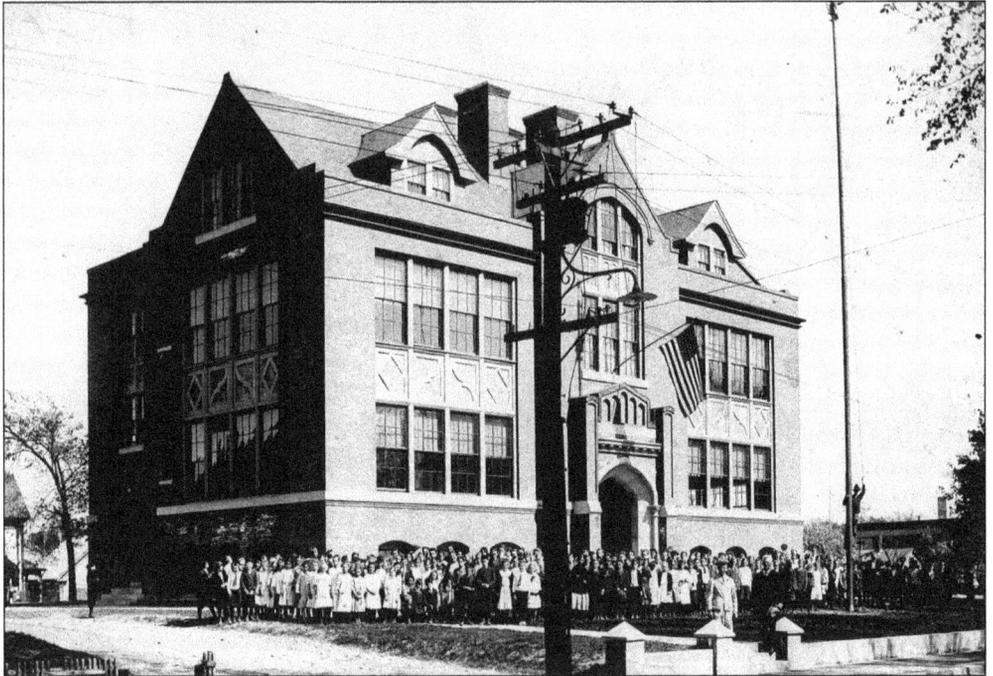

The three-story brick Thompson School was built in 1913 and served grades one to three for 60 years. It was dedicated to Dr. John Thompson, a local physician and member of the school committee from 1907 to 1916. The flagpole in front of the school was donated by Thompson and his sister, Nellie. (Contributed by Webster-Dudley Historical Society.)

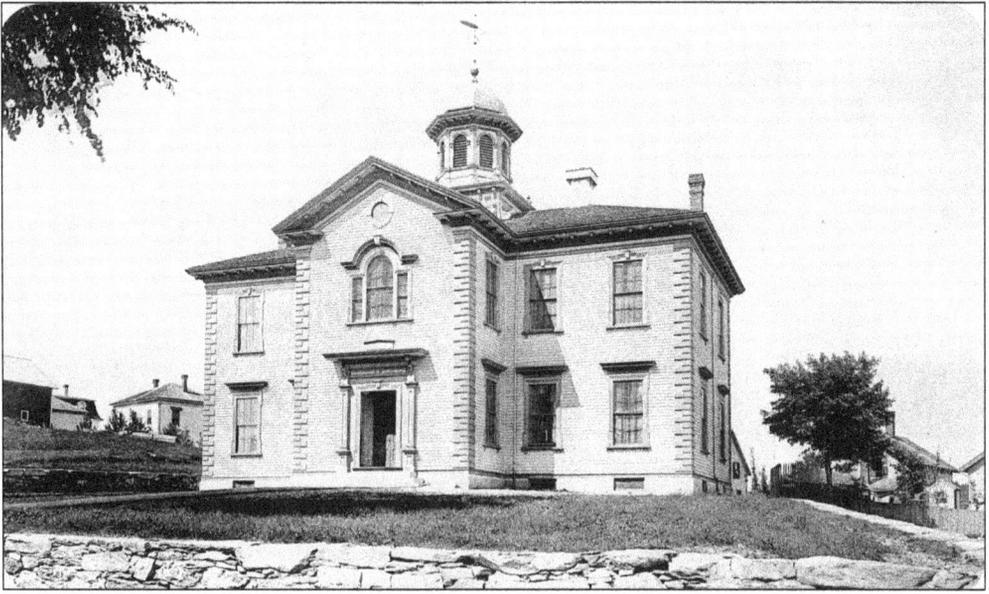

School Street School, built in 1869, replaced an older school that was divided into two parts and moved. Renovated in 1919, it was, for many years, the largest elementary school in Webster. The 10-room building, too expensive to repair, was abandoned upon completion of the intermediate school on Park Avenue, which opened in September 1961. A firehouse substation now occupies the site. (Contributed by Webster-Dudley Historical Society.)

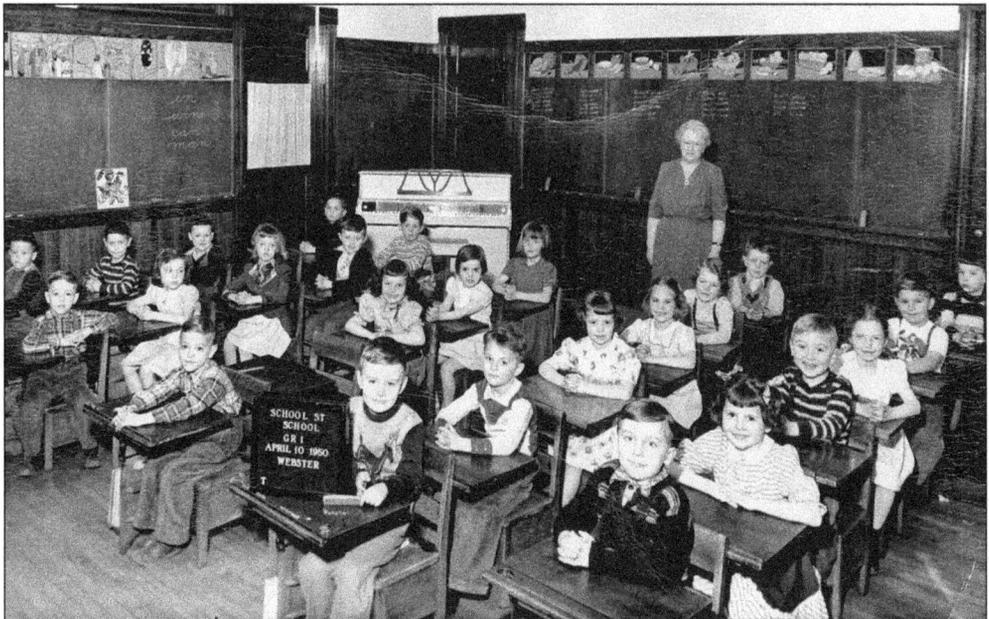

This photograph from 1950 shows a bright-looking group of first graders at School Street School. The class includes the following: John Hoye, Beverly Patrowicz, William A. R. Klebart Jr., Roberta Conrad, Irvin Piehler, Thomas Ciesla, James H. Dugan, Thomas Kliss, Susan Semino, Beverly Evans, William Waldron, Alexis Pappas, Evelyn Geotis, Joan Korch, David Holke, Richard Levasseur, and John Jablonski. The teacher was Florence Tucker. (Contributed by Irvin Piehler.)

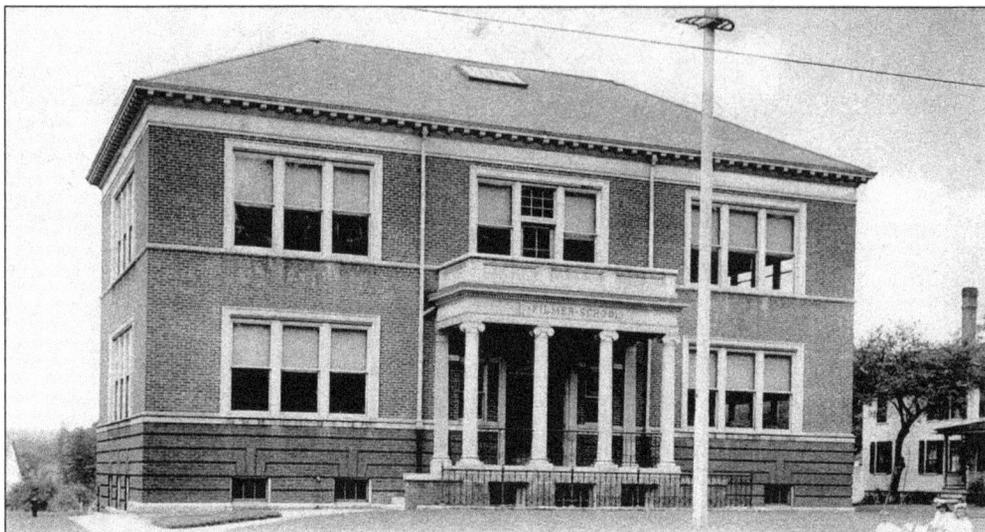

Built in 1899, Filmer School on East Main Street was named after Rev. Thomas T. Filmer, pastor of the nearby First Baptist Church for 30 years. Having served as an elementary school for many years, the building now houses the Webster public schools administrative offices. (Contributed by Jim Manzi.)

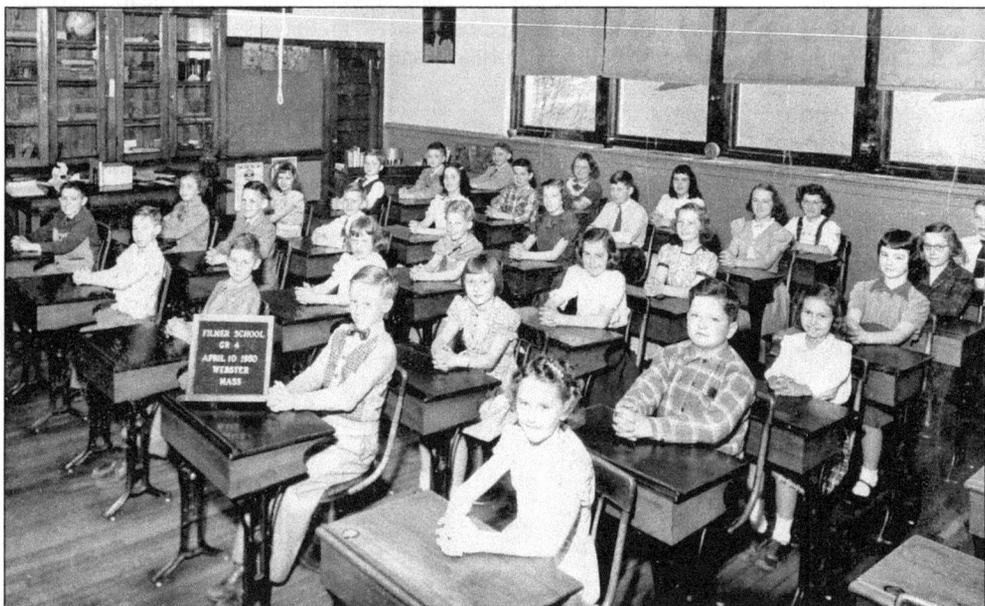

In 1950, the Webster school system photographed classes and used signs to identify the school and grades. The young man in the front row wearing the bow tie appears very proud that he was chosen to hold the class sign. Members of the class include the following: Norma Fregeau, Charlene Makowski, Pauline Cardin, Elaine Bonnette, Richard Lewis, Lois Armstrong, Richard Bishop, Judith Johnston, Bernard LaFountain, Elaine Heller, Beverly Schumann, Robert Sellig, Carolyn Johnson, Francis Galvin, Arlene Barry, Joyce Marcustre, Mary Ann Fiske, Doris Schur, Betty Gatzke, Arlene Quigley, Penelope Brownell, Theresa Daniels, Marilyn Miller, Sheila Boland, William Martin, Francis Lefebvre, David Small, Bernard Cyr, Russell Spahl, Richard Cherrier, Richard Pion, and Clayborne Rosebrooks. (Contributed by Webster-Dudley Historical Society.)

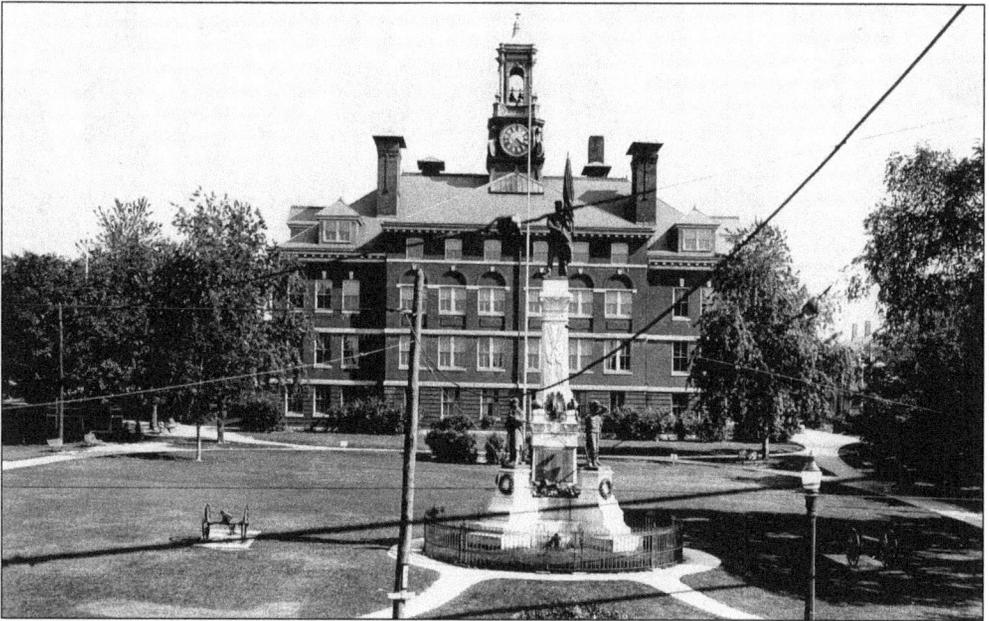

Webster High School's name changed during the 1913–1914 school year. To honor former principal and Civil War hero Amos Bartlett, the Negus Street facility was renamed Bartlett High School. The Webster-Dudley School Union was officially dissolved in 1973, with the last of the Dudley students graduating from Bartlett High School, forever changing the dynamics of both towns. In 1979, a new high school was completed on Lake Parkway. (Contributed by John and Nancy Byrnes.)

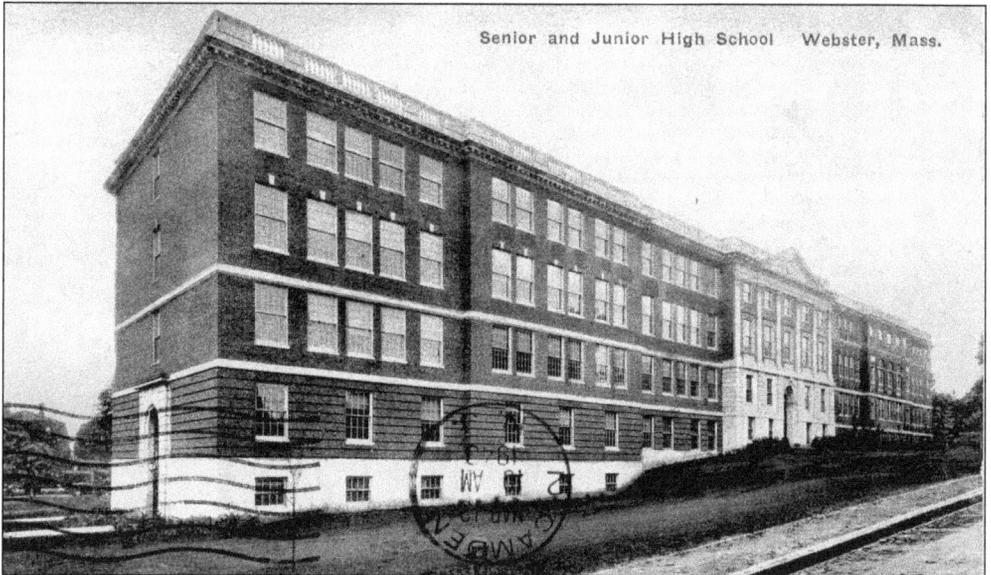

Since Webster's incorporation, there have been five different locations for high school facilities, which include the following: part of the town hall on East Main Street, the McQuaid Block on Main Street, and the Rock Castle School on Prospect Street. In 1905, the new high school on Negus Street was ready for occupancy. A major expansion took place from 1927 to 1928 in conjunction with the building of a new town hall. (Contributed by the Reichenberg family.)

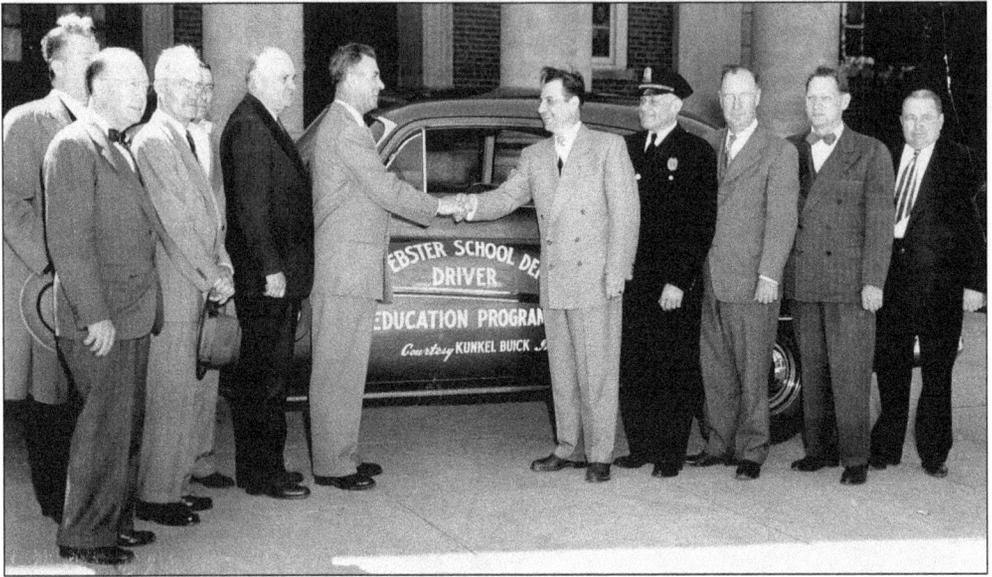

In this 1952 scene, Edward "Kiki" Kunkel presents a new Buick to superintendent of schools George A. Sellig to use in Bartlett's driver education program. Pictured in the photograph are, from left to right, G. O'Day; Cyril Smith, principal; T. Kokocinski; unidentified; Rudolph King, registrar of motor vehicles; George Sellig; Edward Kunkel; Del Nadeau, police chief; two unidentified men; and Leo Kujawski, fire chief. (Contributed by Edward S. Kunkel Jr.)

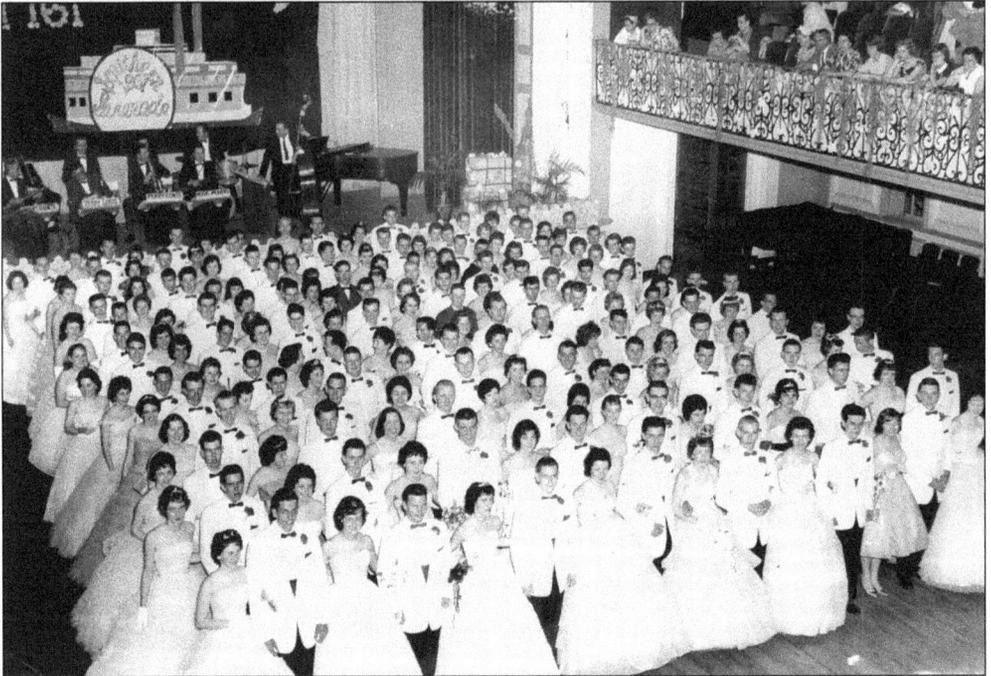

For many teens, the highlight of their high school experience is the junior-senior prom. Bartlett held its proms in the town hall auditorium, which would be specially decorated for the occasion by the prom committee. A live band would play, and many proud friends and relatives would have the opportunity to watch the festivities from the upper balcony. (Contributed by Irvin Piehler.)

66

Five

PLAY BALL!

The 1959 Bartlett football squad is shown being led by captain Dick Nowak (No. 74), arguably the finest scholar-athlete ever to graduate from Bartlett High School. Nowak would go on to captain the West Point football team and would appear on the front cover of *Sports Illustrated* prior to the Army-Navy game in 1963. Other recognizable players include: Len Langevin, Jim D'Allesandro, Irv Piehler, Ed Kunkel, Leo Biron, Ron Swierzbin, John Ivascyn, Paul Vajcovec, Paul Marrier, Len Kullas, Mike Nalewajk, John Swiewak, Jim Kindler, Joe Beresik, Bill Ceppetelli, Joe Drobot, Stan Lempicki, Ron Battista, George Kasierski, Chuck Szymczak, Jesse Rulli, Joe Annesse, Bob Ducharme, Donald Bernier, Ron Napierata, and Al Poprovo. (From the Joseph Capillo collection.)

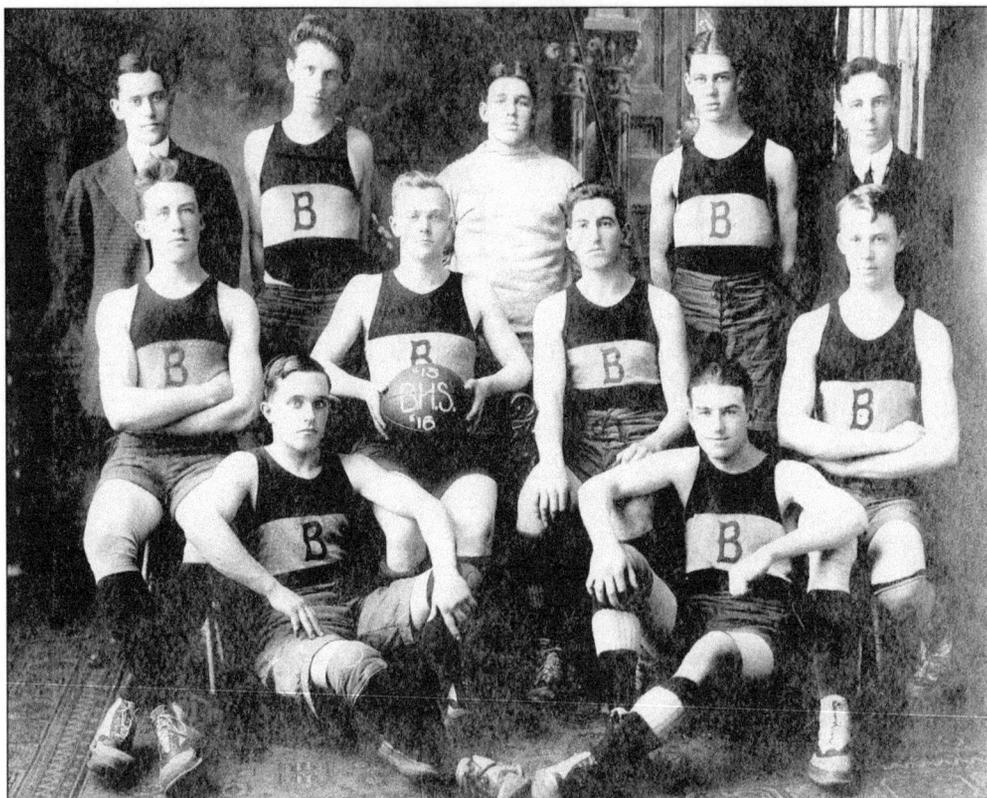

The 1915–1916 team was one of Bartlett's best early basketball teams. They were Central Massachusetts Champions and the first squad to win more than 20 games in one season with a 21-4 record. (Contributed by Jim Manzi.)

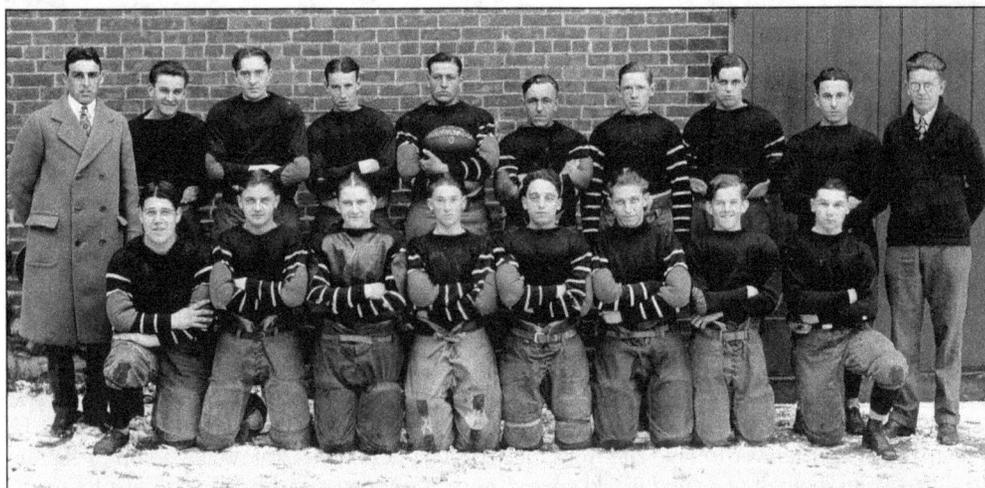

Captain Edgar Gadoury proudly displays the game ball and the 6-0 score of the Bartlett-Southbridge Thanksgiving Day game. Besides coach George Finnegan standing on the left, identifiable is the manager standing on the right, future town engineer Rodney Klebart, and kneeling in the middle of the photograph is Eddie Bastolla, considered by many to be the premier Bartlett athlete of the 1920s. (Contributed by Ruth Klebart Lavigne.)

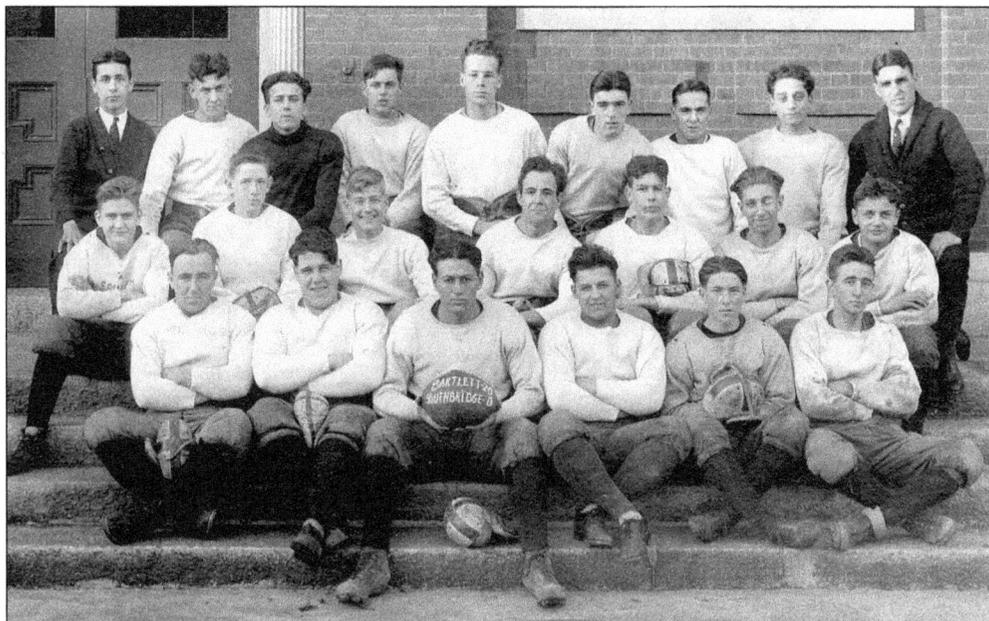

Over the years, Bartlett has possessed a number of excellent teams, but undefeated seasons have been rare. The first Bartlett team to achieve this status in the 20th century was George Finnegan's 1924 football squad (5-0), pictured here in their practice jerseys. John Mrazik's 1995 District Champion girls' tennis team (18-0) was the last in the century to attain the lofty goal. Bartlett's best-ever win total was set by the 1935 basketball squad, who obtained a perfect 23-0 record. (Contributed by Ruth Klebart Lavigne.)

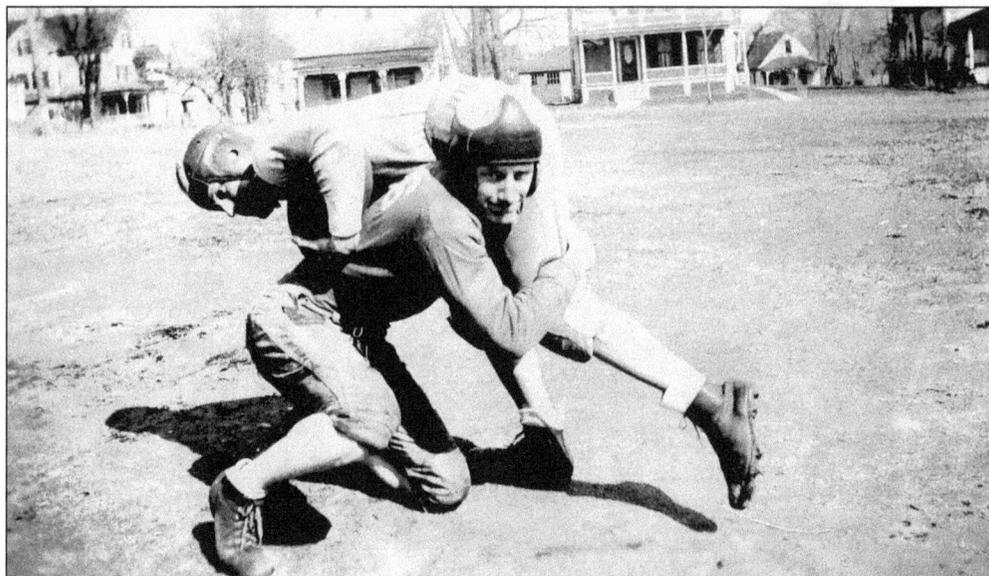

Walt Pauli, Bartlett grid captain of 1936, is being tackled by teammate Oscar Spahl. Webster's largest sporting spectacle is the traditional Thanksgiving Day game between Bartlett and Southbridge. Crowds of over 5,000 were not uncommon in earlier years, with some outstanding games taking place in the series that started in the 1920s. In the mid-1960s, attendance was at its highest with as many as 10,000 spectators. (Contributed by Eric Pauli.)

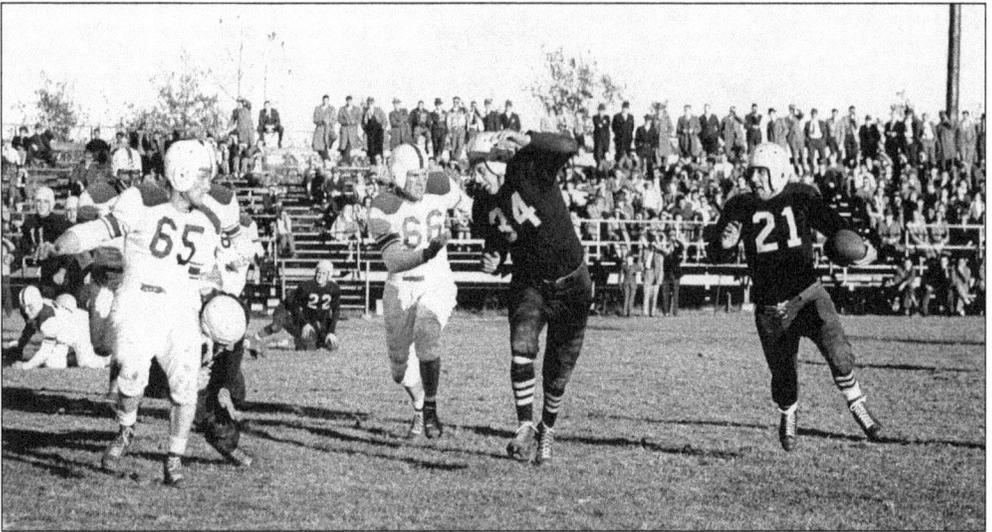

In the 1930s and 1940s, semiprofessional football played a pivotal role in Webster's sport scene. Large crowds would attend the Sunday afternoon tilts, where the Webster Colonials were the featured squad. Colonial Club owner Ted Morse would provide the funds to field the team, offering locals an opportunity to watch games against the likes of the Leominster Lions and Burrillville Mules. In this scene, Thomas "Whigs" Deary sweeps left for a big gain versus Gardner. (Contributed by Thomas Deary.)

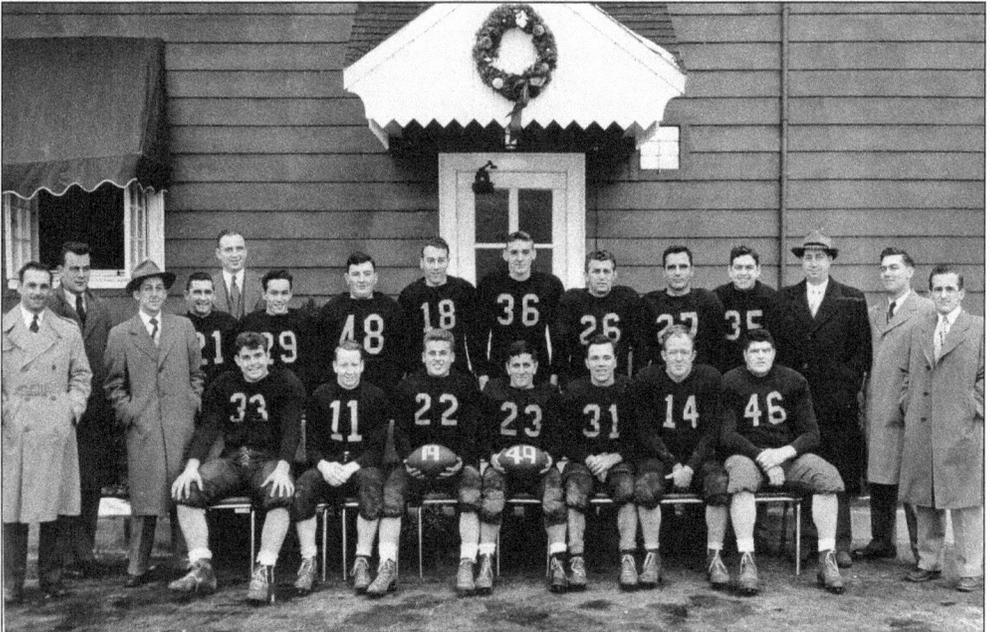

The 1949 Colonials were crowned Worcester County champions. From left to right are the following: (first row) Bob Caplette, Gary Fitzgibbons, Rudy Starzec, Tom Gorski, Ed Russell, Ken Wayma, and Paul Mrazik; (second row) Chris Pappas, John Bunnewith, Clarence Pelletier, Whigs Deary, Bill Starzec, Dick Grzyb, Paul Kelly, Ray Morgan, Ted Lorkiewicz, Connie Constantine, Joe Theodore, Amby Canty, Herb Semino, Fran Burke, and Torchy McGeary. (Contributed by Thomas Deary.)

70

Webster's Stasia Czernicki dominated the sport of women's candlepin bowling for years, capturing eight world titles. One could turn on the television at noontime on Saturdays and watch Czernicki mow down her opponents on *Candlepins for Cash*. In 1999, the *Boston Globe* included Czernicki on their list of New England's top 100 athletes of the century. Pictured here is Czernicki in great form in 1959. (Contributed by Anthony Czernicki.)

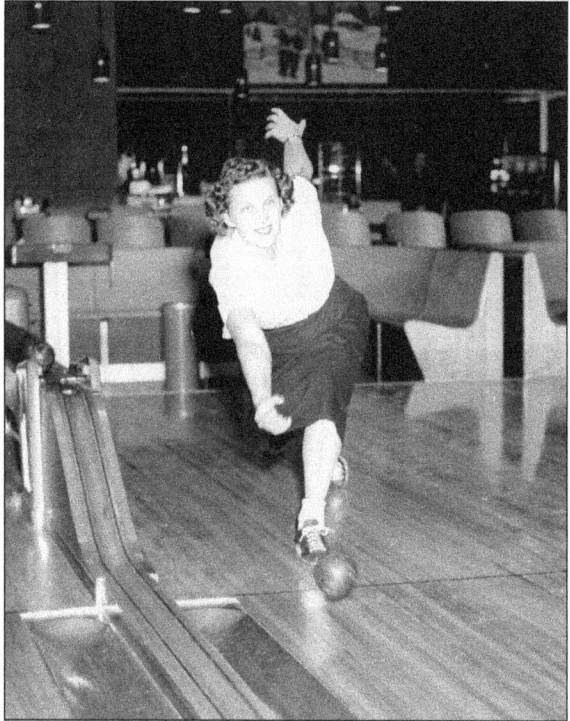

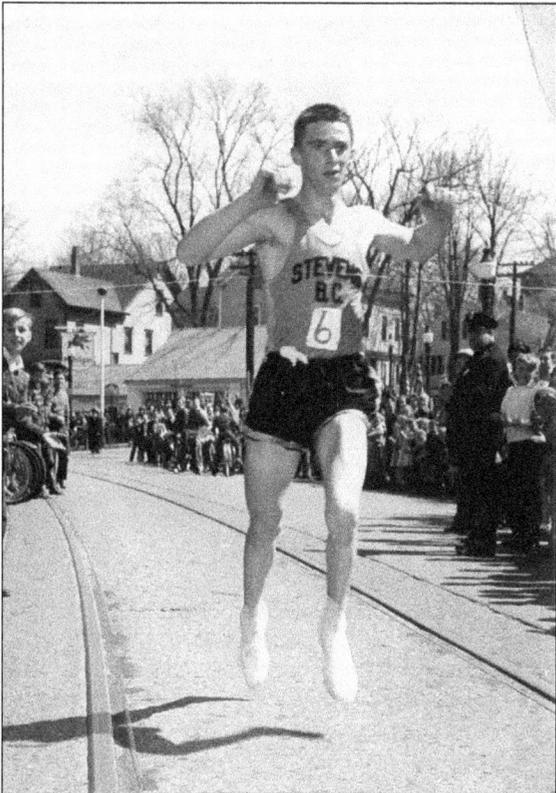

The *Webster Times* 5.4-mile race from Oxford Center to Main Street was held each year on Patriot's Day. Pictured here is the winner of the 1941 and 1942 races, Frank Wysocki, who could certainly be classified as a patriot. Wysocki was wounded in Italy serving with the army in World War II and later died of his wounds in Africa. The newspaper of the day described Wysocki: "He gave his best in these races; he gave his all in far-off North Africa." (Contributed by Webster-Dudley Historical Society.)

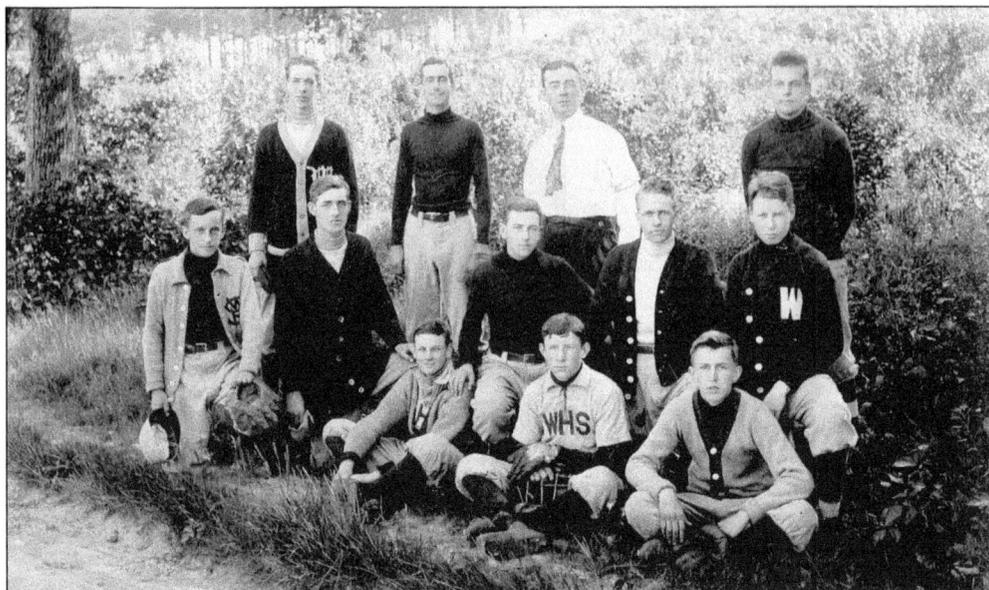

This outstanding photograph depicts the Webster High School baseball squad of 1910. Notice the W on the uniforms and sweaters, in comparison to the now traditional Bartlett B. During the 1913–14 school year, the school committee would vote to change the name of Webster High to Bartlett High. Two of the players pictured here are Edgar Asa Craver and Josiah Perry Parsons. (Contributed by Benjamin Craver.)

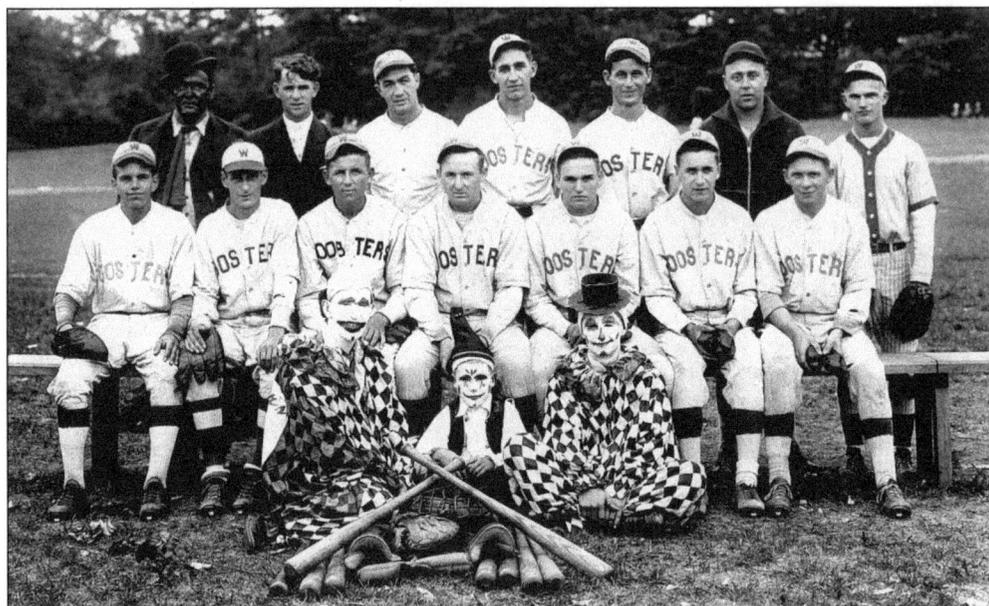

Each spring and summer, Webster, like many surrounding communities, would field baseball teams of all types. The teams represented mills, churches, bars, athletic clubs, and social clubs of all kinds. Webster teams played primarily at Marcustry Park, near today's little league complex, and at Greenfield's, near today's Leo's Construction. The teams traveled extensively throughout the area and were often accompanied by their team mascots. Pictured here is the 1934 Boosters baseball team. (Contributed by Stanley Kabala.)

Pitcher Mike "Kash" Kasierski dominated the local scene and would draw the interest of professional baseball, but Pearl Harbor waylaid any thoughts of playing in the majors. Kash played in the service and in Triple-A leagues, ending up at Class B in Waterbury, where he gained national attention for pitching and winning five doubleheaders on successive Sundays. (Contributed by Lillian Kasierski.)

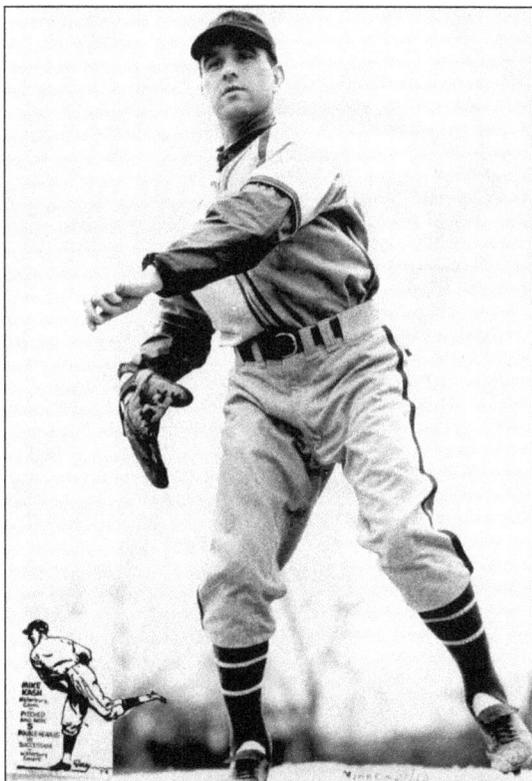

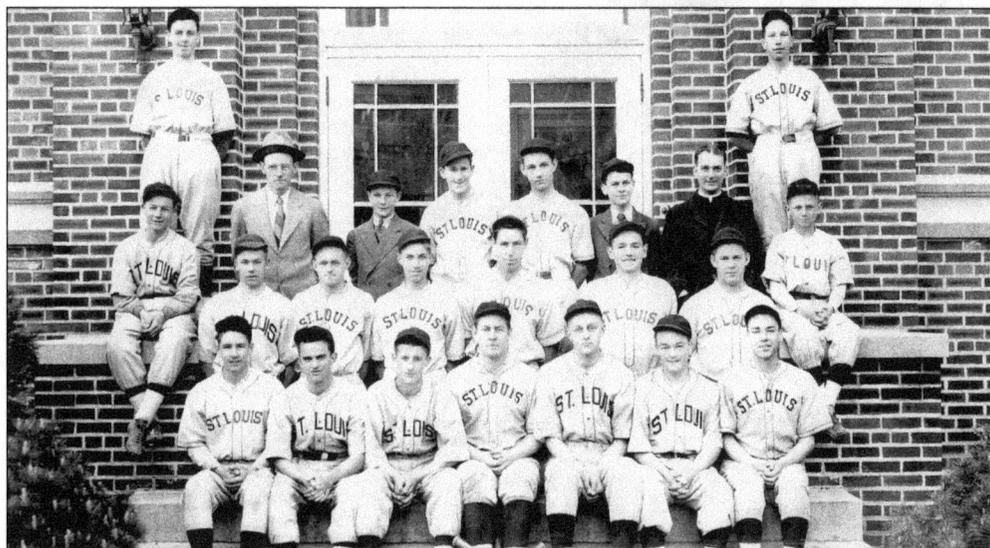

St. Louis High School closed in 1969, ending a proud tradition of athletics at this school on Negus Street. Pictured here is the St. Louis squad of 1937. From left to right are the following: (first row) Bill Collins, George Dellana, David Bernier, Francis Davern, Jim Groblewski, Chick Hart, and Earl Hart; (second row) Richard Bernier, Sonny Tourangeau, Bob Graham, Lester Magnant, Harold Sellig, Dick Gibney, Joe Davern, and Norman O'Connor; (third row) Edward Lewis, coach John McCormac, Don Branniff, Toppy Donovan, Edgar Martel, Charlie Dutram, Father Hilbert, and Ernie "Pro" Pizzetti. (From the James Groblewski collection.)

Sigmund "Ziggy" Strzelecki served the Webster school system as a teacher, administrator, and coach for 37 years. Ziggy's basketball exploits in Worcester and at Clark University were legendary. He coached the Indian baseball squads from 1952 to 1974, leading them to many successful seasons. Discipline and sportsmanship were always hallmarks of the Strzelecki squads. Many may also recall his trademark unlit cigar on the bench. (Contributed by Dorothy Strzelecki.)

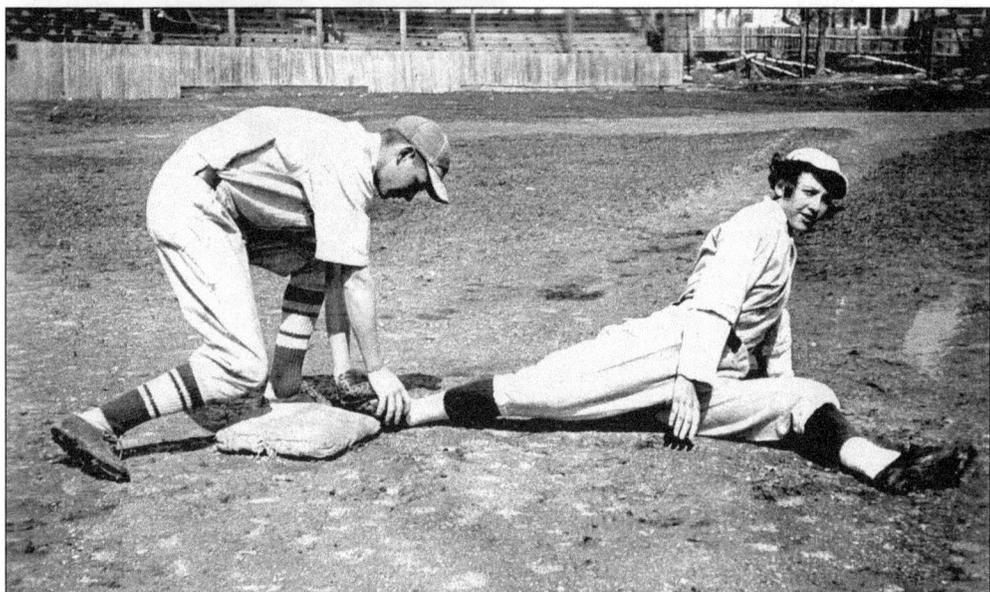

In this 1935 photograph, future police chief Anthony Szamocki places the tag on Nellie Twardzik as she slides back to base. Coach George Finnegan said, "She is the finest girl ball player that I ever did see," but the concept of a girl playing on the boys' team created controversy in mid-1930s. Twardzik is listed in the National Baseball Hall of Fame Library in Cooperstown, New York. (Contributed by Richard Girardin.)

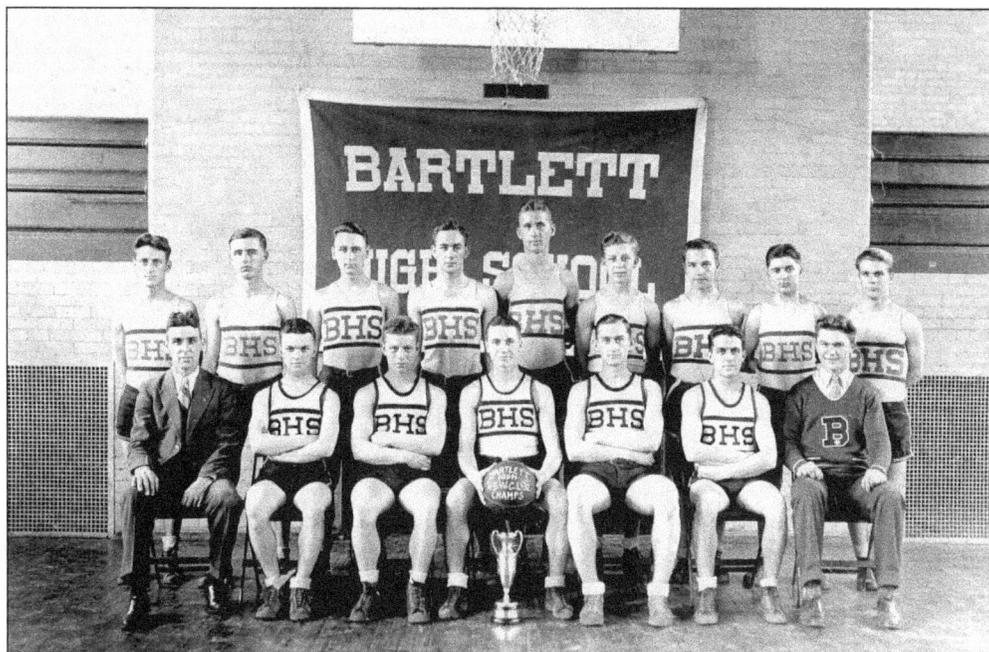

George Finnegan (seated left) coached football, basketball, and baseball at Bartlett from 1922 to 1945 and served as athletic director until 1963. Finnegan laid the foundation for one of the best high school athletic programs in the area. The 1932 Southern Worcester County Champions were lead by team captain Joe White (holding ball), who received plenty of assistance from future physician Anthony Wojciechowski (on White's immediate right) and Bartlett High hall of famer Nicholas Mikolajczak (standing in the center). (Contributed by Webster-Dudley Historical Society.)

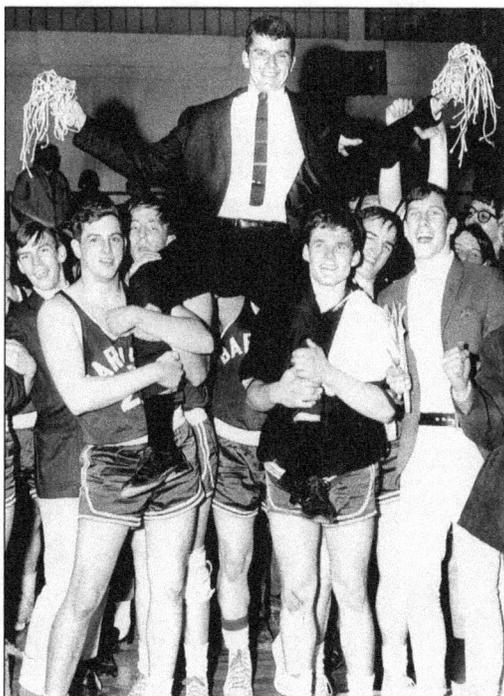

Bartlett High School's top coach in terms of victories in one sport is Don Cushing. Cushing recorded an amazing 405 victories in boys' varsity basketball over a split 27-year span. Cushing would go on to win many championships. In this 1967 scene, he is being hoisted in celebration of his first championship in the Holiday Tournament. Some of the recognizable players and fans are, from left to right: Mike Slota, Dick Chauvin, Randy Daggett, Bruce Chauvin, Bob Gould, and Pete Slota. (Contributed by Donald Cushing.)

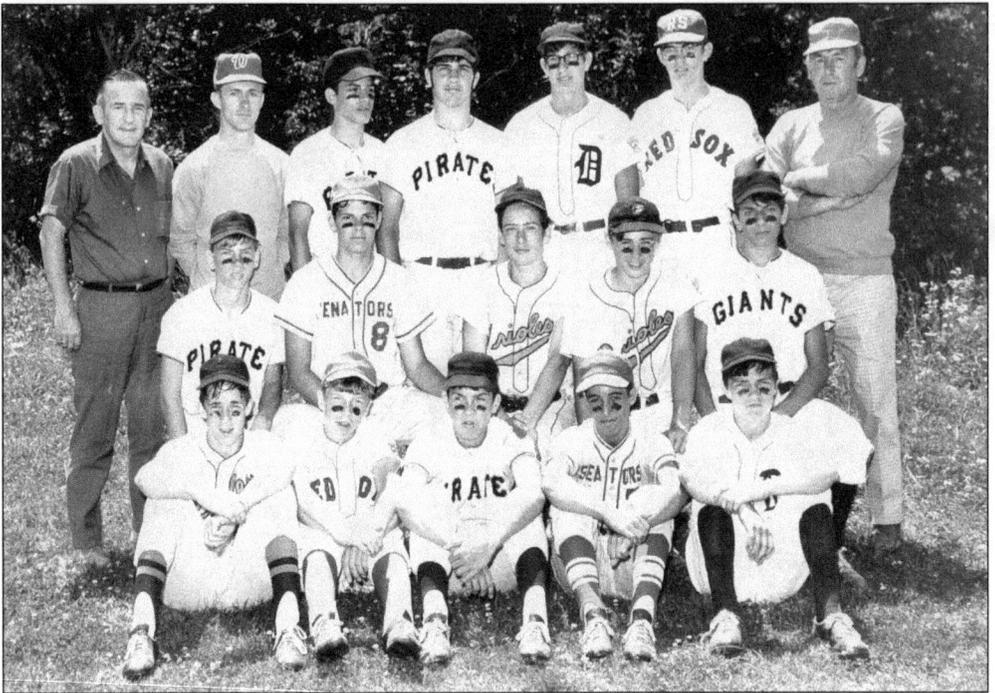

Webster Little League has been a part of growing up in this community for more than 50 years. The 1968 all-star team shown here are, from left to right: (first row) Scott Hurd, Mark Stefanik, Paul Bernier, Bob LaPlante, and Paul Lebeouf; (second row) Peter Russell, Bill Keefe, Stephen Iglowski, Richard Ziemba, and Harry Pappas; (third row) Ed "Torchy" McGeary, John Markiewicz, Gerry Nadeau, Mike Feig, John Vajcovec, Paul Grzyb, and Joe Russell. (Contributed by Louis Piasta.)

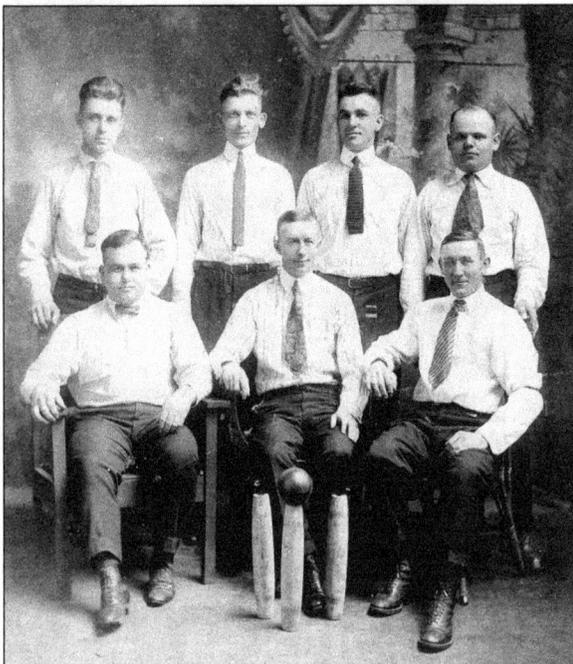

Bowling leagues were in full swing November through April. In 1937, more than 300 men and women participated in competitive bowling at Billings Alleys, Dwyers Alleys, Turn Hall Alleys, Marcustry Alleys, and St. Joseph's Alleys. Later the Holden, State, and Mohegan Alleys were popular. Alley proprietor Vic Billings is pictured here in the middle of the first row. (Contributed by Jim Manzi.)

Six

WORSHIP

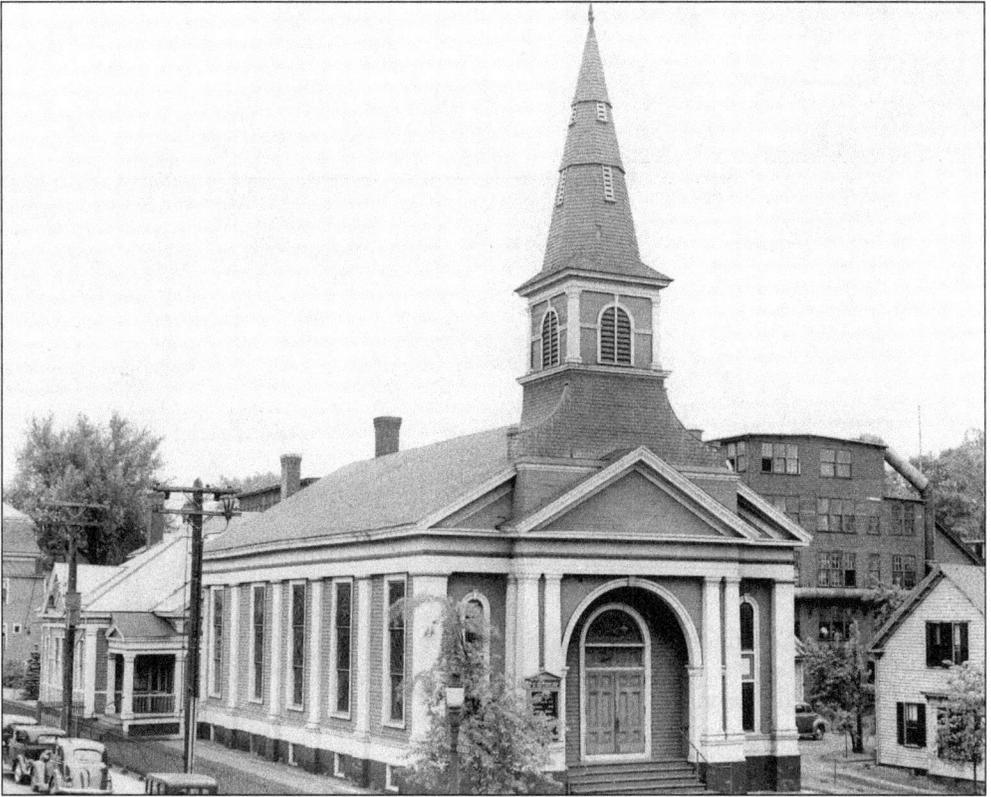

Organized in 1838, the Congregationalists worshipped at the old Methodist church on Main Street until 1842, when the church pictured here, at the corner of Church and Main Streets, was built on land donated by Dr. Charles Negus. In 1948 and 1949, Congregationalists and Methodists voted to join in a federated church, and on September 11, 1955, a new United Church of Christ was dedicated. The gracious brick structure, with its symmetrical spire, was built by Sumner F. Hall of Webster. (Reprinted with permission of the *Worcester Telegram and Gazette*.)

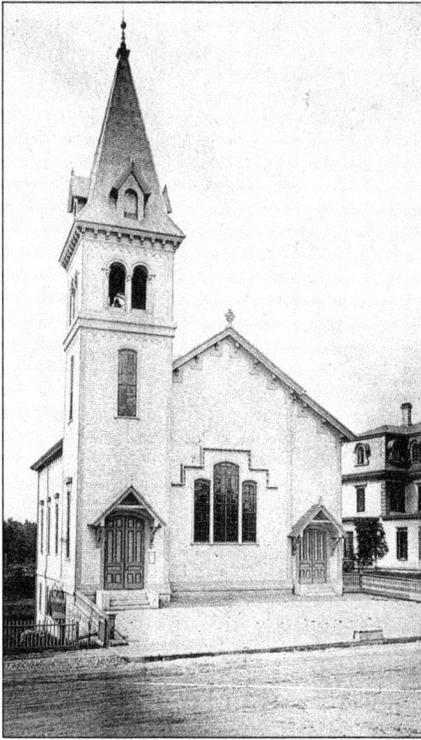

The original Methodist Episcopal Church was erected in 1828, on land where the Webster Shoe Company would be located. The early Methodists were influential in the growth and prosperity of the town. This edifice was built in Depot Village in 1867, across from the Congregational Church. It was demolished in the mid-1950s. (Contributed by Webster-Dudley Historical Society.)

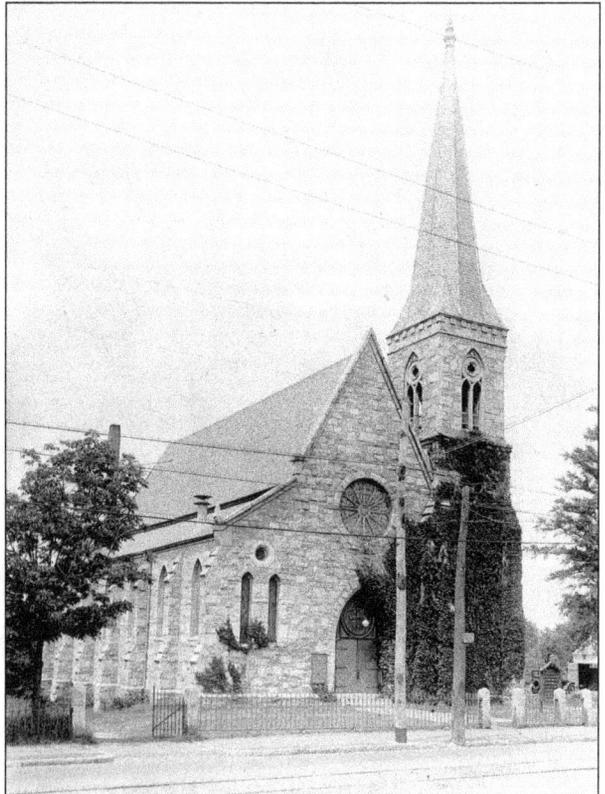

The First Baptist Church was organized in 1814. Built in 1826, a clapboard church on East Main Street was used until the erection of a Gothic stone structure in 1868. Stones from the neighboring Slater quarries were used in the construction. Webster's first town meeting was held in the original church on April 2, 1832. (Contributed by Webster-Dudley Historical Society.)

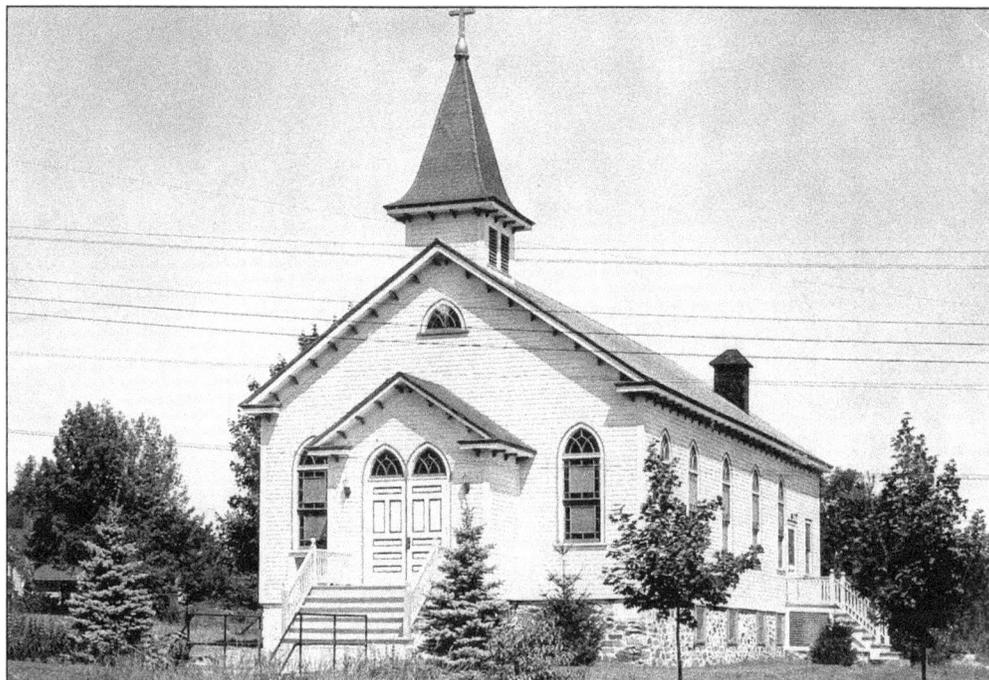

One of the youngest parishes in the community, the Emanuel Lutheran Church, on the corner of Mount Pleasant and First Streets, was established by German-speaking residents who had separated from the older Zion Lutheran church. The wooden church was dedicated on August 7, 1926. A parsonage on Mount Pleasant Street was dedicated on June 12, 1955. (Contributed by Webster-Dudley Historical Society.)

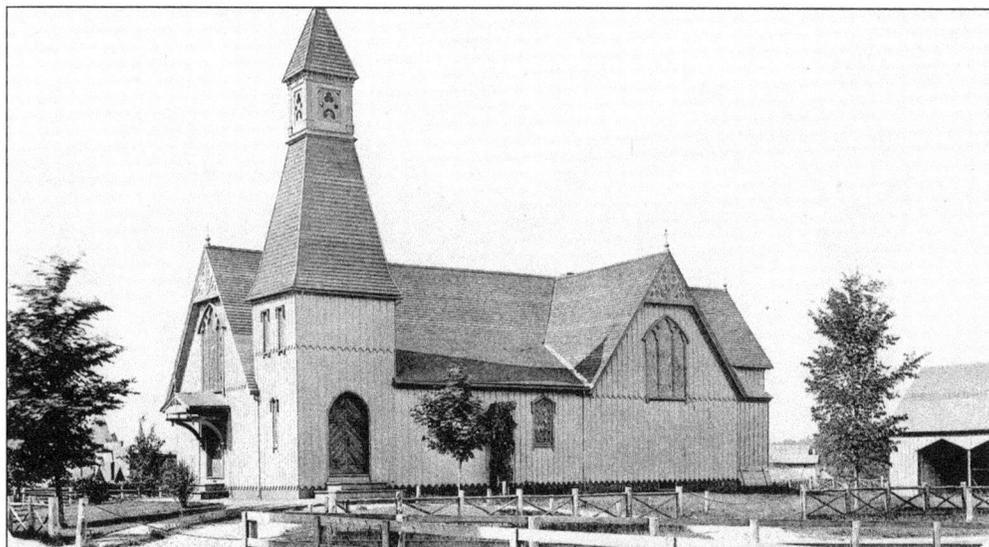

The Slater family was a great benefactor to the Church of the Reconciliation on North Main Street. William Slater, Samuel's grandson, donated the land in 1871. In 1884, the clock tower was given by Mrs. Horatio Nelson Slater, and in 1873, Lydia Slater donated a pipe organ. In 1898, the parish hall was given in memory of William S. Slater by his five sisters. (Contributed by Webster-Dudley Historical Society.)

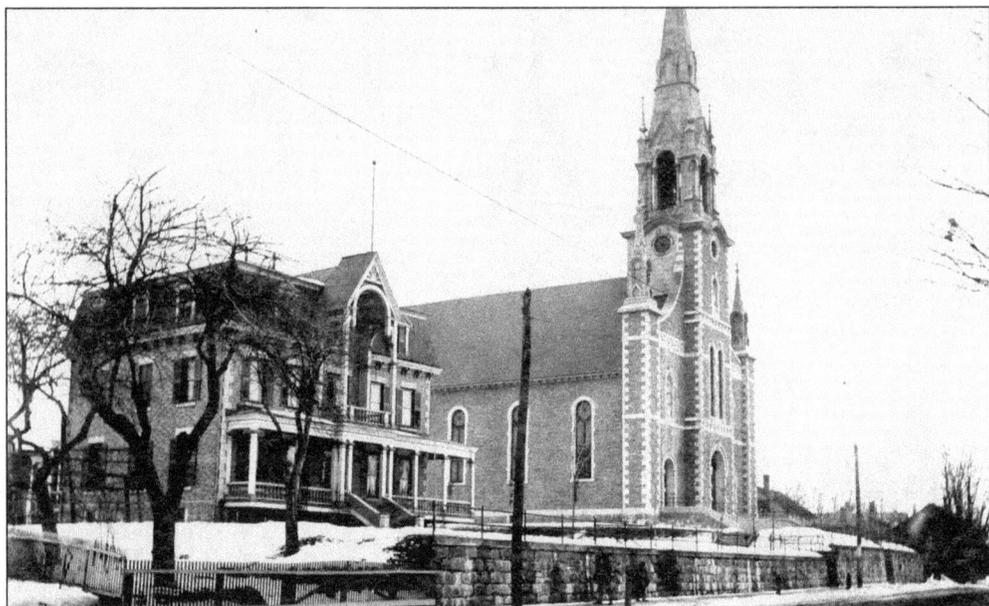

Built in 1895 of Canadian granite, Sacred Heart Church was a result of the burgeoning French Canadian population that had come to Webster to work in the mills. Fr. Agapit Legris was the first pastor in the new church. Construction difficulties resulted in the death of one worker when walls collapsed, but work continued, and the beautiful church and rectory on East Main Street were completed and remain impressive structures in the 21st century. (Contributed by Webster-Dudley Historical Society.)

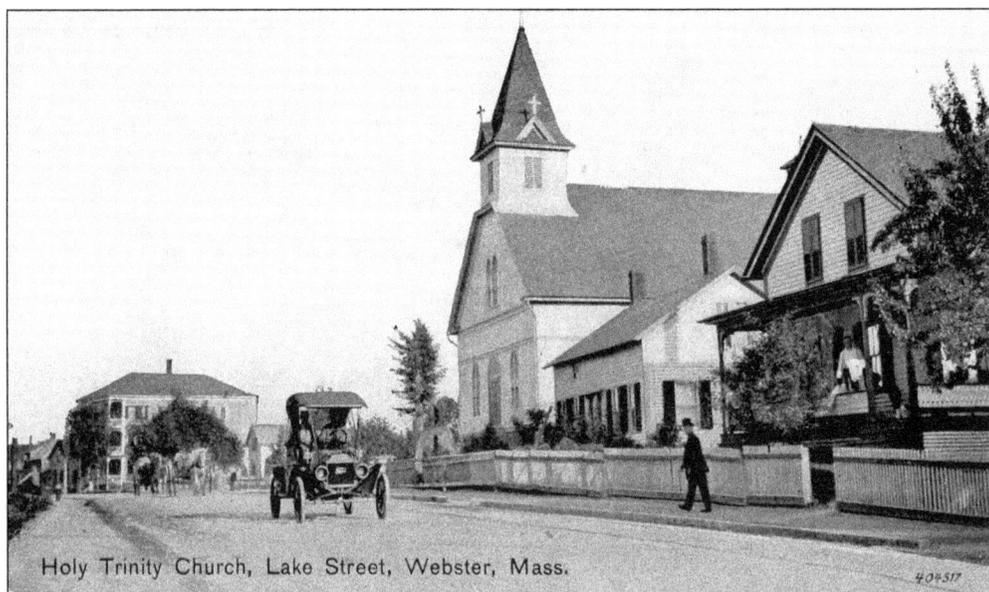

Holy Trinity Church, Lake Street, Webster, Mass.

Lore has it that this church on the corner of Lake and New Streets was built on the same location where the Nipmuc Indians moved after the last of their reservation was sold off in 1887. Affiliated with the Polish National Catholic Church, Webster's parish developed in 1903 after a rift with St. Joseph's Roman Catholic Church. (Contributed by Webster-Dudley Historical Society.)

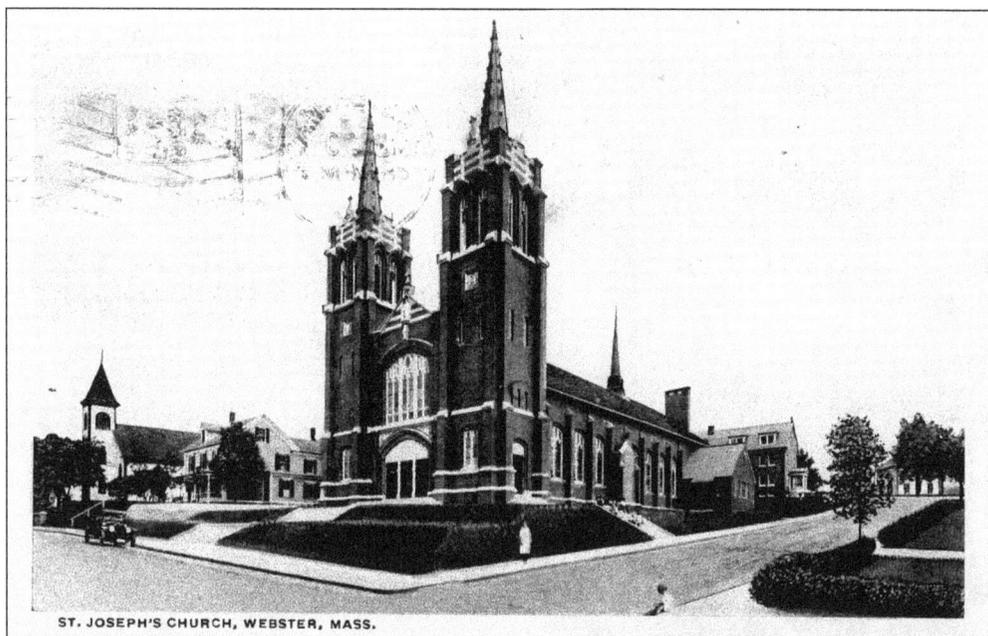

ST. JOSEPH'S CHURCH, WEBSTER, MASS.

In the late 1870s, Webster's Polish families formed their own parish. By 1888, St. Joseph's Church on Whitcomb Street was built, becoming the first Polish Catholic church in New England. In 1914, the imposing brick structure with twin spires replaced the old church, which served as a school until it was destroyed by fire in 1924. St. Joseph's was named a basilica by Pope John Paul II in 1998. (Contributed by Robert J. Miller.)

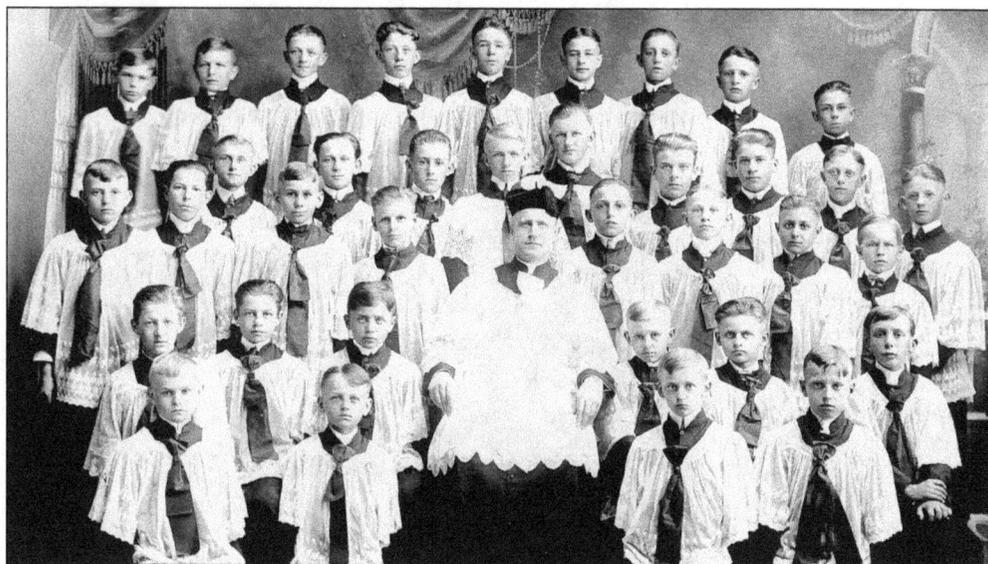

The driving force behind the formation of Webster's Catholic churches was the ethnic affiliations of the congregations. St. Louis Church was formed by the Irish, Sacred Heart Church by the French, St. Anthony's Church by the Slovaks, and St. Joseph's Church by the Polish. In each of these churches, it was an honor and privilege to be an altar server, and some parishioners hoped that some of the young men would consider the priesthood. Pictured here, Monsignor Anthony S. Cyran, the Polish pastor, and his servers strike stoic poses. (Contributed by Alfred Nowicki.)

Ireland's potato famine, the completion of Webster's railroad, and the booming textile industry all attracted the Irish to Webster. St. Louis Church, organized in 1851, is the town's oldest Catholic parish. The Lake Street church was built in 1853. Fr. James Quan bought Calvary Cemetery in 1864, built a rectory in 1866, and started a parochial school in 1882. The old church was demolished in 1970, and a new church was built in 1971. (Contributed by Webster-Dudley Historical Society.)

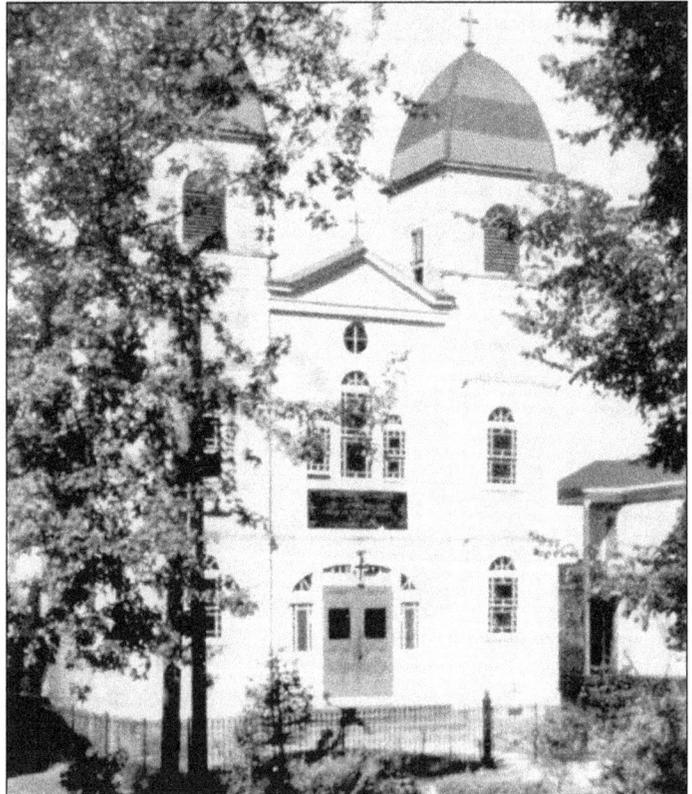

Twenty-six members of the Greek community in Webster purchased land to build their own church on High Street in the early 1920s. Prince Paul of Greece (later King Paul of Greece) attended the consecration services of the SS. Constantine and Helen Greek Orthodox Church in 1924. The church burned on February 28, 1966, and a new church was built on Lake Parkway in 1968. (Contributed by the SS. Constantine and Helen Greek Orthodox Church.)

Built in 1867, St. Anthony's, originally a Universalist church called the Church of the Redeemer, became the spiritual home for the Slovakian families of Webster in 1912. In 1935, Fr. Joseph Ferenz began a legendary term as pastor, renovating the School Street edifice, establishing a cemetery, building an elementary school, and growing a financially and spiritually strong Slovak parish. The 120-foot spire on the church was severely damaged in the 1954 hurricane and replaced with a much lower copper steeple. (Contributed by Webster- Dudley Historical Society.)

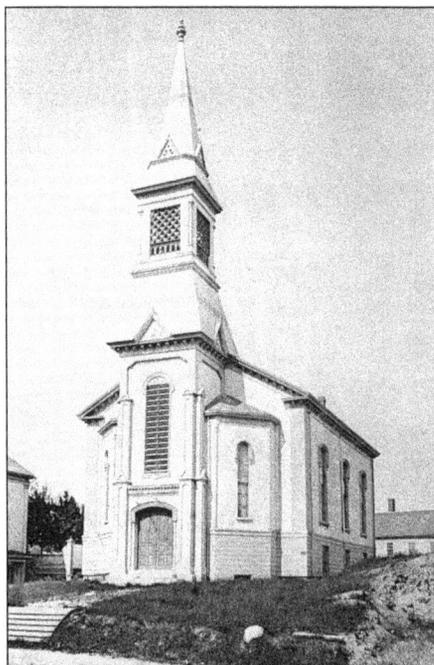

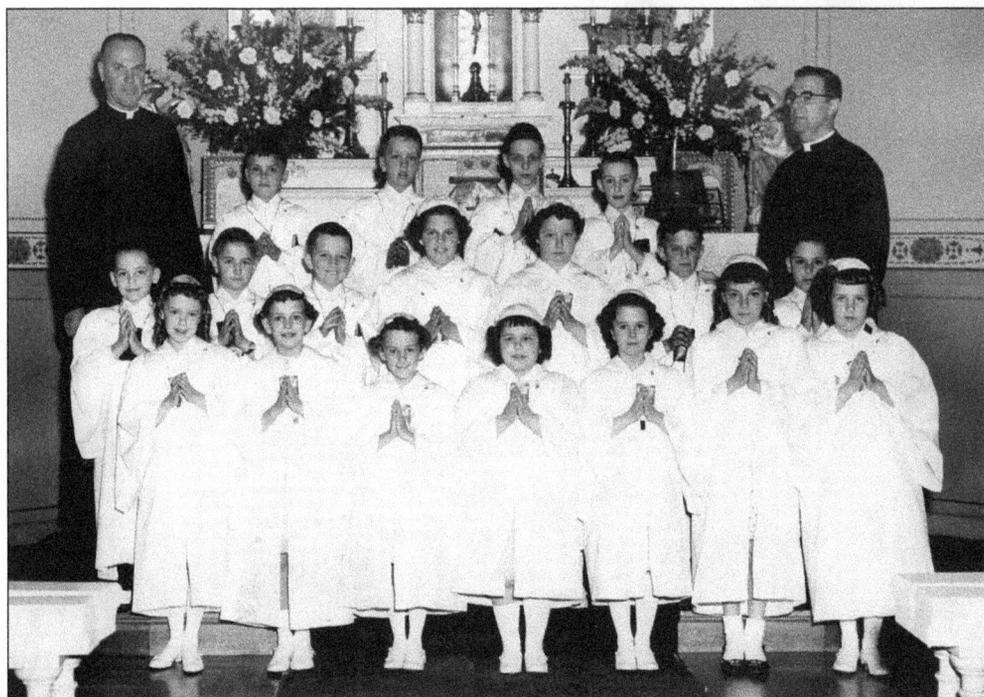

The 1959 St. Anthony's Church communion class pictured here are, from left to right: (first row) Lee Ann Majercik, Joan Susienka, Judy Beresik, Madeline Koziak, Maria Polletta, Barbara Stasko, and Kathy Bond; (second row) Paul Ondrasek, Bob Minarik, unidentified, Susan Vajcovec, Edith McCausland, Mark Adamec, and Steve Duquette; (third row) Fr. Peter Barauskas, George Plasse, Gary Chosta, Kevin Mrazik, Christopher Kralik, and Fr. Joseph Ferenz. (Contributed by Lee Ann Majercik.)

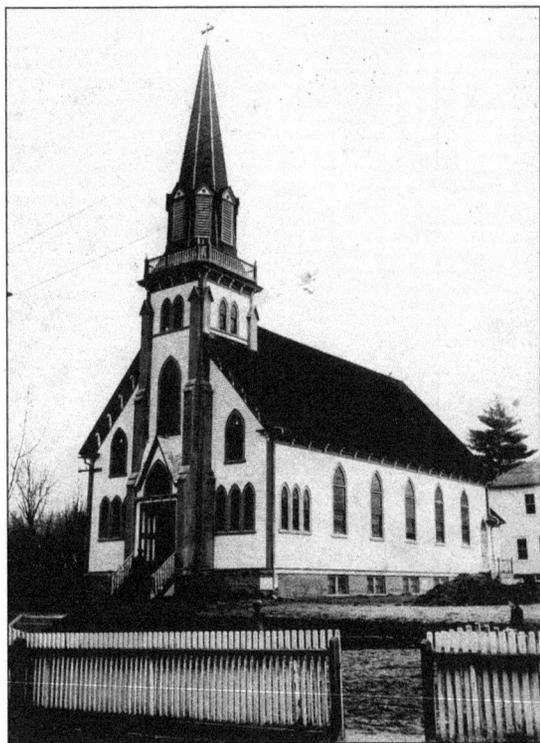

The vital German Lutheran community first held services around 1890 in Eagles Hall on Main Street. They later held services in the old Advent church on Myrtle Avenue at the corner of Park Street. Their first pastor, Rev. F. C. G. Schumm, was instrumental in establishing the parish and building this 350-seat church, which was erected in 1895 in the "German Woods" on the corner of Lincoln and Nelson Streets. Presently the First Assembly of God worships here. (Contributed by the Zion Lutheran Church.)

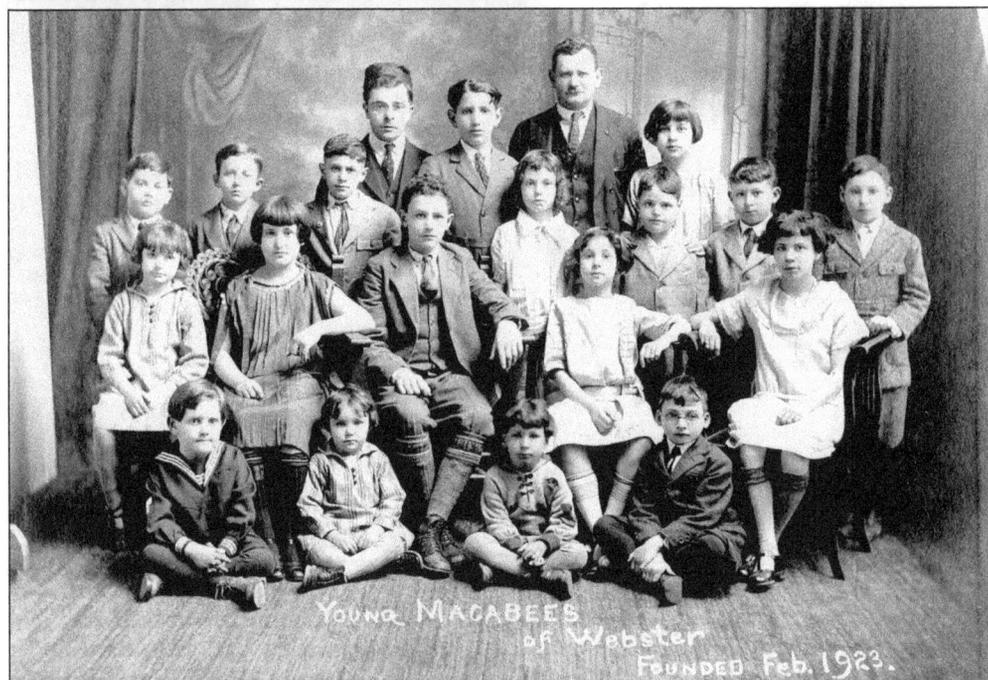

The synagogue on High Street was originally owned by the Siegal Lodge D.O.H., a benevolent order of German citizens. By 1919, the organization dissolved and the property was sold to the Congregation Sons of Israel. In 1958, a large addition was constructed at the rear of the building. Pictured here in 1923 is the Jewish youth group the Macabees. (Contributed by Mark Erlich.)

Seven

MUNICIPAL

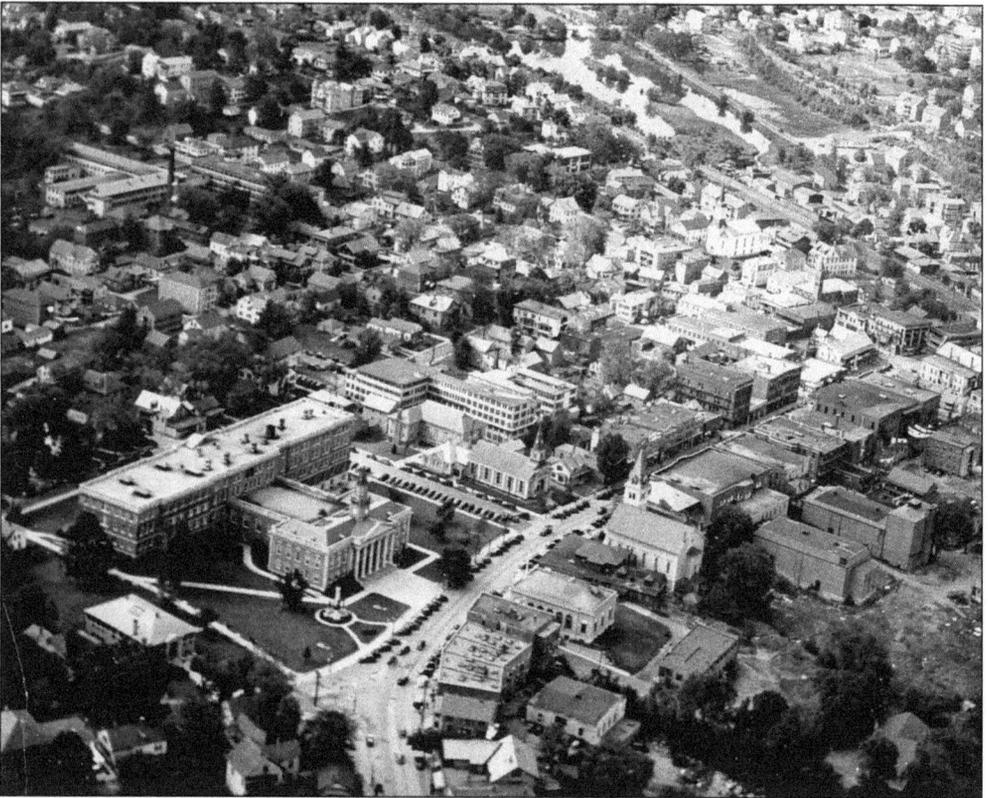

This 1940s aerial photograph gives an opportunity to observe changes to the downtown area. Visible are the former Corbin and Webster Shoe Corporations and the Congregational Church on Main Street, located near the center of the picture. Also visible are the French River, St. Anthony's Church, the fire station, the Maanexit and Main Streets commercial district, the Methodist church, the post office, Chester C. Corbin Public Library, Bartlett High School and town hall complex, and the Bates Shoe Company and Jeffco Fibers, Inc. (Contributed by Mrs. Francis Groblewski.)

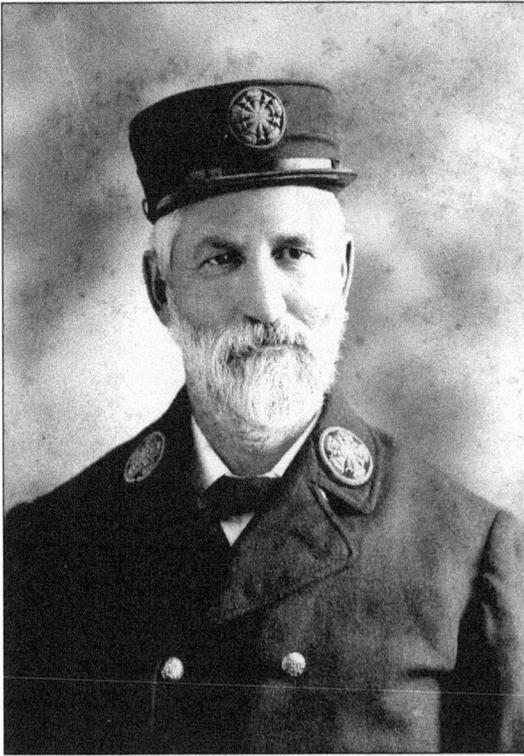

L. E. Pattison, a distinguished soldier in the Civil War and prosperous lumber and coal dealer, contributed to the success of the town. Besides being appointed fire chief in 1888, his activities included serving on the library and school building committees, the board of assessors, as bank president, and as a key member of the local Grand Army of the Republic post. (Contributed by Chester C. Corbin Public Library.)

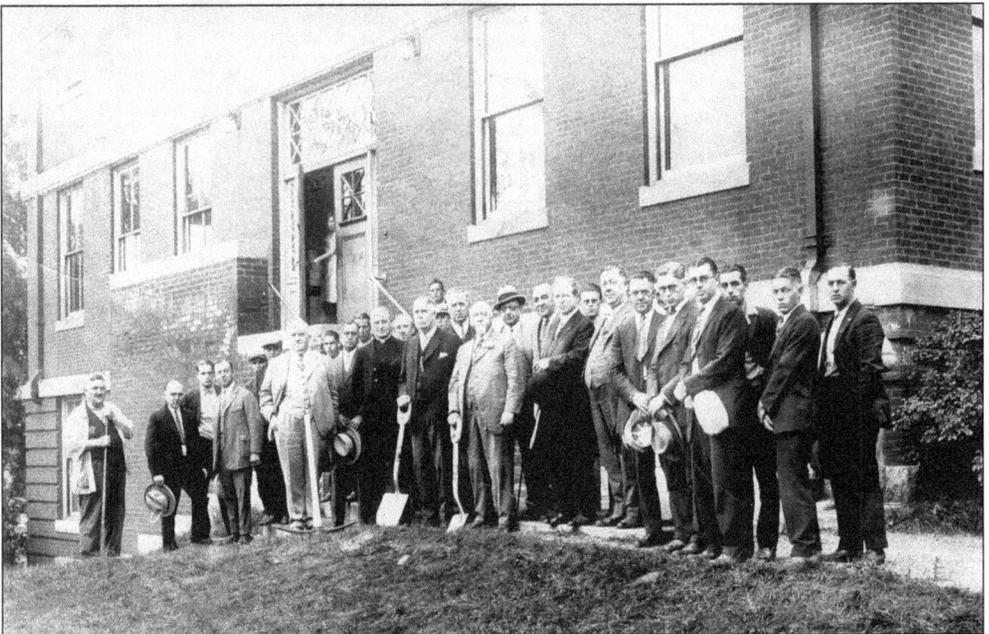

An educated guess on the identity of this photograph would be that it shows town dignitaries standing along Bartlett High School with picks and shovels in hand, ready to break ground on a town project. It is reasonable to assume that this photograph shows the initial phase of the town's largest building project, the expansion of Bartlett High School and the construction of the new town hall complex in 1927. (Contributed by Bruce White.)

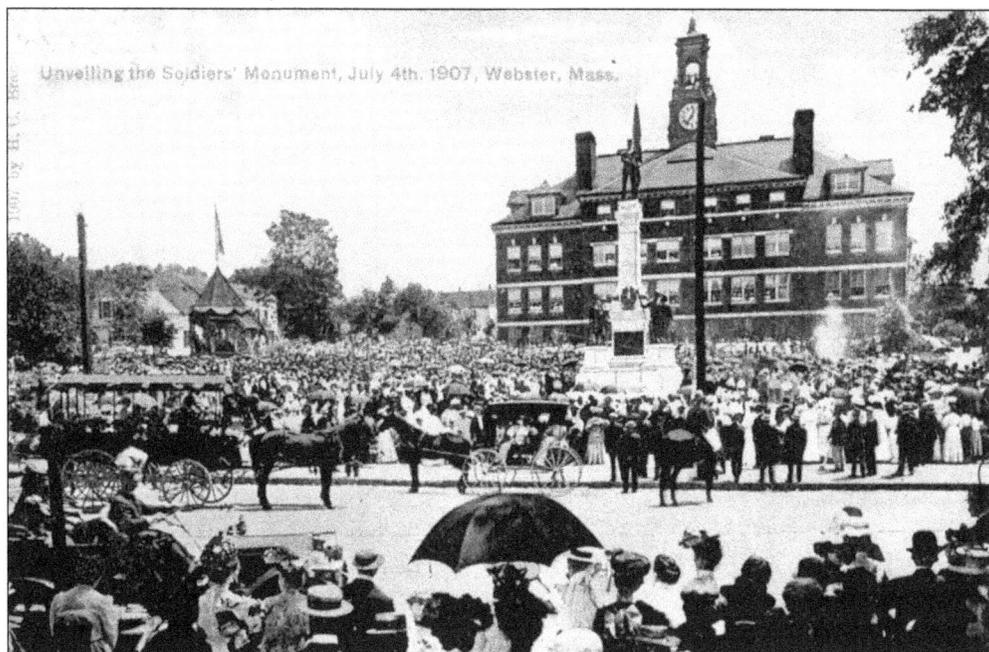

The 40-foot-high Soldiers' Monument on Main Street was dedicated on July 4, 1907. A large parade preceded the formal unveiling by George Hodges Bartlett. Many dignitaries were in attendance, including Clara Barton, the "Angel of the Battlefield" and founder of the American Red Cross. The local Grand Army of the Republic had pushed the town long and hard to see this project come to fruition. (Contributed by Jeffrey Stefanik.)

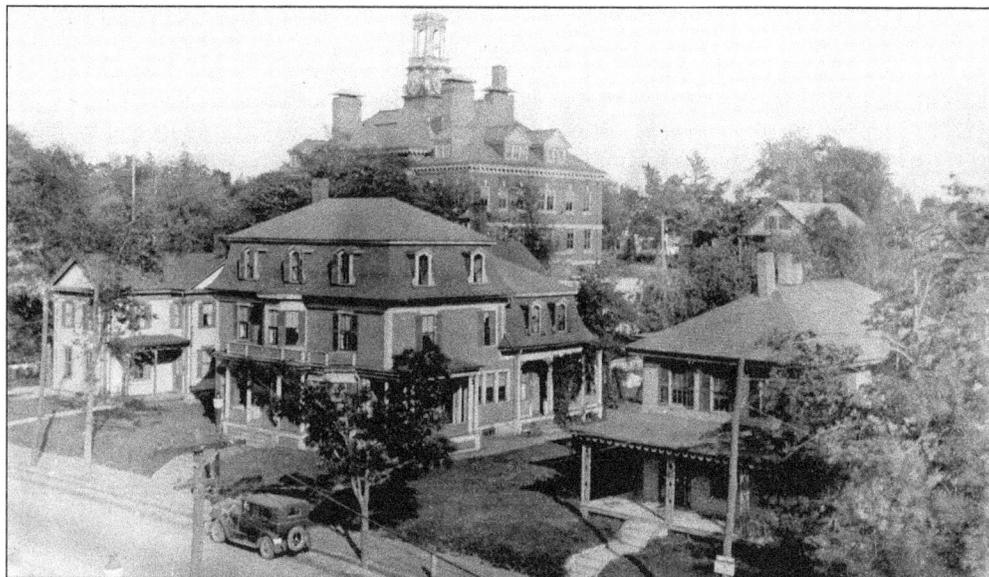

The original idea for a town hall and school expansion project was suggested in 1922 but was not acted upon until a town meeting in 1926. To complete the project, stately homes on Main, Church, and Negus Streets (which appear in this photograph) needed to be removed. One of the houses was the Marble House (center), which was moved to Church Lane where it still stands as the Veterans' Service Department. (Contributed by Webster-Dudley Historical Society.)

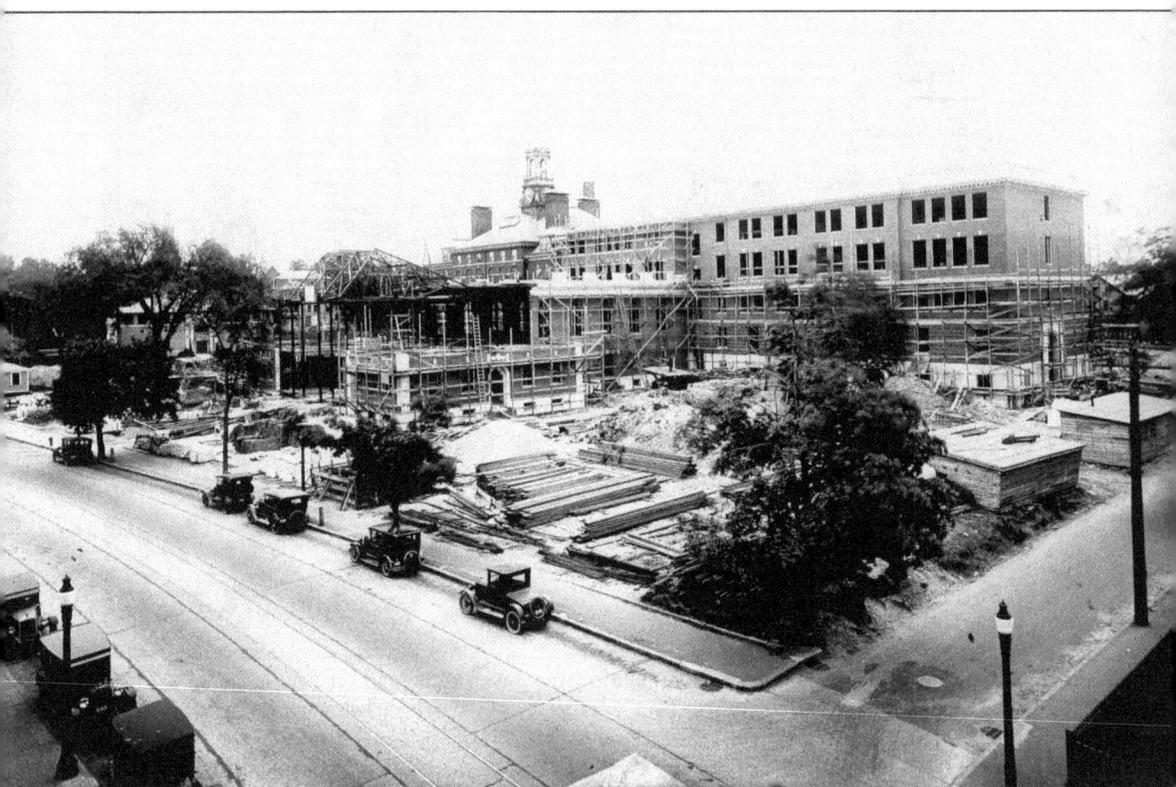

Built in 1928 and situated in the center of town on what was the site of the Stockwell Block (moved in 1842 to the corner of School and Main Streets), the municipal building construction project was immense for its time. According to the architect, it was built with enough bricks "to erect a sidewalk from here to Worcester." To make the existing Bartlett High School compatible with the new building, a wing was added that connected the school to the auditorium. Also, the school's roof was raised, and the clock and tower moved to the roof of the municipal building, where it stands today. Attorney Joseph A. Love was chairman of the school building committee, and townspeople called the building "Love's folly," for its nearly $1 million cost. Love passed away in 1927, less than a year before the building was dedicated in May 1928. (Contributed by Chester C. Corbin Public Library.)

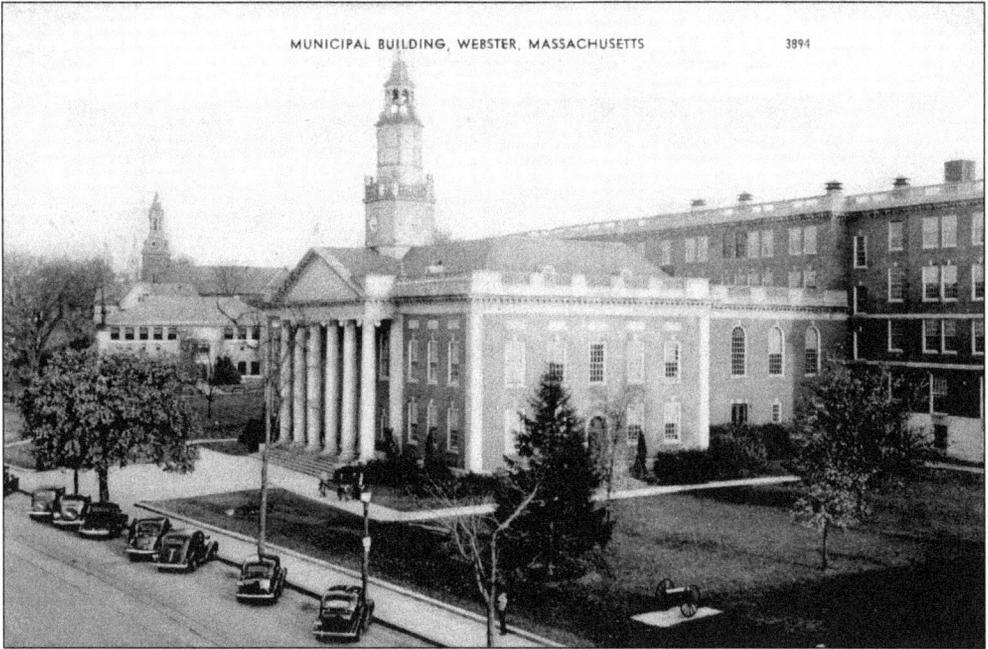

In 1928, the town of Webster completed a magnificent and functional structure, which still serves the town in the 21st century. An interesting note on the structure is the various uses of the basement over the years, which included the following: a kitchen, dining facility, veterans' room, Works Progress Administration (WPA) youth center, headquarters for the National Guard and Air Force Reserve, and Sector 3C Civil Defense Office. (Contributed by Richard Cazeault.)

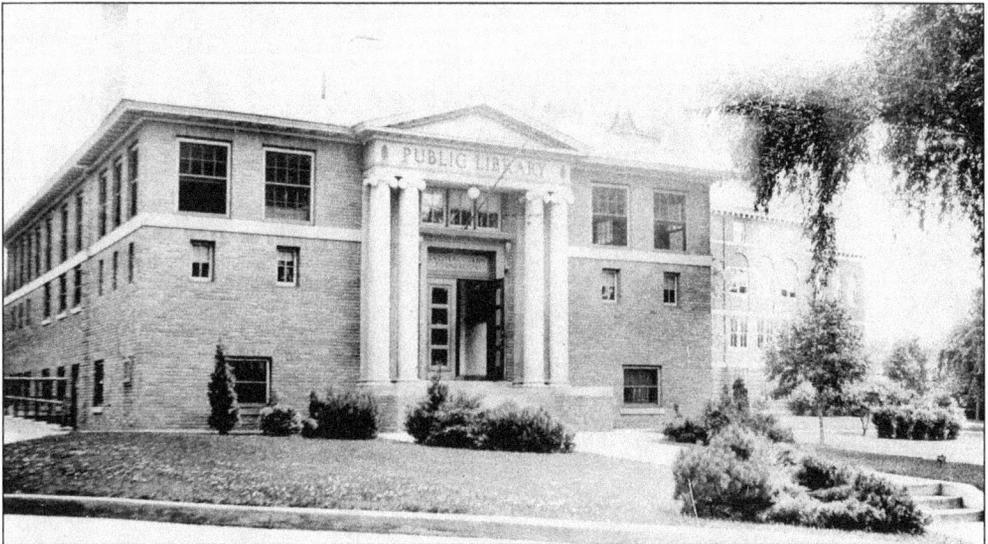

The earliest library records in Webster date back to 1867, and the first free public library opened in 1889. The construction of a new library in 1921 was made possible through a bequest from Augusta E. Corbin, in memory of her deceased husband, Chester C. Corbin. Edward Tilton, one of the finest library designers in the country, served as architect during the project. (Contributed by Chester C. Corbin Public Library.)

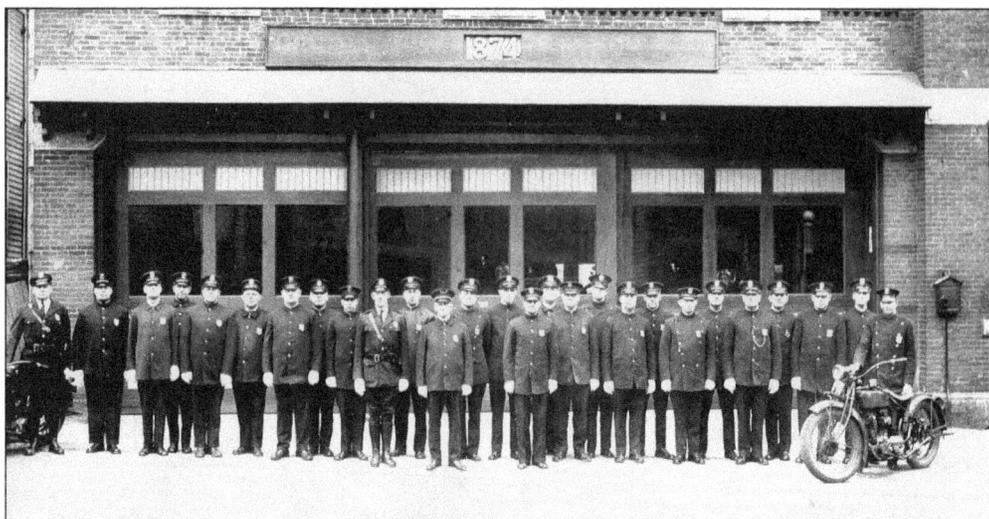

In this 1930s scene, the entire Webster police force line up for a formal portrait in front of the fire station on School Street. It is interesting to note that the 1874 stone marker on the central fire station was moved up the street to the new fire department substation. Webster established watch districts in 1865, and a formal police department was organized in 1899. (Contributed by Russell Nadeau.)

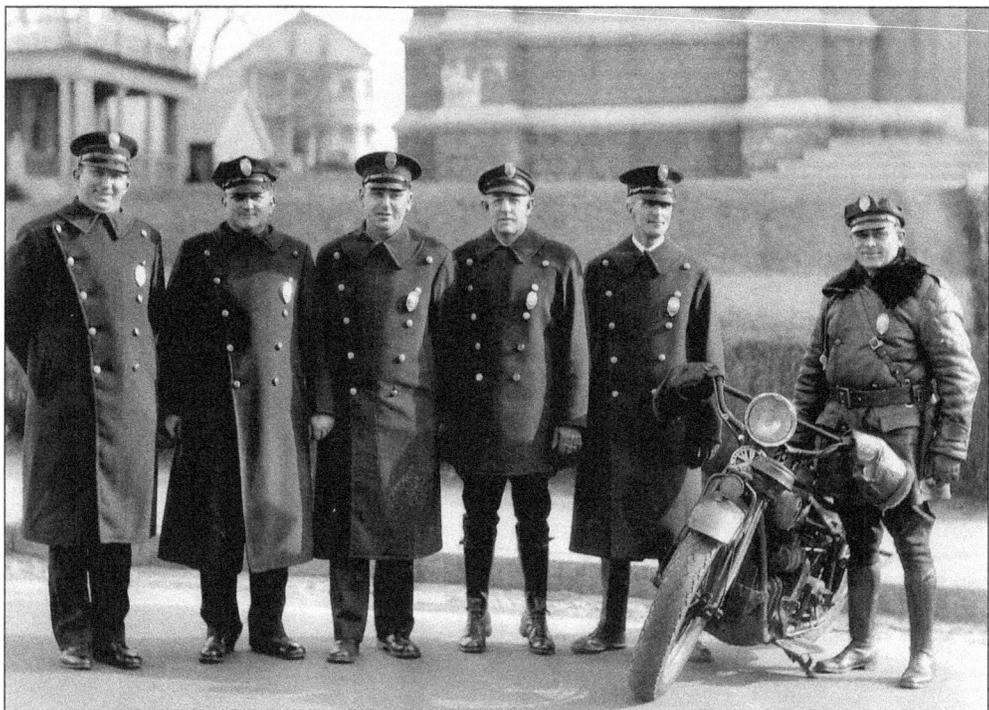

This photograph, taken in front of St. Joseph's Church, shows officer Del Nadeau manning a handsome motorcycle and Chief John Templeman, who, evident by his toe-raising pose, wishes he were taller. In the past, Webster police chiefs had long tenures, which included the following: James Hetherman (1916–1934), John Templeman (1934–1947), Delphis Nadeau (1947–1957), and Anthony Szamocki (1958–1984). (Contributed by Russell Nadeau.)

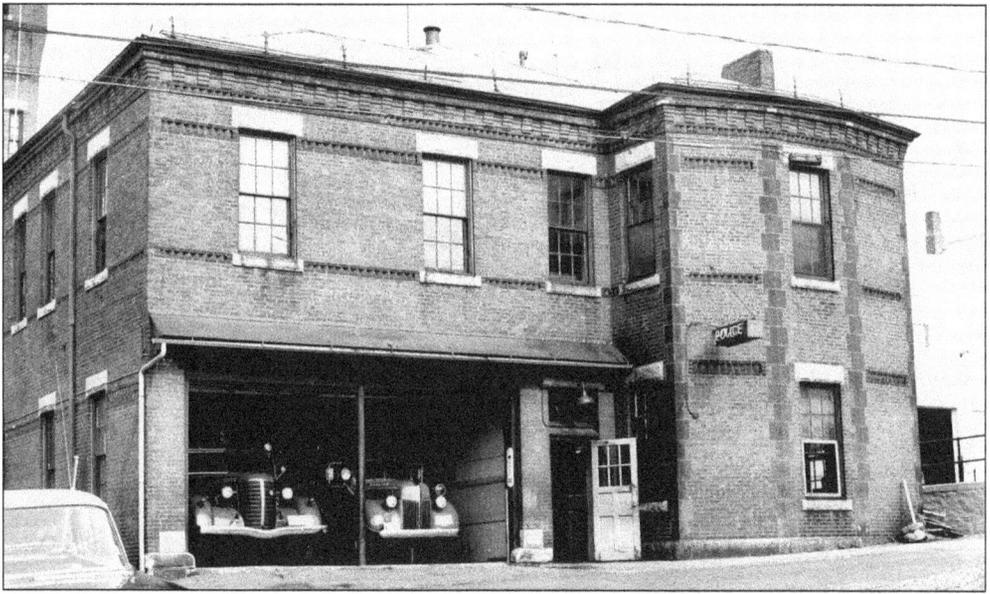

The fire and police station building was located on School and High Streets. The police portion, on the High Street side, had two bay doors for fire apparatus. The right portion of the building housed police headquarters and a cell block, which was inadequate for the town's size and activity. (Reprinted with permission of the *Worcester Telegram and Gazette*.)

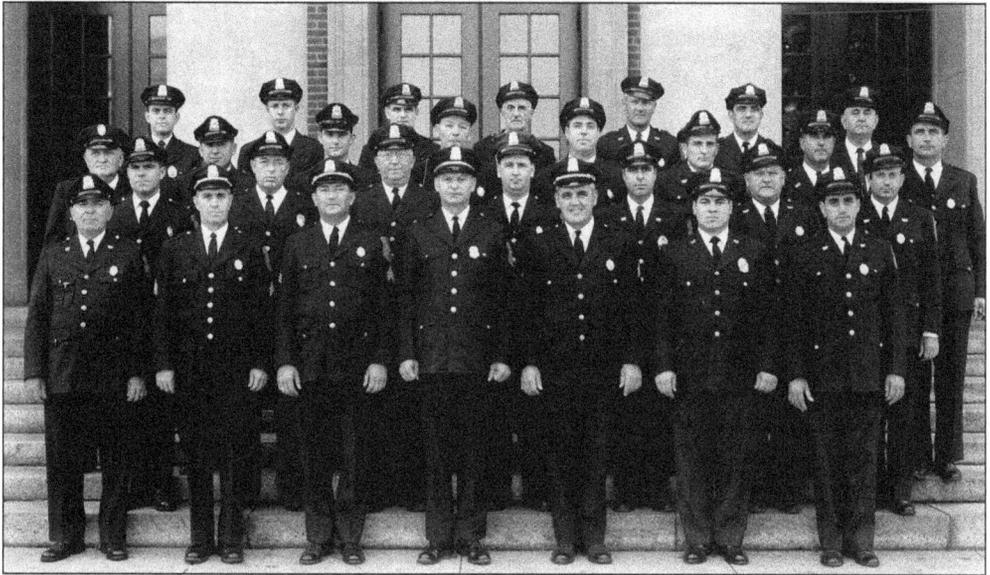

Thirty officers made up the Webster Police Department in May 1959. Pictured are, from left to right, the following: (first row) Ernest St. Germain, Arthur Parent, Anthony Strzelewicz, Chief Anthony Szamocki, Stanley Tanca, Hector Champagne, and Anthony Polletta; (second row) Richard Guerin, John McCausland, Stanley Biadasz, Lawrence Gevry, Joseph Boutillette, Joseph Kullas, and Stanley Lipski; (third row) Joseph Czechowski, Stanley Jarzabski, John Dansereau, Thomas Dwyer, Harold Sellig, Richard Mason, John Zmetra, and Stanley Kwasniewski; (fourth row) Ronald Morrill, Mike Mahan, Raymond Noga, Thomas Martin, Edward Grochowski, Bernard Conti, and Justin Herideen. Absent was Francis Haggerty. (Contributed by Anthony Polletta.)

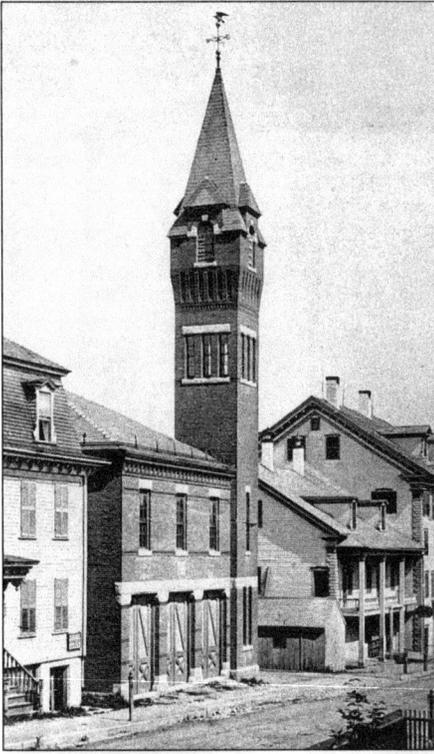

The fire station on School Street was built in 1874. Over the years, the structure was utilized as the town hall and fire station. The Firemen's Hall, which was located on the second floor, was used as a function room for lectures, concerts, and church meetings. The tower was used for drying hoses and plane spotting during World War II. Despite efforts by the Webster-Dudley Historical Society to save the fire station from demolition, the building was torn down in 1979. (Contributed by Webster-Dudley Historical Society.)

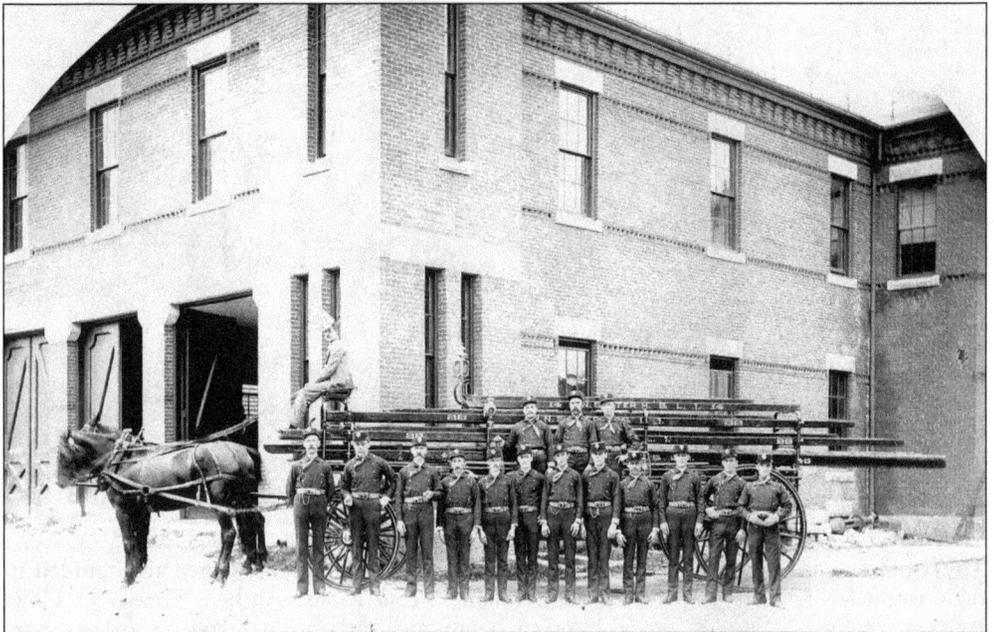

Like other communities, Webster's early firefighting efforts depended on hand-to-hand bucket brigades, which was not a very effective method of handling major fires. The Slater Company, the town's largest property holder, was actively involved in the town's firefighting efforts, which included purchasing firefighting equipment and helping establish a water system in 1868. (Contributed by Webster-Dudley Historical Society.)

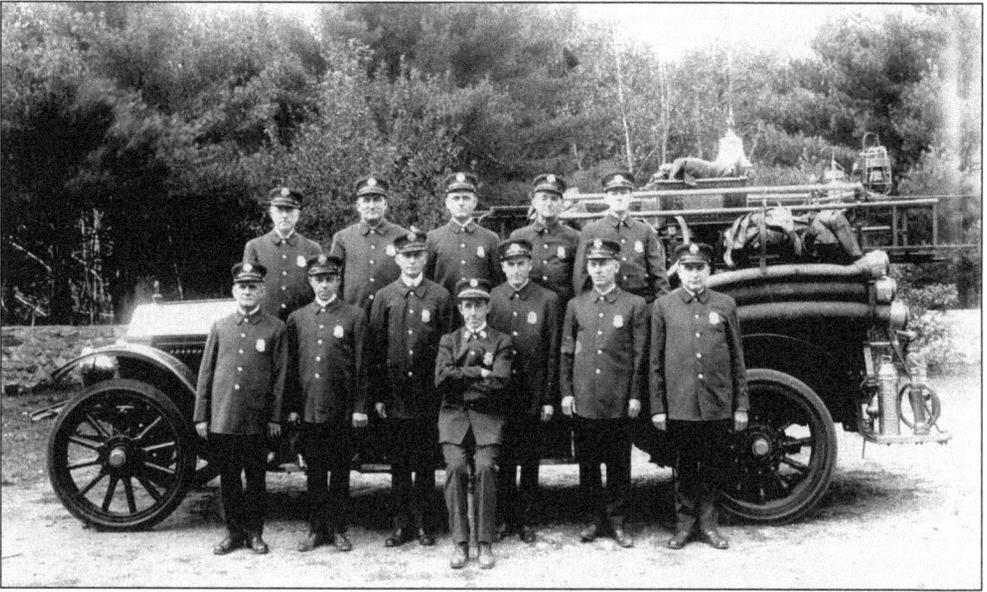

The modernization of the Webster Fire Department included the installation of an electric box alarm system in 1893 and the purchase of a combustion engine Pope-Hartford fire truck in April 1910. Webster was one of the first communities in the area to purchase such a truck, and it was not long afterward that all of Webster's horse-drawn fire apparatuses were retired. (Contributed by Webster-Dudley Historical Society.)

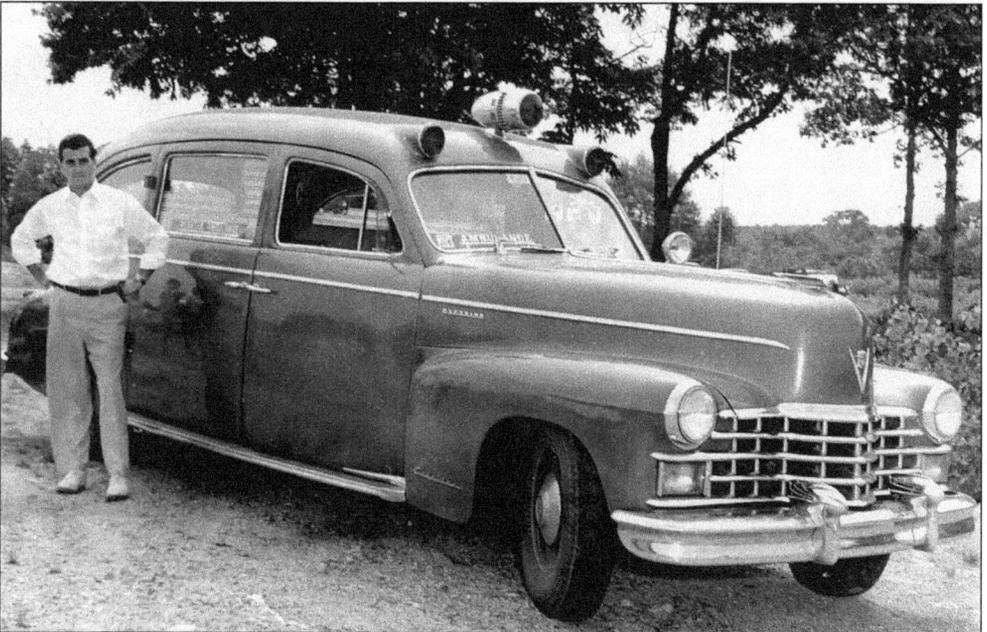

Anthony Polletta is pictured with the town's ambulance, a 1952 Cadillac. Poblocki's Webster garage on Lake Street had the contract to provide ambulance service to the town. Prior to that, Simcusky's Webster Buick would pull their mechanic from the job to transport a sick or injured passenger to the hospital. This ambulance assisted the city of Worcester in transporting those injured during the tornado of 1953. (Contributed by Anthony Polletta.)

Dr. Joseph Olivier Genereux was once called the "Dean of the fraternity of Webster's physicians," earning that title after 65 years of practicing medicine in the town. On March 11, 1943, the *Webster Times* commented, "Starting with a horse for transportation fifty-six years ago, Dr. Genereux has 'used up' five horses, a bicycle, a motorcycle and 10 automobiles in making calls during the 56 years he has spent administering to the ill in the community." (Contributed by Bruce White.)

Marion B. Kleczka retired in 1975 after 41 years of service to the town as the board of health nurse. Polio, measles, and pox vaccines were administered to the school children at clinics under the direction of Kleczka. (Contributed by Bruce White.)

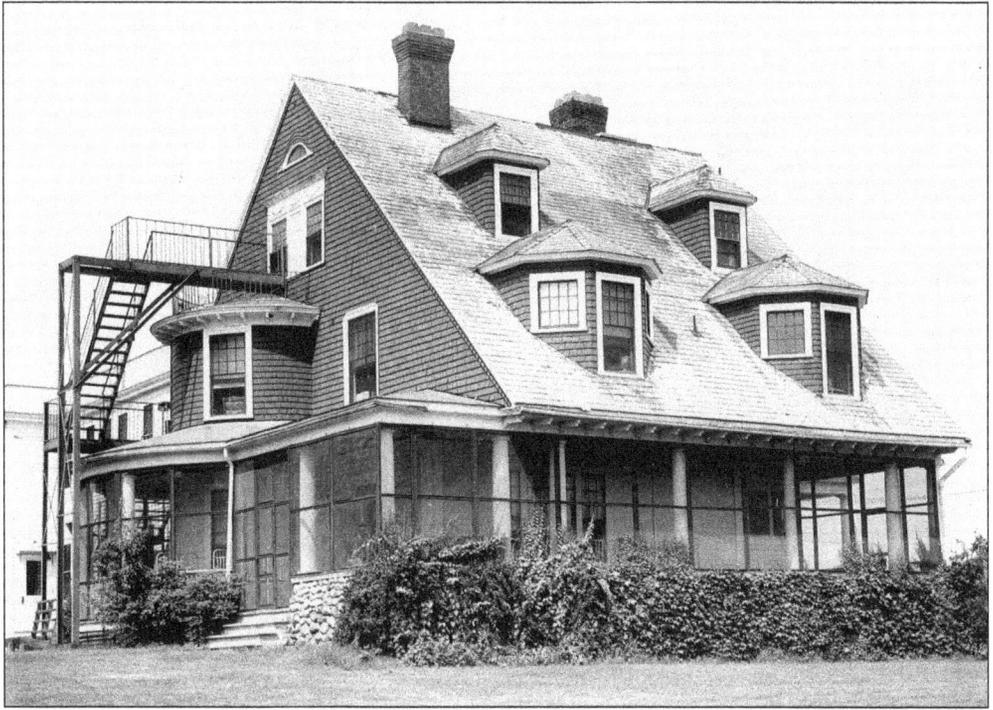

The Webster District Hospital, predecessor of today's Hubbard Hospital, opened in 1929, when a hospital corporation purchased the Bates's homestead on Thompson Road. The facility served the community health needs for over 25 years until a modern brick replacement was built behind it in 1955. A number of additional expansions took place in subsequent years. (Reprinted with permission of the *Worcester Telegram and Gazette*.)

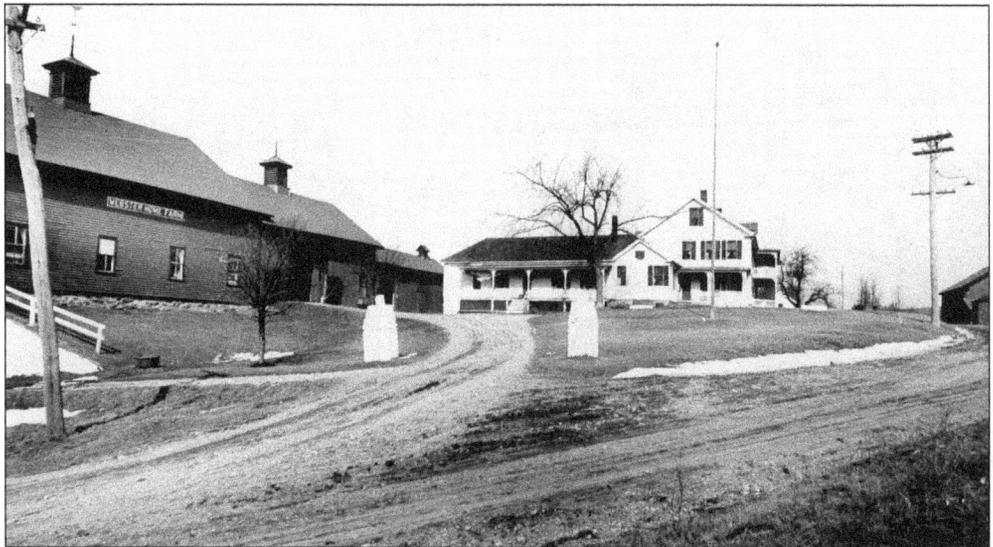

The Poor Farm served as home for those who were down on their luck. Visible while traveling along Cudworth Road would be folks sitting in their rocking chairs on the long porch. The farm was designated for industrial use in 1957, and the buildings sold at auction in 1962 for removal from the property. (Contributed by Webster-Dudley Historical Society.)

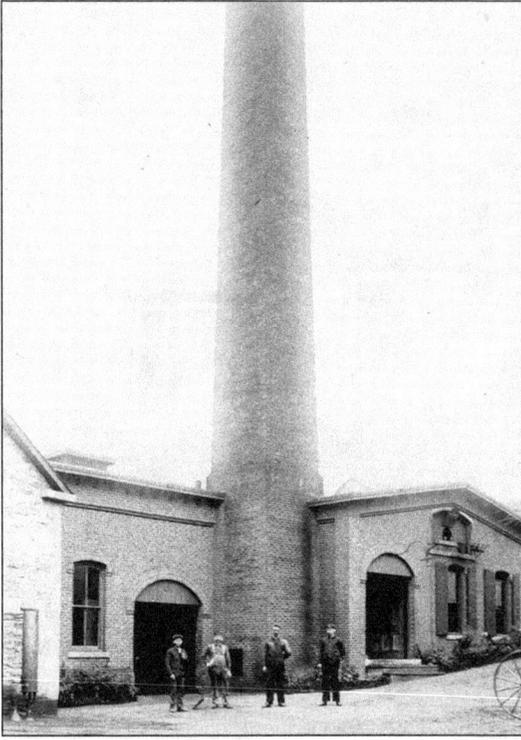

The electric company, with its distinctive tall chimney, and the gas company, with its massive gray tank, were located adjacent to one another in the Union Street area near the French River. In 1867, Webster streetlights were fueled by gas, with Webster's first electric lights appearing in December 1887. The workers in this photograph are standing directly in front of the electric company chimney. (Contributed by Jonathan Shaw.)

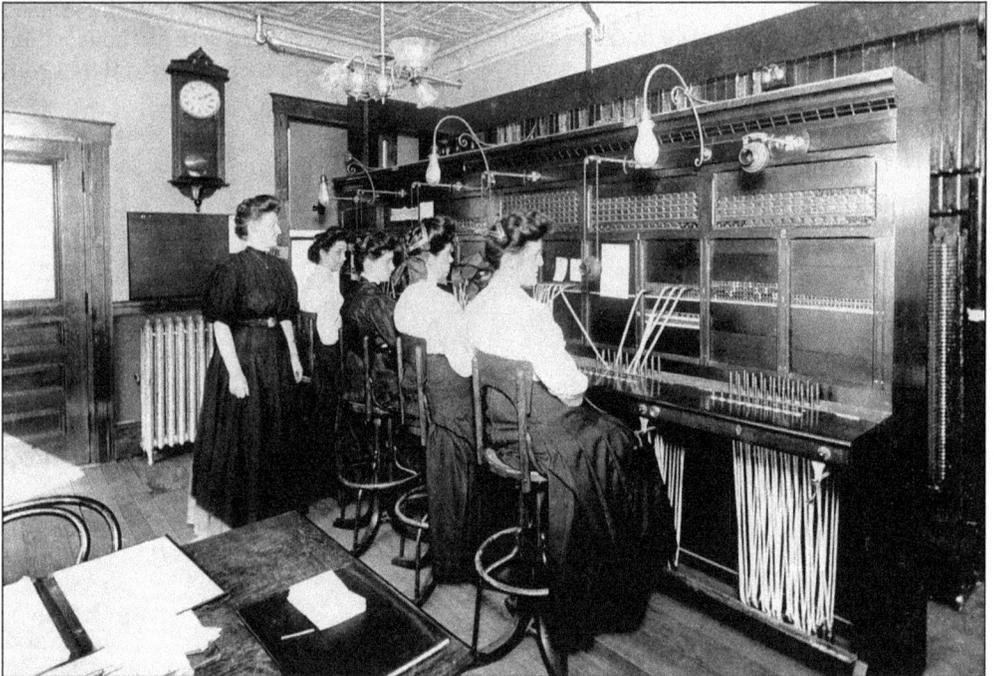

The first telephone office in Webster was established in 1880 and was located in the Dresser Block. In this early-20th-century scene, the supervisor oversees the four line operators. Every time a person would make a call, they would hear a live operator speak the familiar refrain "number please." (Contributed by Bennett J. Smith.)

A water department of sorts was formed in 1868, with its main function to provide water for firefighting efforts. In the early 1880s, plans for a water system started taking shape, but a truly functional all-purpose system was not established until the mid-1890s. In this scene, workers are busy hand-digging a well near today's pumping station off of Thompson Road. (Contributed by David Lavallee.)

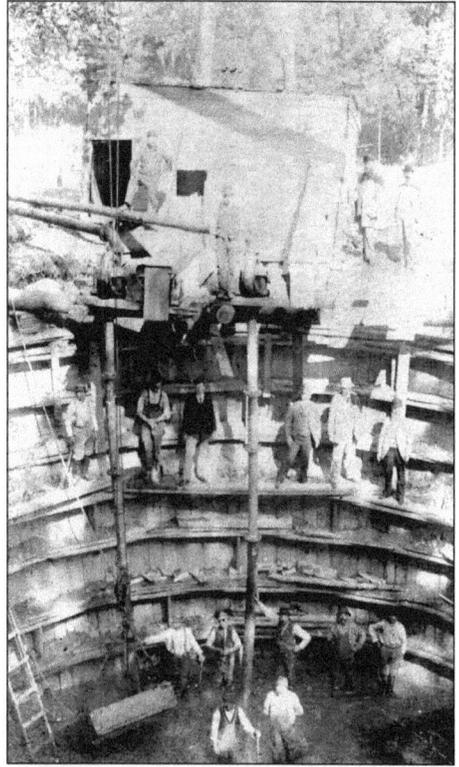

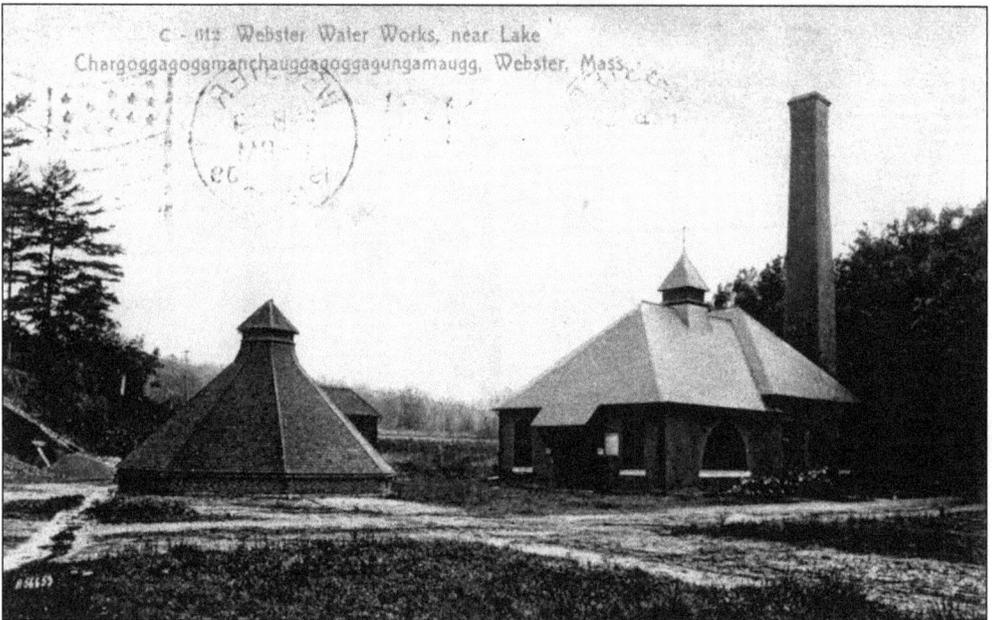

The first attempt at drilling wells in the Narrows area failed, but the second attempt, near today's pumping station, proved very successful. Water is taken from the wells and pumped for approximately a quarter mile up the hill to a standpipe on Webster's high ground, near today's Tower Street, for storage and distribution throughout the town. The original standpipe, which was erected in 1893, was replaced in 1939. (Contributed by Webster-Dudley Historical Society.)

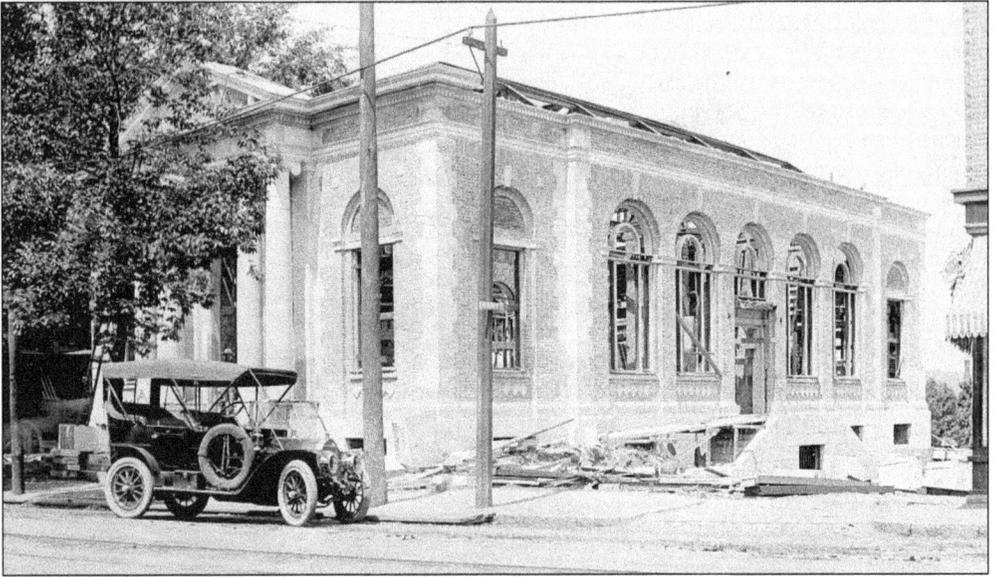

The cornerstone for Webster's new post office was laid on February 28, 1911, and from the appearance of this July 1, 1911, photograph, one can tell that a great deal of progress took place in four months of construction. The facility opened for business on May 1, 1912, and the beautiful structure remained in service for just over 50 years. (Contributed by Richard Girardin.)

The window at the old Webster post office closed for the final time on September 5, 1963, when postal worker Anthony Czernicki conducted the final transaction with customer Bill Pepka. That same year, the now familiar zip code system was introduced, much to the chagrin of many postal customers. A favorite pastime for many Webster youths was the challenge of walking the thin ledge around the entire post office without falling. (Contributed by Webster-Dudley Historical Society.)

Eight

THOSE WHO SERVED

In time of war, Webster men and women have served their country with distinction, many making the supreme sacrifice. Webster's representation was certainly notable in the Civil War, Spanish-American War, World War I, World War II, Korean War, and Vietnam War. In this Associated Press photograph of 1966, Sgt. James P. Mason, a Marine from Webster, tends to a wounded comrade just south of the demilitarized zone in South Vietnam. (Contributed by Jeffrey Stefanik.)

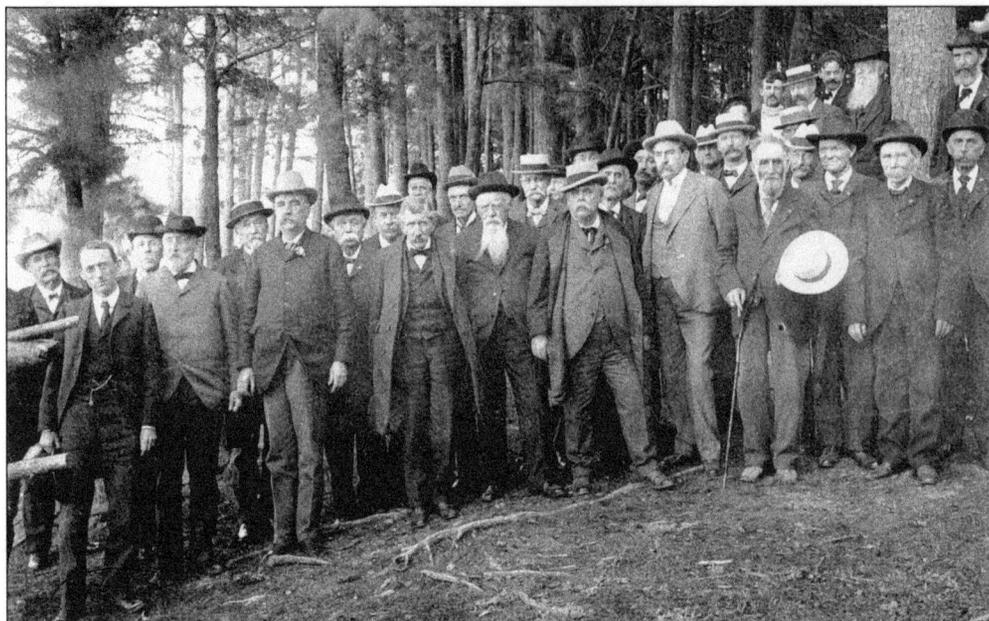

In 1861, when the call to arms went out, Webster responded. The Slater Guards, headed by Amos Bartlett, joined the Massachusetts 15th Regiment. The 15th would participate in some of the bloodiest battles of the Civil War, including Gettysburg and Antietam. Sixty-nine men from Webster and Dudley would not survive. The man in the middle with the straw hat is Amos Bartlett attending a Grand Army of the Republic veterans gathering at the lake. (Contributed by Lucinda Bartlett Day.)

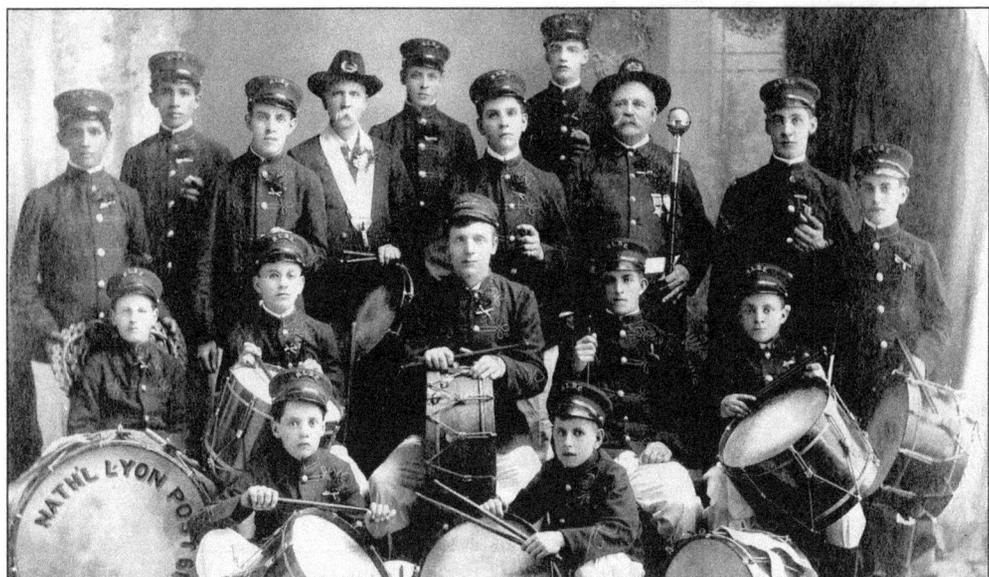

In 1868, a local Grand Army of the Republic organization was formed. It was named in honor of Nathaniel Lyon of Eastford, Connecticut, the first union general to die in the war. The post's last Civil War veteran to die was Christian Holley, in 1936. The local Grand Army of the Republic was active in the community with an auxiliary and band. In 1907, a monument was erected to honor the Civil War veterans. (Contributed by Webster-Dudley Historical Society.)

Thirty-five Webster men would serve with the "Boys of '98." It was a time in American history when expansion and sphere of influence played a major role in the country's decisions. The destruction of the *Maine* in Cuba prompted America to take action against Spain. Pictured here is Arthur Tucker of Webster, who joined the army in 1898. Most Webster residents in the war joined Company K in Southbridge. (Contributed by Kathleen Swierzbin.)

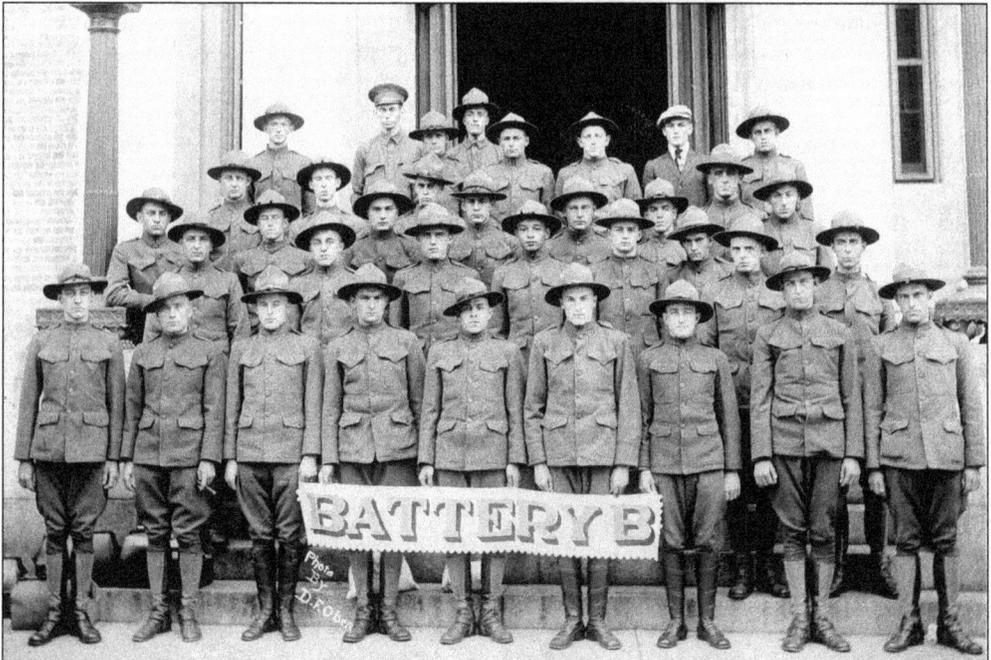

A number of Webster and Dudley men served in Battery B in World War I, including Frank Ryan, James McGeary, John Warnke, Charles Healy, Charles Authier, Maurice Shea, and Edmund Forand. Thirty-nine men from the Webster-Dudley area would make the supreme sacrifice, perhaps none more tragic than William Zacek, who died only one hour before the war ended, in the 11th hour of the 11th day of the 11th month. (Contributed by Jim Manzi.)

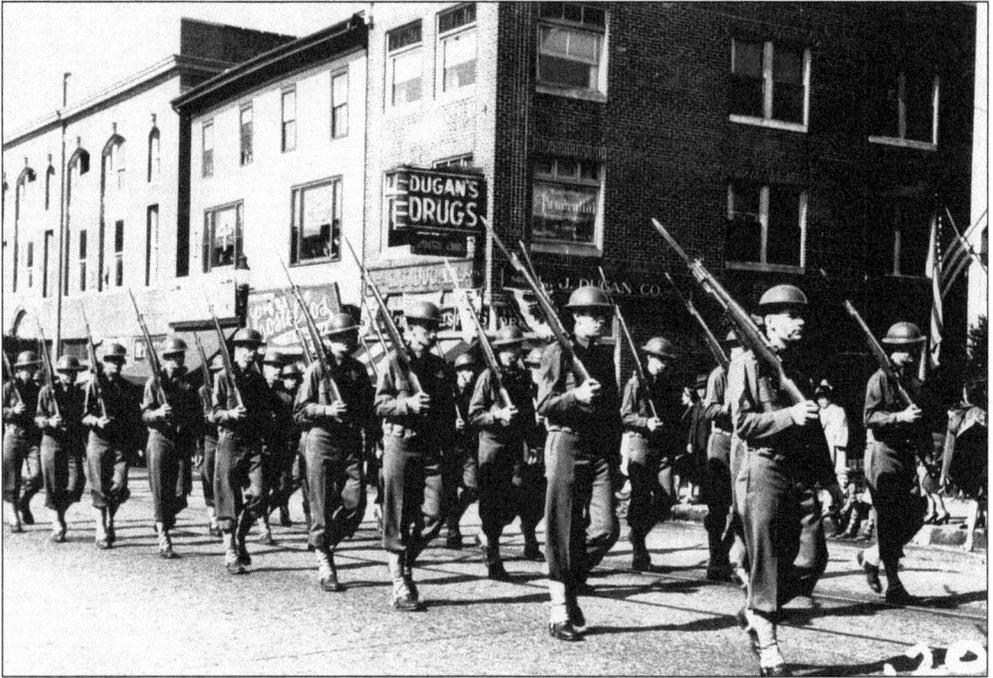

The time frame for this photograph is probably just before the start of World War II. Two telltale signs are the types of helmets and leggings being worn by the soldiers. In 1939, the local National Guard Company L was federally recognized, and in January 1941, the company would be inducted into active federal service and become a component of the famous Yankee Division, which would see heavy action in Europe. (Contributed by Jim Manzi.)

Pres. Franklin Delano Roosevelt declared that December 7, 1941, was a day that would "live in infamy." This handsome sailor, Oscar "Jake" Jacobson, was stationed at Pearl Harbor on that fateful Sunday morning. As a result of the bombing, the U.S. Pacific fleet would be severely crippled. At first, word came back to Jake's family that he had not survived the attack, but fortunately the report was false and Jake still lives in the Webster area. (Contributed by Oscar Jacobson.)

Pictured here is Cpl. Jim Manzi of the U.S. Army Air Force on the island of Tinian in the Marianna group of islands. Manzi was with the 20th Air Force, B-29 super bombers, or super-flying fortresses. This plane was the largest plane of the day. He was one runway over from where the Enola Gay, which was the aircraft that dropped the first atomic bomb over Japan, was stationed. (Contributed by Jim Manzi.)

Webster servicemen were involved in all types of activities in the war effort. In this photograph, Marine John Stefanik works on the guns of the gull-winged Corsair, used by the United States Navy and Marine Corps in the Pacific. On the home front, it was a time of short supplies and the rationing of goods such as sugar, butter, meat, gas, and tires. Webster residents, for the most part, gladly sacrificed these goods. (Contributed by John T. Stefanik.)

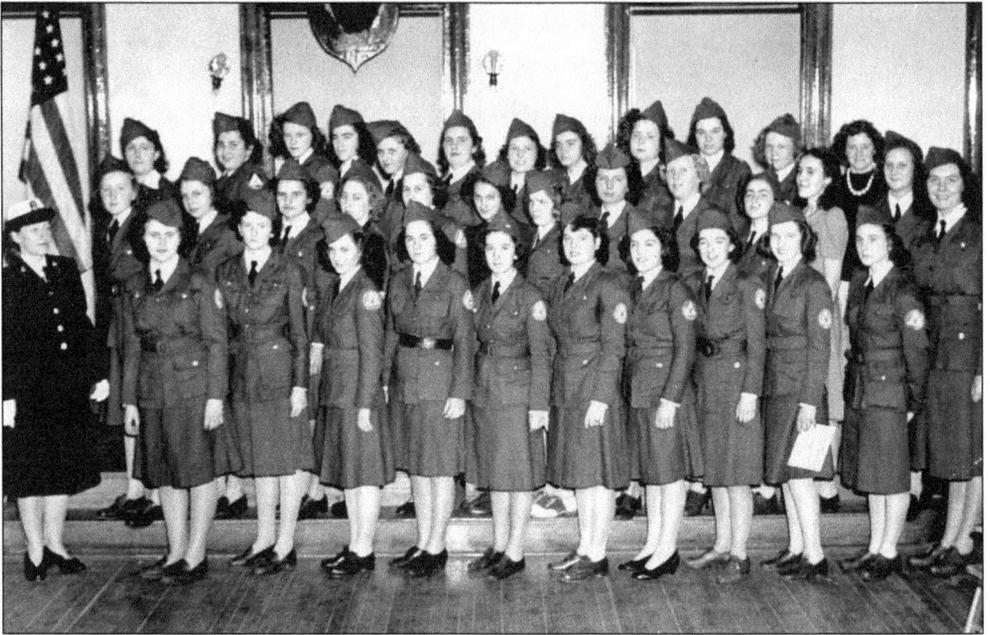

This photograph, taken in Fireman's Hall atop the fire station on School Street, features the Webster contingent of the Civil Defense Group during World War II. Organized by Lt. Cdr. Frances E. Biadasz of the United States Navy, a Webster resident, these women volunteers monitored the phones for air raid information. (Contributed by Louise Madura Mason.)

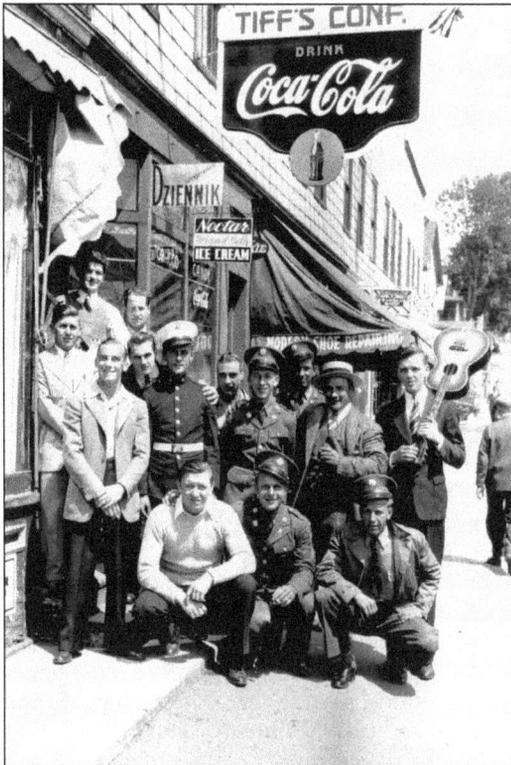

Near the end of the war in 1945, the mood of the country was changing. The end of the war was near and the Allied victory was inevitable. Here a group of happy returning soldiers, some still in uniform and others in their civvies, strike a happy pose in front of Tiff's in Webster's hub section. Nearly 100 Webster and Dudley men would fall and not return home. (Contributed by John Przybylek.)

Norman Deptula (left), longtime Webster educator, poses with his buddies in Taegu, South Korea, in the spring of 1951. Deptula participated in the Battle of Chosin Reservoir, considered by many to be the most difficult battle of the war. More than 50,000 Americans would die, including 5 from Webster. Included in this number was Margaret Grace Kennedy, the only Webster woman to die in any war effort. (Contributed by Norman Deptula.)

Paul Mrazik, positioned on the right with a Marine buddy, served with the First Marines in Korea from 1950 to 1951. The fighting in Korea was often very difficult. Not only were the North Korean and Chinese forces tough and unyielding adversaries, but the mountainous terrain and extremely cold temperatures made fighting much more difficult. (Contributed by Antoinette Mrazik.)

The Seige of Khe Sanh, Vietnam, in the late 1960s, was considered by many military experts to be America's most difficult battle of the entire war. The enemy pounded the plateau daily. The U.S. Marines defending the location held fast. Pictured here, defending the perimeter at Khe Sanh, is Sgt. Ed Lawida of Webster, a Marine and one of the "Myrtle Ave. Boys." (Contributed by Stanley Duszlak.)

Though the Vietnam War is known for its political intrigue, home front protests, and lack of a decisive victory, what must not be overlooked is the valiant and brave efforts made by local servicemen in the jungles of Southeast Asia. Seven local heroes would not return from the war. Pictured in this photograph is Cpl. Stanley Duszlak of the U.S. Marines in Vietnam in 1969. Today Duszlak continues serving his hometown as the town surveyor. (Contributed by Stanley Duszlak.)

Nine

PEOPLE AND PLACES

The Order of Red Men, which dates back to the Sons of Liberty and the American Revolution, promotes honoring the flag and the principles on which our nation was built. Freedom, friendship, and charity were the key words that drove this organization, which had a membership of 150,000 by the 1920s. The local Webster unit, Tribe 130, was involved in a number of community efforts, including this 1922 parade. (Contributed by Al Zdunczyk.)

The Hermitage was the symbol of the Slater family. Located across the street from the East Mills, the Hermitage was home for Samuel and his sons when they stayed in Webster to oversee the mills. Slater died there at age 67, on April 20, 1835. The home was demolished in the 1970s, and a gas station now occupies the site. (Reprinted with permission of the *Worcester Telegram and Gazette*.)

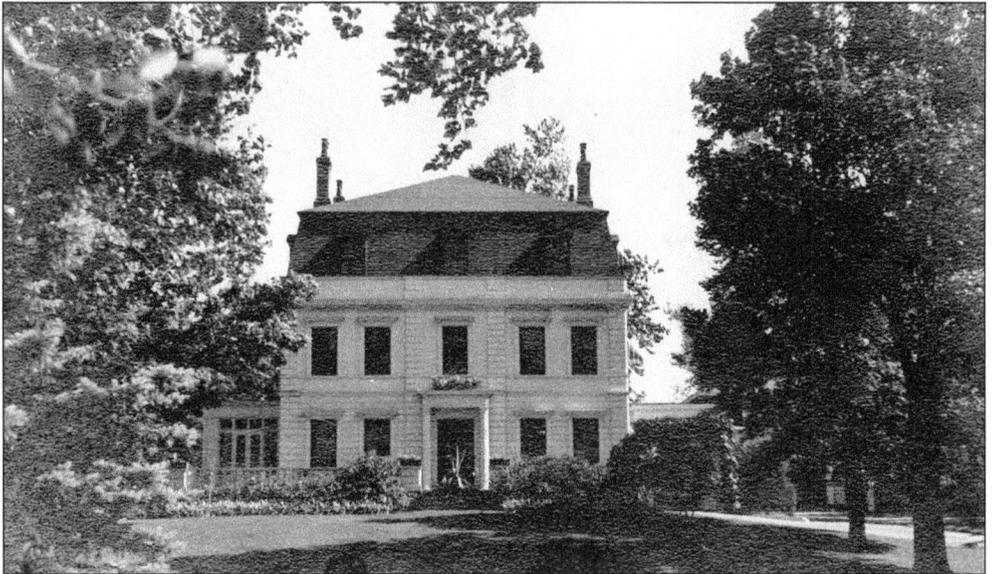

One of Webster's most beautiful homes, the Knolls, was located at the present site of the Price Chopper Plaza. The grand home was built in 1865 by James Howe for his wife, Elizabeth, granddaughter of Samuel Slater. Following Howe's death in 1887, the house became the property of Horatio Nelson Slater, who owned it until 1937 when it was sold to Clarence A. Paradis for use as a funeral home and personal residence. In the 1960s, the home and beautiful grounds gave way to commercial development, when the Key Department Store and Nu-Way Market were built. (Contributed by the Paradis family.)

The basic architectural design of many of the homes in Webster could be described as multi-family. In the 19th century, when the Slater forces built their factory complexes, construction of mill housing adjacent to factories was commonplace, to be followed by widespread construction of two- and three-deckers throughout the town. A number of the Slater factory dwellings still exist, especially in the North Main Street area. (Contributed by Bruce White.)

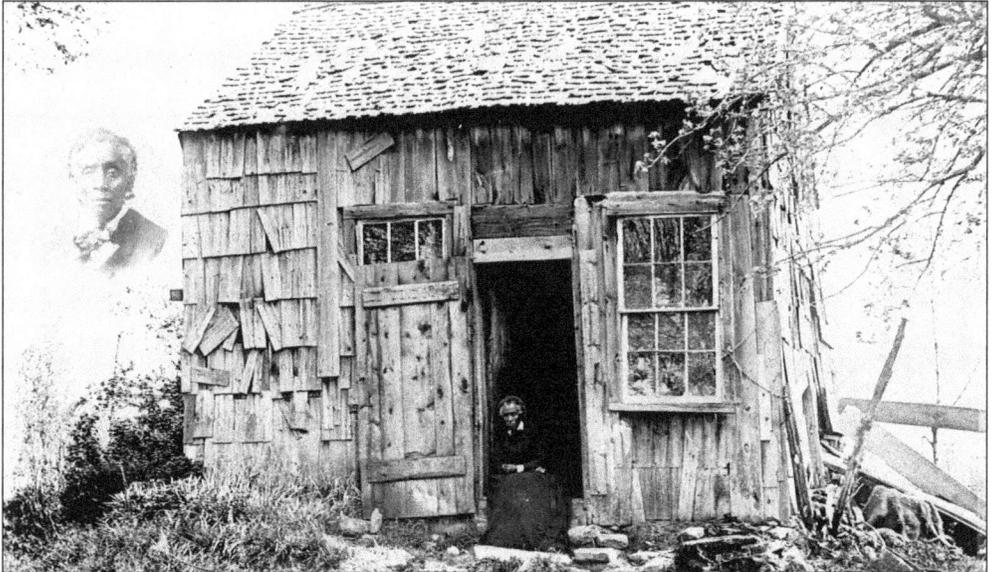

Some of Webster's early homes could be described as humble, and the Lucy Boston abode on Fifth Avenue was no exception. In the late 1800s, Caucasians dominated Webster's population, and other racial groups were barely represented. Boston, who was described as an African American and Native American mix, met her demise in a terrible fire at her home on January 6, 1900. (Contributed by Webster-Dudley Historical Society.)

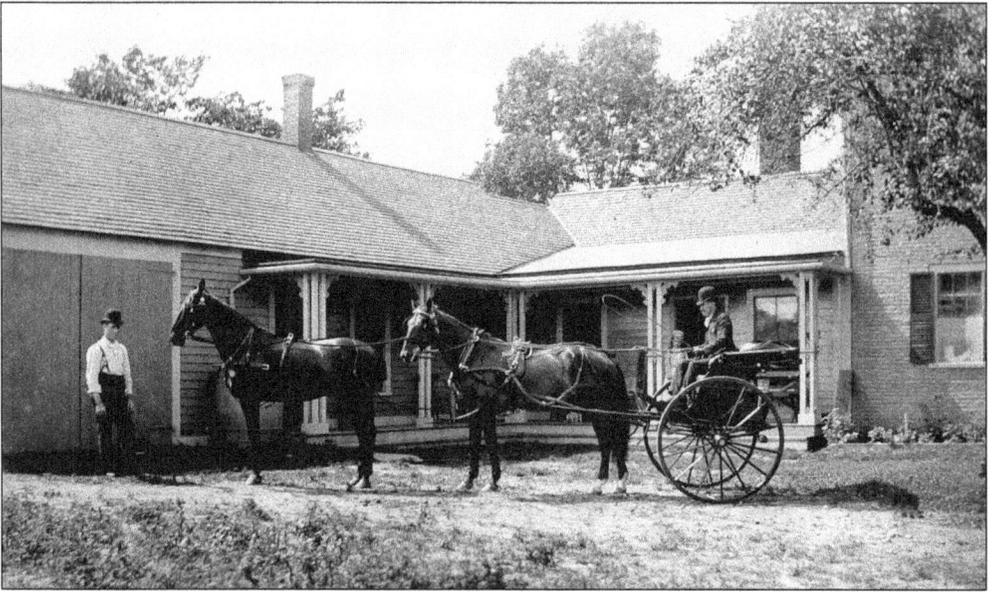

Edgar Asa Bates is pictured here with a beautiful tandem near the paddock of the original Bates family home on Thompson Road. The home is located near the base of today's Hubbard Regional Hospital and has been known by several different names over its long span, including Brick Ends House, Fox and Hound Tavern, and Anedjo Farm. (Contributed by Benjamin Craver.)

In this 1934 photograph, Webster's Patrick Francis Dugan shakes hands with a Connecticut resident, who stands in the Nutmeg State across the brook. In geography classes, it was always easy to teach the students where Webster was located on a U.S. map. For example, one could direct a student to place their finger where Massachusetts, Connecticut, and Rhode Island meet, and, congratulations, there is Webster! (Contributed by Chester C. Corbin Public Library.)

In this 1930s scene, the photographer captures a parade passing the Dugan and Patenaude Buildings, both of which still stand today. Dugan's Drug, established in 1905, ceased operations in 2004 after 100 years of service to the community. The Newsroom, which sold papers, periodicals, and sporting goods, was located to the left of Dugan's Drug, and the Methodist church to its right. (Contributed by Webster-Dudley Historical Society.)

This beautiful horse-drawn float is on Davis Street. If one looks at dress of the young people on the float, it is not too difficult to surmise that patriotism is the theme of the float. Another telltale sign that the country's virtues were being extolled is the presence of the adult Grand Army of the Republic member located near the front of the wagon. The people on the second-floor porch of the City Hotel have a bird's-eye view of the proceedings. (Contributed by Jim Manzi.)

Alfred Kleindienst was truly an extraordinary man. At a young age, Kleindienst developed an interest in a new technology, radio. In 1912, at age twelve, he had built his own radio set, followed by a transmitter by age 15 at his home on Emerald Avenue. He secured a broadcast license in 1925 and started Webster's first radio station, WKBE, with local talent filling the airwaves each week. Kleindienst went on to form WORC in Worcester. (Contributed by Sylvio Gilbert.)

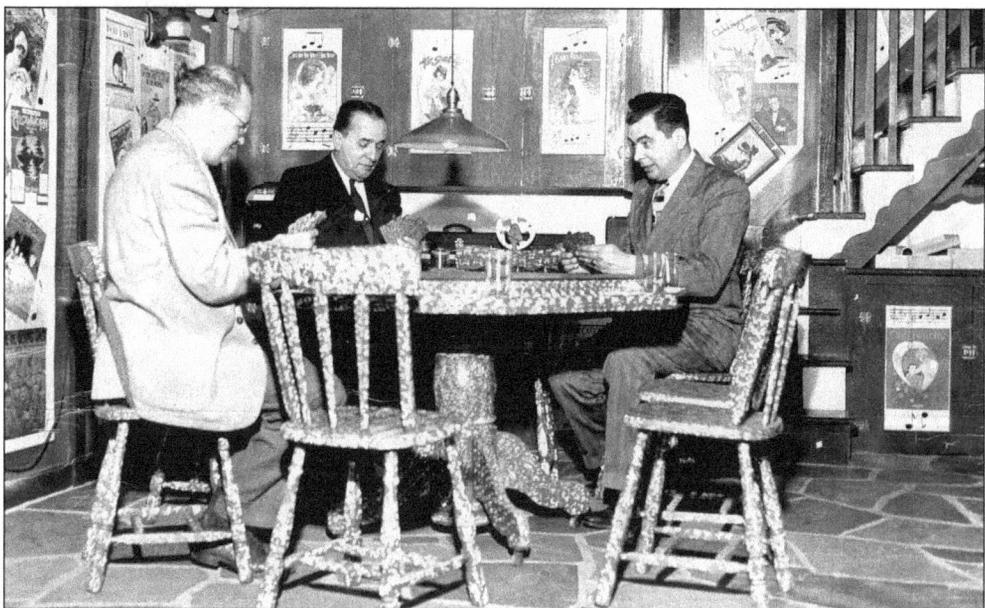

Joseph Patenaude (center), longtime selectman, enjoys a game of cards in the "melody room" at his home on Wakefield Street with his son, Bernard, and regional editor of the *Telegram and Gazette*, Frank Crotty. Patenaude gained notoriety for taking the unusual action of blowing up the railroad, thus the moniker "Dynamite Joe." (Contributed by Bruce White.)

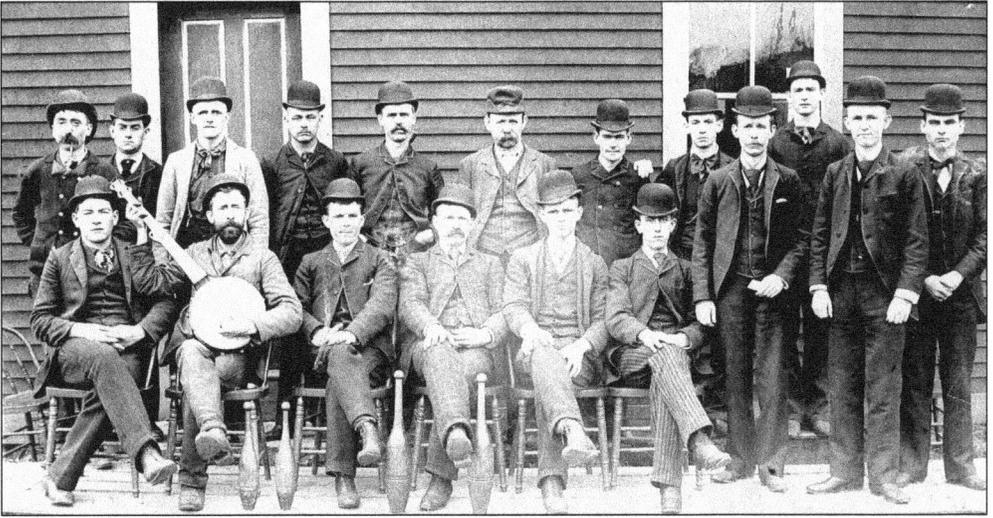

The early mills played a dominant role in the lives of their workers. Besides wages, the company store, and company housing, mill work also involved other activities, such as sports, orchestras, and social organizations. This fine-looking group, photographed in 1887, was referred to as the Slater Club. (Contributed by Webster-Dudley Historical Society.)

The Slaters' period of heavy involvement with Webster lasted just over 100 years. The process of divesting started in the 1920s and continued into the 1930s, but the family still impacted the town by making some sizeable land donations after the mill closures. Pictured here are James Howe Slater, William Strutt Slater, and Lydia Robinson Slater. (Contributed by Lucinda Bartlett Day.)

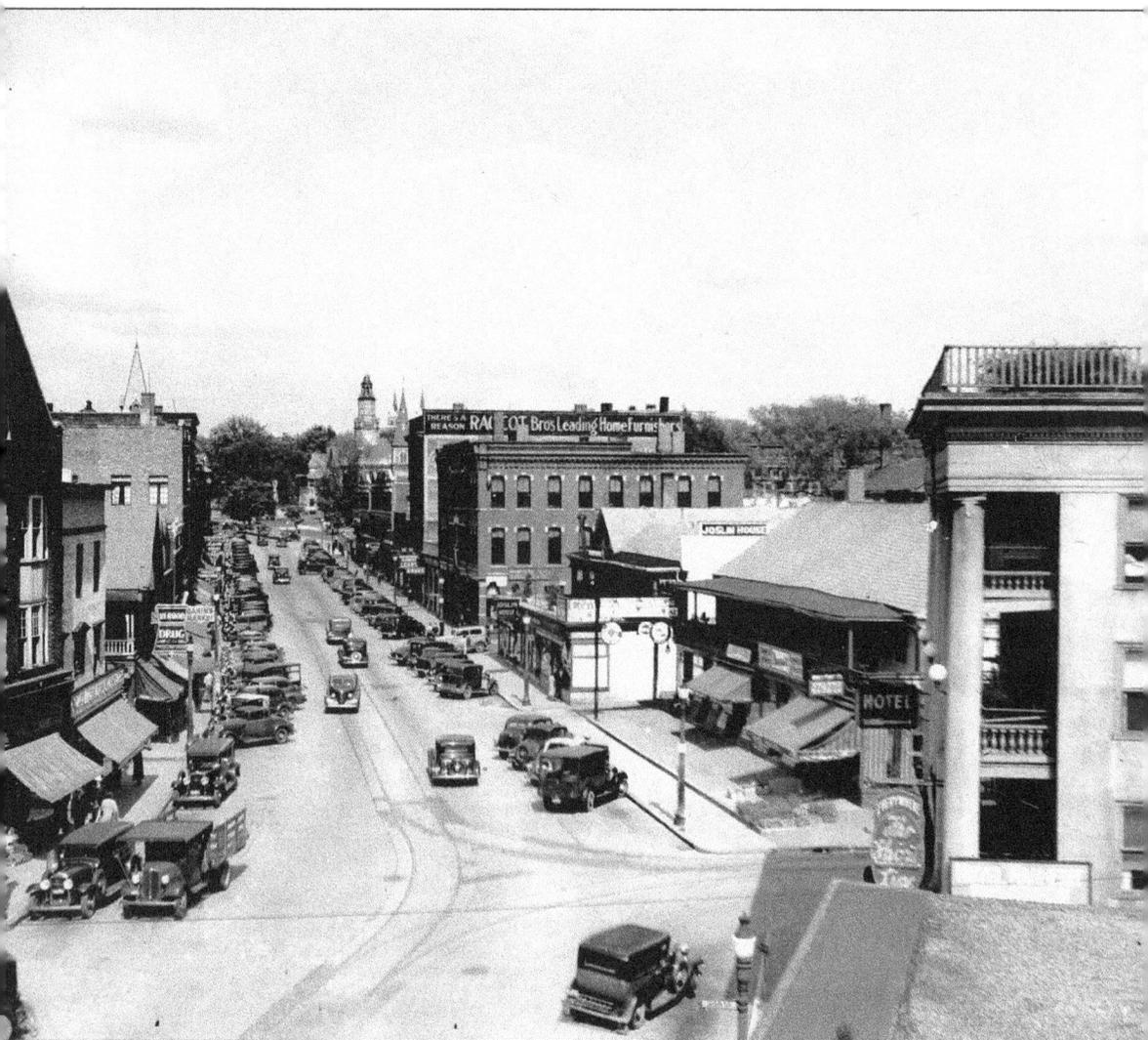

Webster's Main Street was a very busy and interesting place well into the middle of the 20th century, but the advent of a more mobile society, shopping malls, and lack of parking spaces all contributed to a major regression in downtown activity. The Main Street shown here, with its wide variety of businesses, attracted customers from many of the surrounding communities. Sidewalks filled with business patrons were the norm. Most of the structures in this 1930s photograph were built in the last part of the 19th and early part of the 20th centuries, and a good number of them are still in use today. (Contributed by Webster-Dudley Historical Society.)

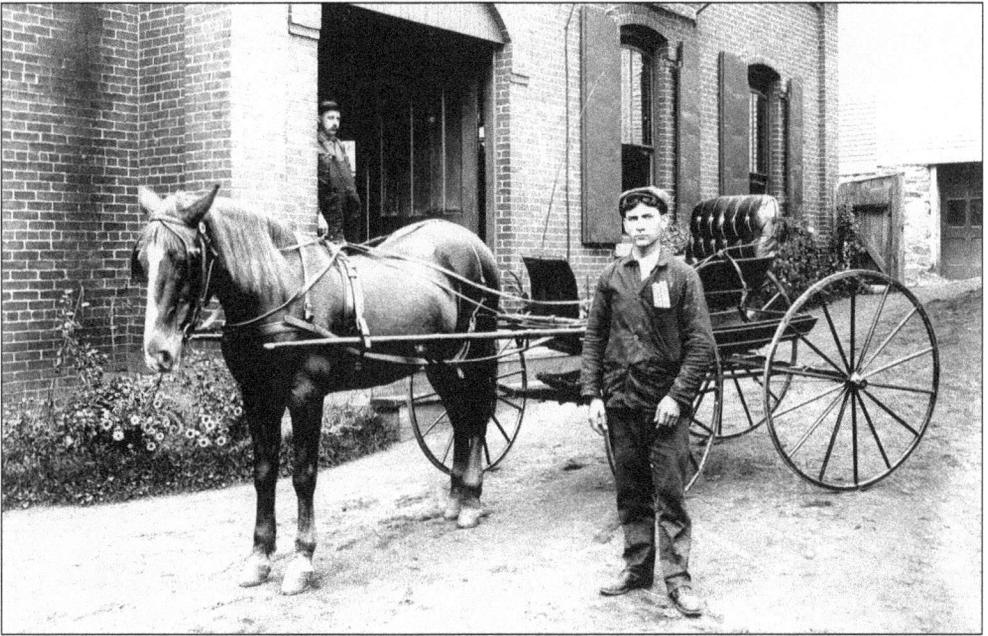

The first electric lights in Webster were lit on December 24, 1887, with the first electric-light poles placed into service on Main Street in 1889. Felix and his horse, Rosie, stand in front of Webster Electric, where the electric power was generated. Chief engineer William Mills stands in the doorway of the engine room. (Contributed by Jonathan Shaw.)

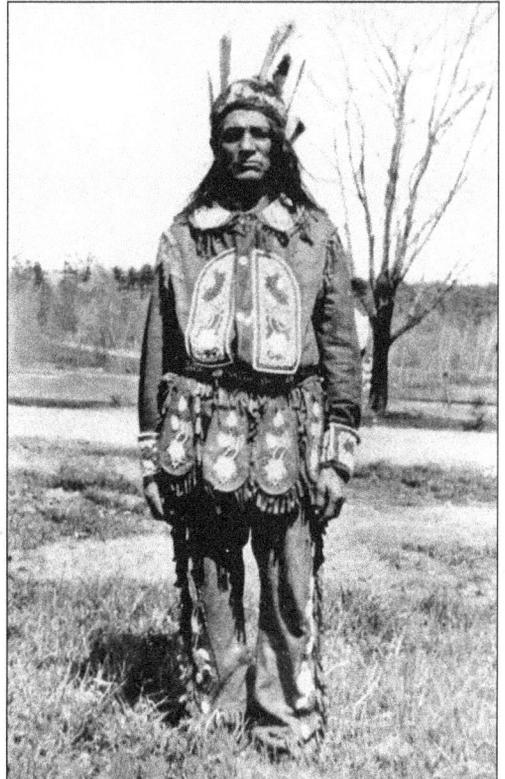

Prior to the arrival of white settlers, the Nipmuc tribe dominated the land surrounding the beautiful lake. The last of the full-blooded Nipmucs in the area were the Henries brothers, Walter and Payne. Walter, of Quinebaug, conformed to the white man's ways, but Payne maintained the Native American lifestyle of hunting, fishing, and trading. Payne lived in a hut south of the lake and died in 1937. Pictured here is Payne, dressed in his Native American clothing. (Contributed by the Bartlett High School Library.)

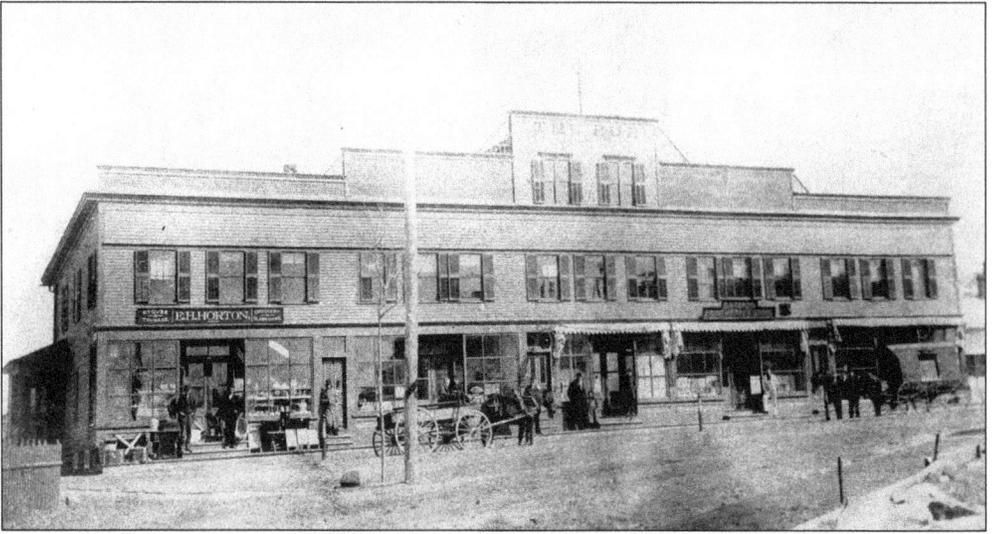

E. H. Horton Company was originally located in Webster's hub section, a part of Lake Street that intersects with Negus, Granite, Harris, Maynard, and Goddard Streets. Horton originally started out in groceries but soon expanded to home furnishings. Perhaps the most notable business in the hub neighborhood was Jean Cyr's, noted for their famous fish and chips as well as an unforgettable array of penny candy. (Contributed by Webster-Dudley Historical Society.)

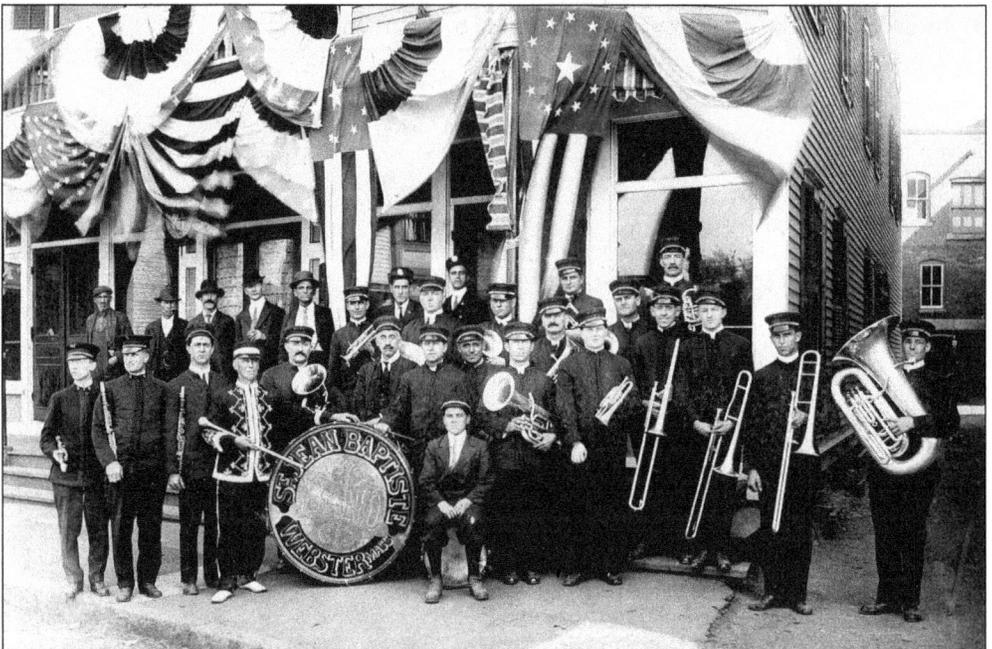

The local Catholic churches had societies that sponsored social activities and offered insurance policies to their members. The Slovak community had the Sokol union, the Polish St. Joseph's Church had the Towarzystwo Polskich Kanonierow organization of the Polish Cannoniers, and the Sacred Heart Church parish had the French organization Union Saint-Jean-Baptiste. Pictured here, the St. Jean Baptiste Band gets ready to perform at July 4 festivities. (Contributed by Webster-Dudley Historical Society.)

Ten

IN THE NEWS

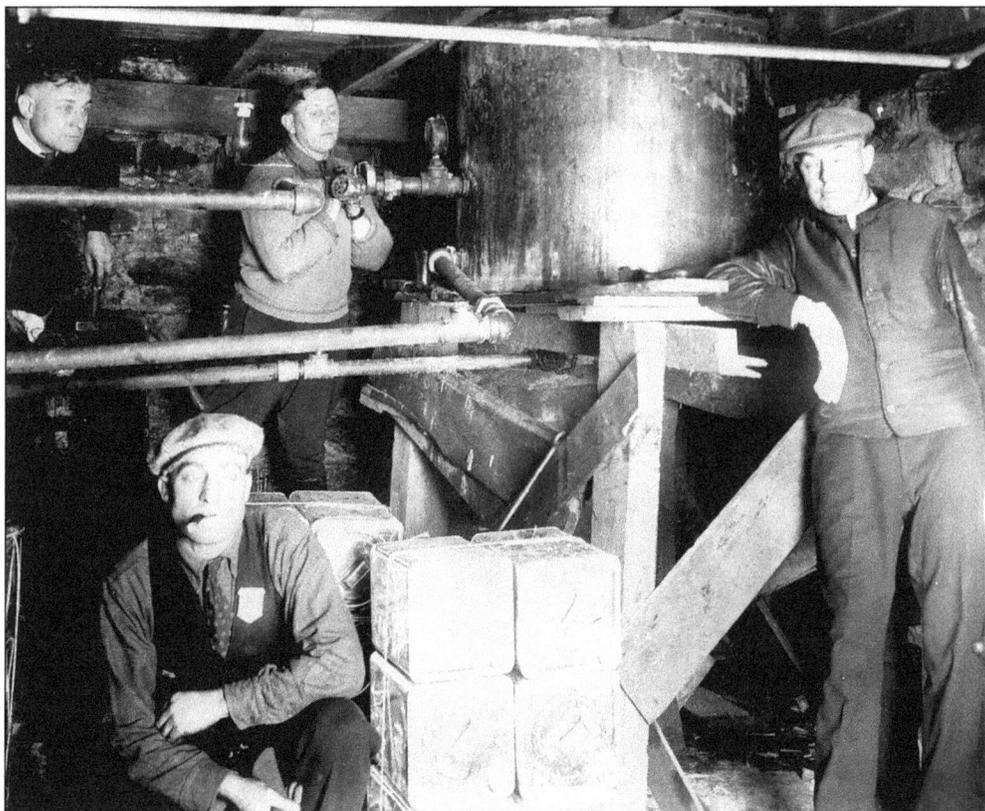

Officers Delphis Nadeau, Buck Plasse, Roy Burns, and Max Millette, from left to right, were in on the discovery of an illegal liquor-producing still during Prohibition. Called a gypsy still, traveling bootleggers would set them up in various locations. This one was in a building near the corner of Mechanic and Negus Streets. (Contributed by Edie McCausland.)

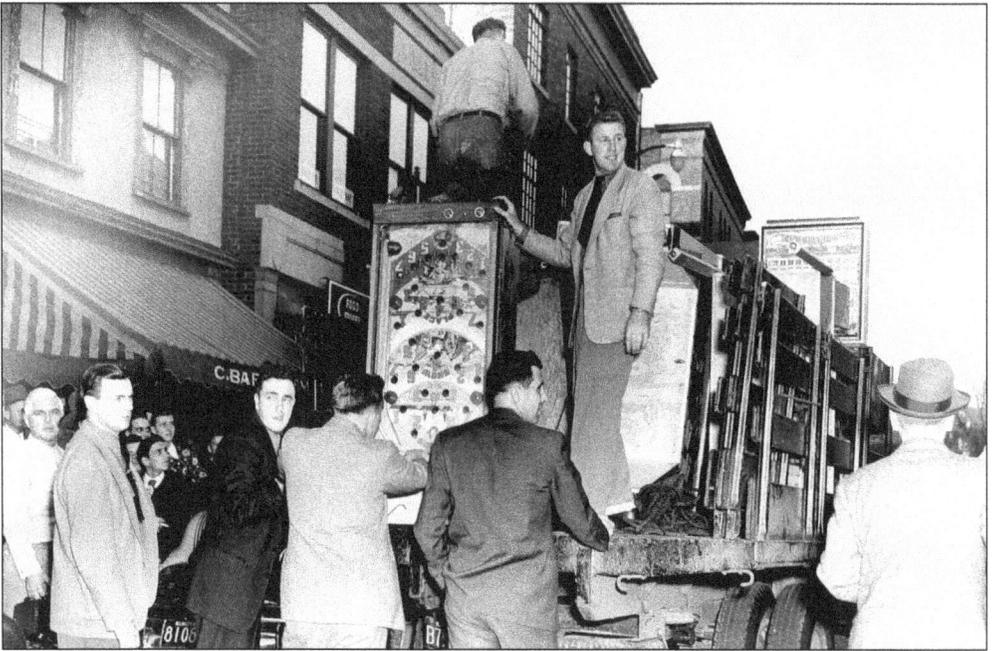

Saturday, May 7, 1949, marks the date of the biggest raid of gambling establishments in Webster's history. Thirty state troopers, under the direction of Lt. James Ryan, 1st Sgt. Orville Wesley of the Holden barracks, and Cpl. John Sidney of the Grafton barracks, simultaneously raided 11 establishments on Main Street, resulting in the arrest of 69 people and seizure of gambling machines valued up to $15,000. (Contributed by Edie McCausland.)

In this 1934 scene, Chief John Templeman and Patrick Dugan discuss matters with a patrolman at the High Street station. Webster police have had to deal with a number of major cases, but none of them generated more interest than the disappearance of four-year-old Andy Amato in 1978. Despite major search efforts and investigations, the case was never solved. (Contributed by Chester C. Corbin Public Library.)

When one thinks of weather disasters, tornados, hurricanes, and blizzards are normally the first things that come to mind, but ice storms can also be devastating to a community. The added weight of the ice to vegetation very often causes trees and limbs to snap, often resulting in the loss of electricity and phone service, as was the case in this 1922 ice storm. (Contributed by Jonathan Shaw.)

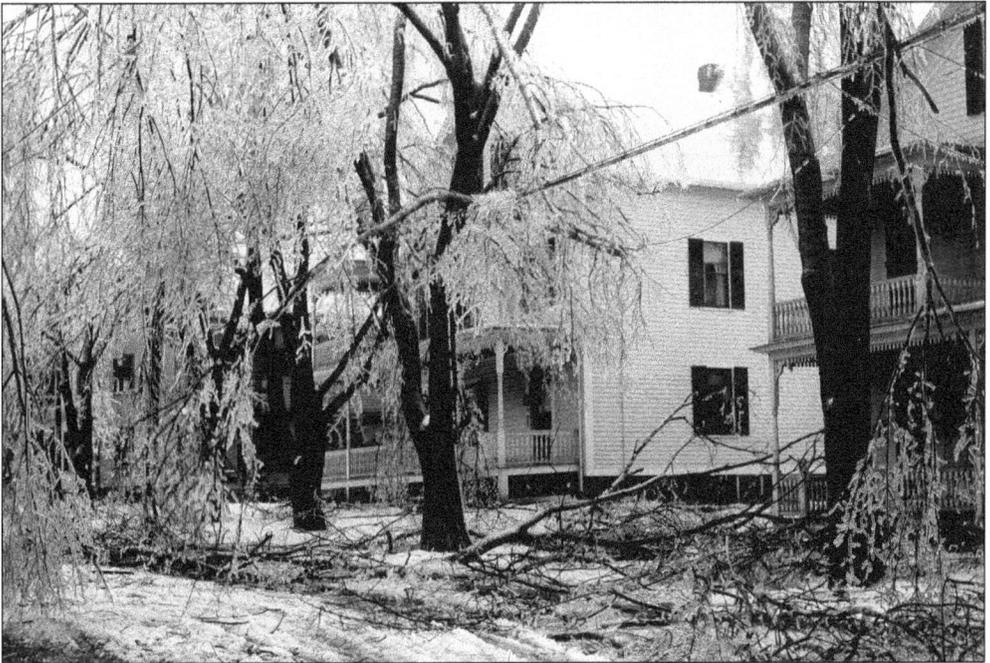

The 1922 ice storm pictured above wreaked havoc in the School Street area, proof being the condition of the street and vegetation at the Prout house on 416 School Street. From all news accounts of this storm, travel was nearly impossible. (Contributed by Jim Manzi.)

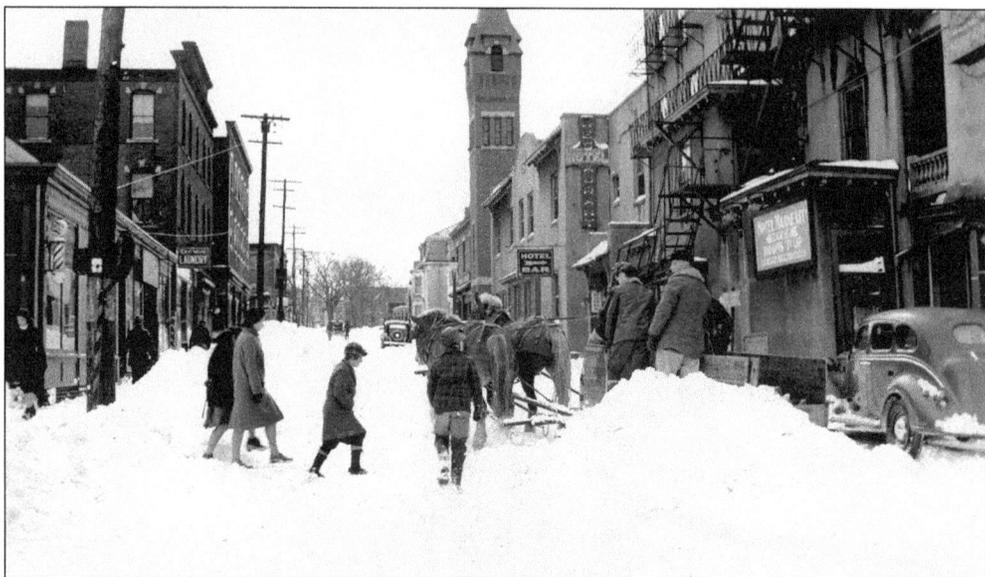

The lower end of School Street is pictured here in a 1930s storm. What makes the photograph so interesting is the contrast in transportation. Automobiles share the street with a team of horses drawing a sleigh. Webster also had a number of memorable blizzards in 1888 and 1896, with drifts reported over 10 feet high. (Contributed by Jim Manzi.)

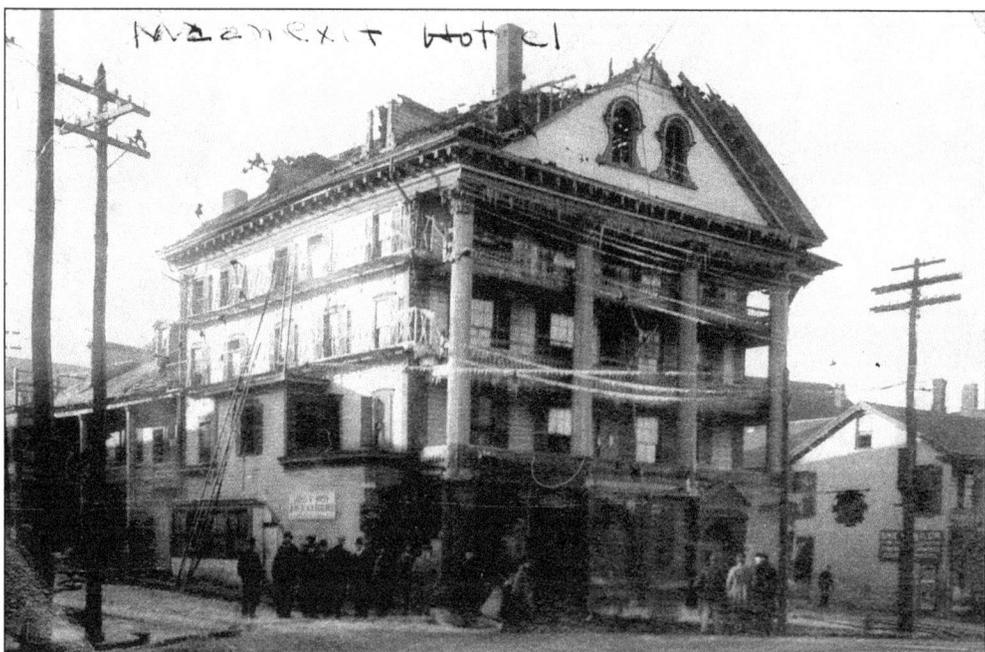

In 1899, the McQuaid Block and Maanexit Hotel underwent a major renovation and expansion, but a fire in 1911 caused extensive damage to the upper floors. The response time to the fire must have been incredibly quick, due to the fact that the Webster Fire Station was next door on School Street. (Contributed by Webster-Dudley Historical Society.)

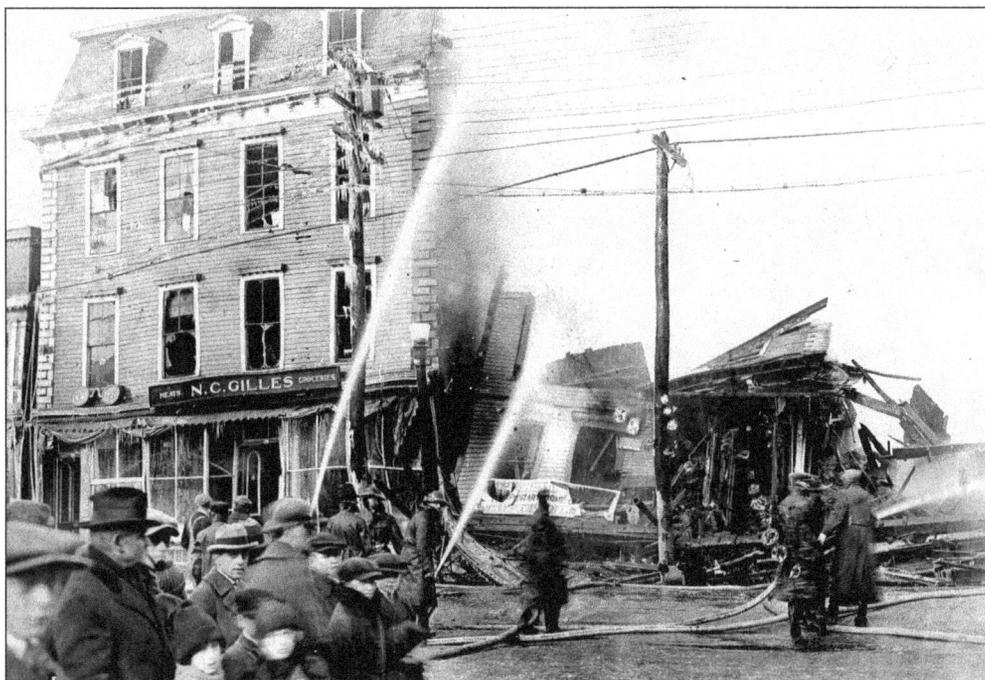

Over the years, the town of Webster has experienced many devastating fires resulting in the loss of a great deal of property, both personal and commercial, and unfortunately, in a number of cases, the loss of life. In this 1924 photograph, Nicholas Gilles's grocery building on Main Street was destroyed, despite the best efforts by the Webster Fire Department. Gilles rebuilt the store not long after. (Contributed by Webster-Dudley Historical Society.)

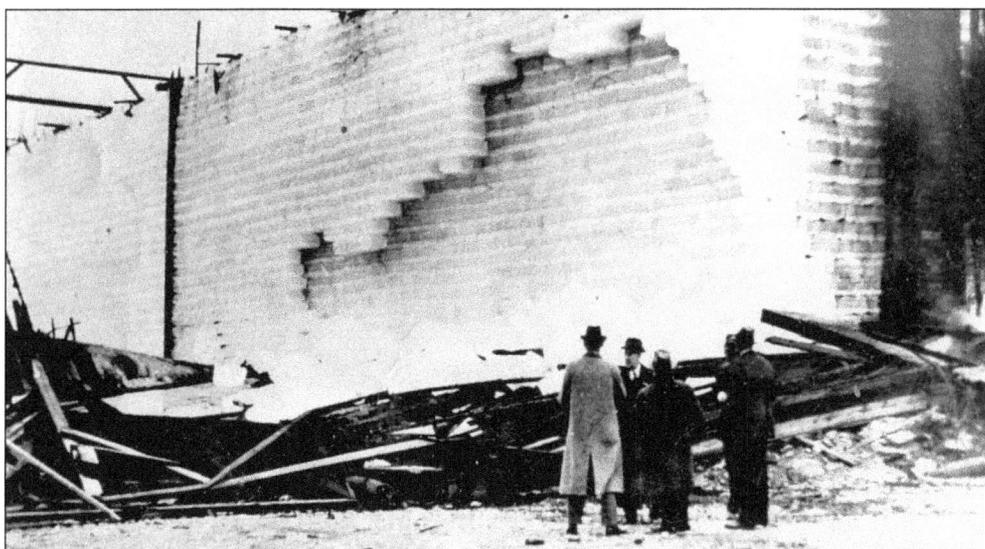

A notable and a rather unusual fire occurred on April 20, 1936, with the complete destruction of McKinstry's icehouse on Thompson Road. The longtime ice business's exterior was completely destroyed, but its contents of stacked ice largely survived the inferno. Alfred McKinstry, Joseph Prout, Fire Chief Art Belmore, and H. Craigin Bartlett look over the damage. (Contributed by Webster-Dudley Historical Society.)

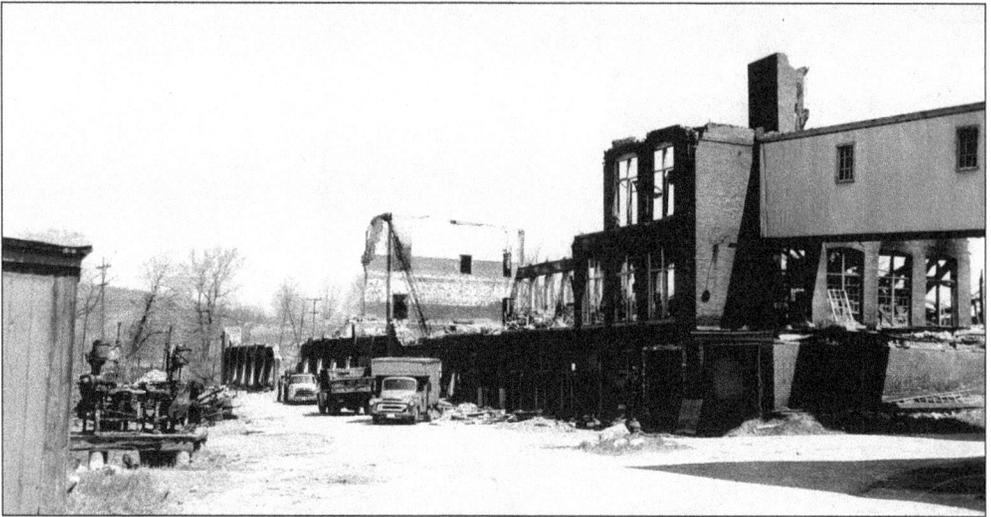

The largest fire to ever strike the community occurred on January 1, 1969, when much of the old Slater North Mills complex was devastated. A number of the town's major businesses were destroyed, including B & W Footwear, Bentley Shoe, and Worcester Paper Box, impacting local economics for several years. In this 1969 photograph, the cleanup process is about to begin. (Contributed by Webster-Dudley Historical Society.)

The combination of a very rainy March and a rapid snow runoff up north was a recipe for disaster in the Webster area in 1936. The Maanexit or French River banks could not contain the volume of water flowing south, and severe flooding occurred throughout the area. The New Haven Railroad tracks, which essentially follow the French River for almost their entire distance through Webster, sustained very heavy damage. (Contributed by John Przybylek.)

The oldest residents of Webster stated that, in 1936, they had never seen the Maanexit River reach such a high water level. There were two floods, with the first occurring on March 16, followed by a second, more severe flood on March 18. Industries in close proximity to the river sustained very heavy damage, including North Village Mills, Headway Shoe, Maanexit Spinning, and American Woolen. (Contributed by Ethelinda Bartlett Montfort.)

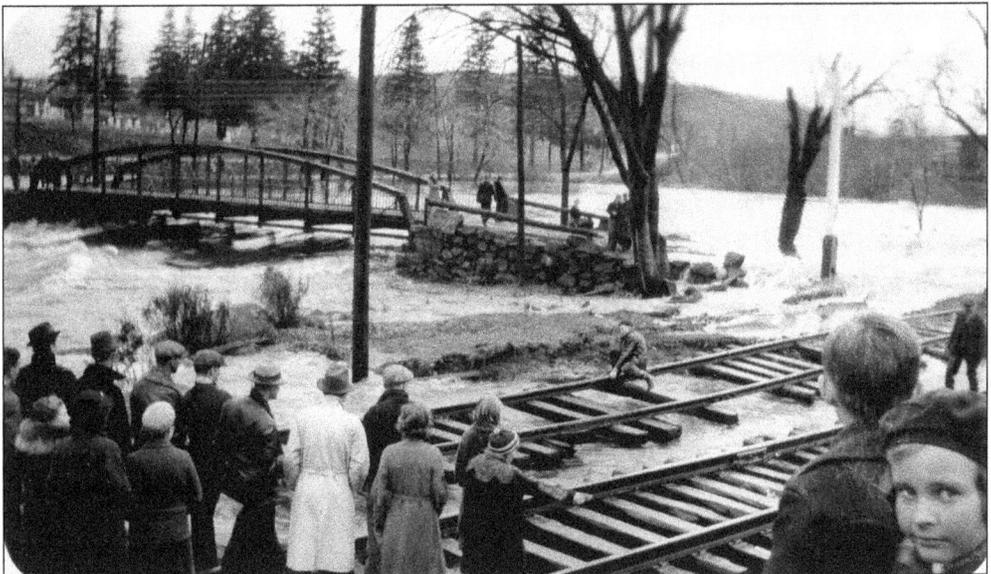

All of the highway bridges sustained heavy damage, in some cases they were totally destroyed, as was the situation in the Perryville section of Webster. The bridge at North Main Street, now at Memorial Beach, had been cut off by the raging waters. (Contributed by Webster-Dudley Historical Society.)

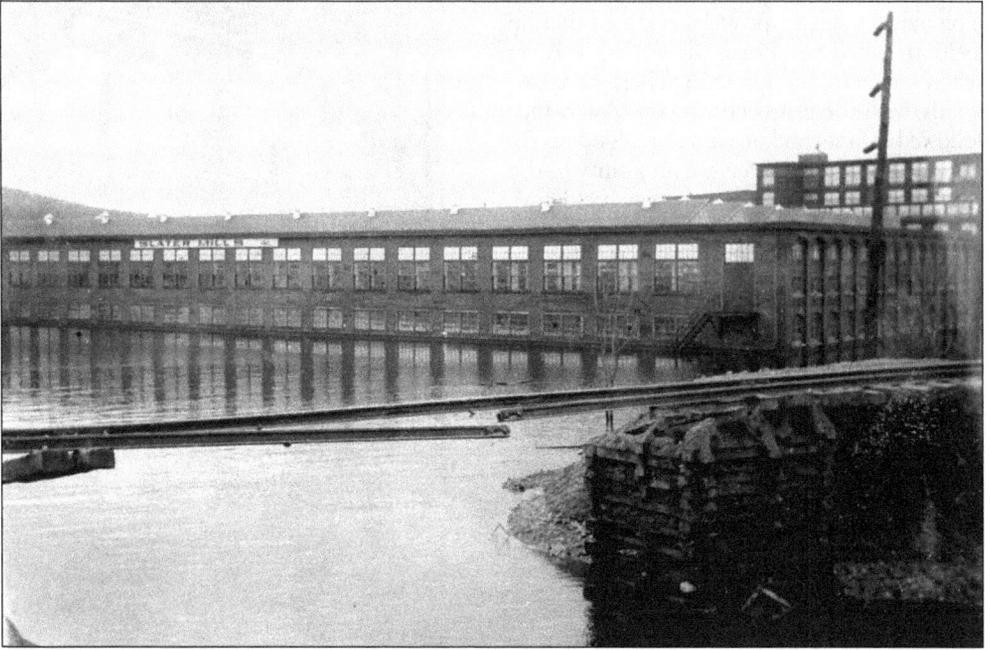

Besides industrial flooding, many homes near the river sustained heavy damage, requiring a large evacuation, especially in the Pearl Street area. The railroad embankment acted as a dam, causing selectman Joseph "Dynamite Joe" Patenaude to give the order to blow up the railroad, not once, but twice. In this photograph, the dangling rail in North Webster is testimony to the handy work of Dynamite Joe. (Contributed by John Przybylek.)

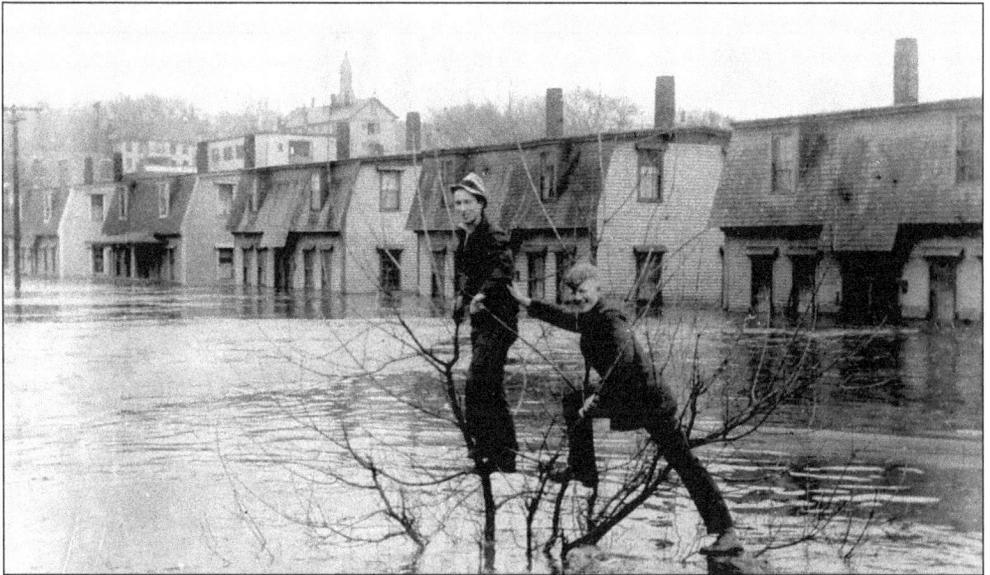

It would appear that locals John Przybylek and Al Socha have found an interesting place to stand on Webster's Pearl Street. Would "up the creek without a paddle" be a fitting caption for this photograph? As a result of selectman Patenaude's actions during the flood of 1936, Larry Daly, *Webster Times* editor, composed a witty poem entitled "Dynamite Joe," describing the circumstances surrounding the flood and Patenaude's actions. (Contributed John Przybylek.)

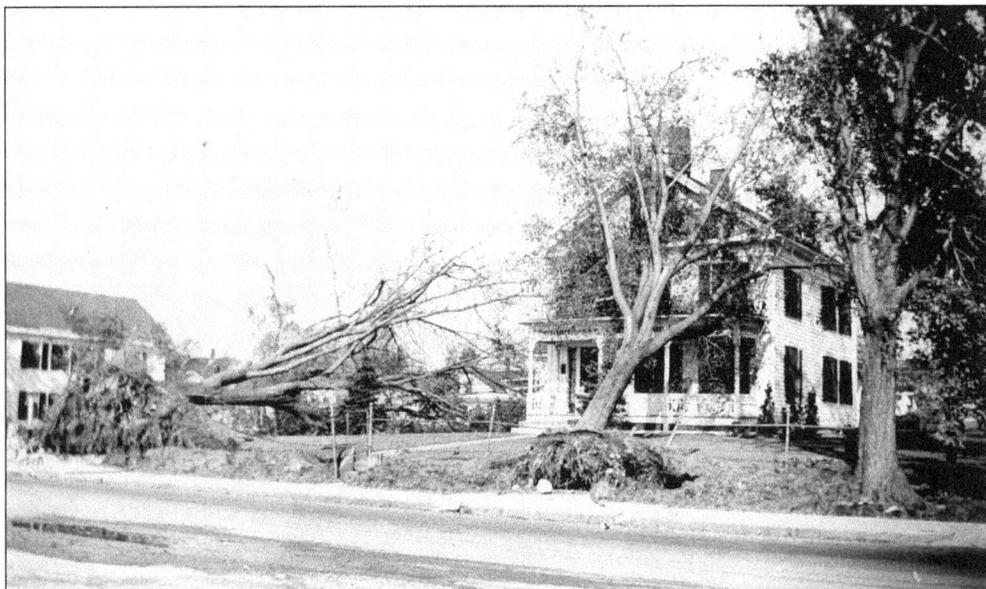

The Hurricane of 1938 was by far the most powerful storm to impact New England, but fortunately it did not cause severe damage in Webster. Hurricanes lose much of their power when over land. Webster's location, being approximately 50 miles inland, significantly reduced the potential damage. The September storm caused a lot of tree damage, resulting in the loss of power and some property damage, but nothing on par with the devastation of the 1936 flood. (Contributed by William Annesse.)

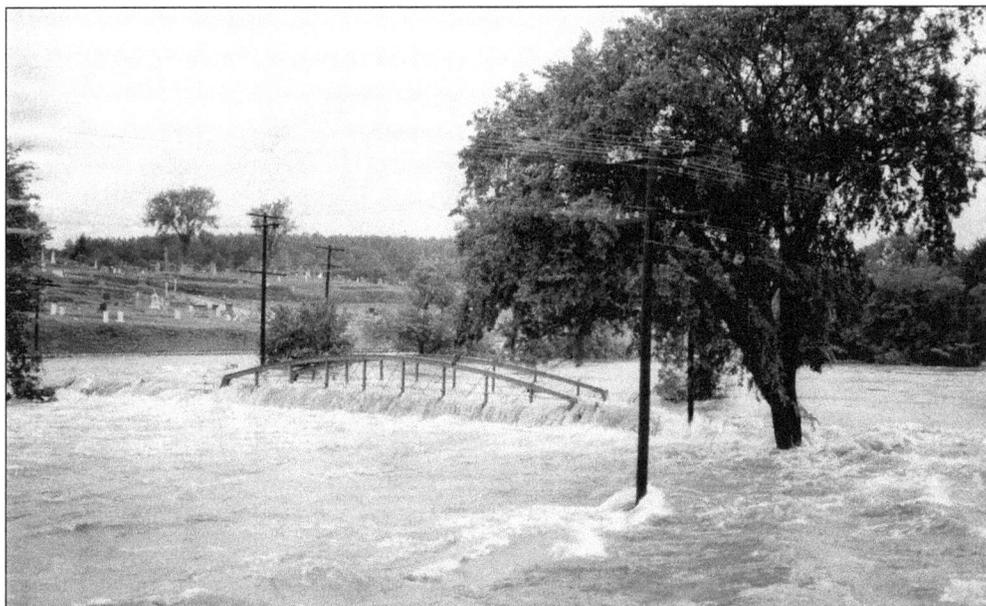

Since Webster's incorporation in 1832, the greatest natural disaster to impact the community was the flood of 1955. The amount of destruction, and its lasting effects, far outdistanced all other disasters that preceded and followed those fateful August days. In the scene above in North Webster, the bridge spanning the French River between Webster and Dudley is completely engulfed by the raging river. (Contributed by Robert Morin.)

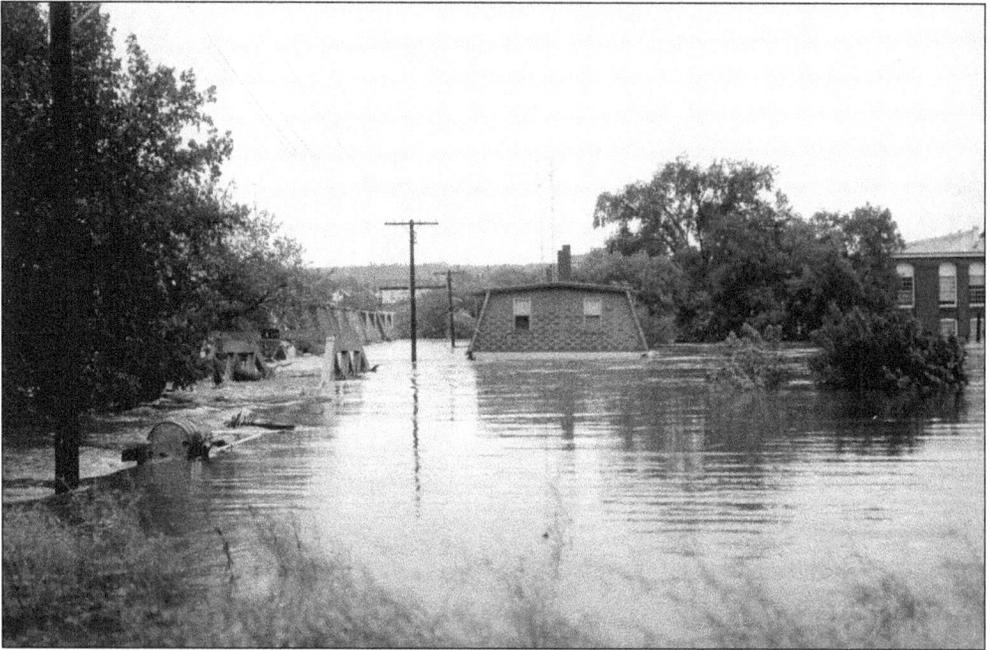

The floods, which occurred between August 18 and 21, 1955, were not a local phenomenon, as much of New England suffered the same fate. Hurricanes Connie and Diane deposited copious amounts of rainfall, with the situation being exacerbated by a series of dams bursting upstream. Factories and homes along the river were quickly inundated with water, forcing people to flee for their lives. For example, consider the water level at Garden City on Peter Street. (Contributed by Robert Morin.).

Bridges between Webster and Dudley were cut off, including this Main Street bridge, making it impossible to travel between the towns for several days after the flood of 1955. A large tank from upstream got hung up on the bridge. The water rose so quickly that people on Davis, Peter, Pleasant, and Union Streets had to be evacuated by boat, and more than 200 people were made homeless throughout the town. (Contributed by Robert Morin.)

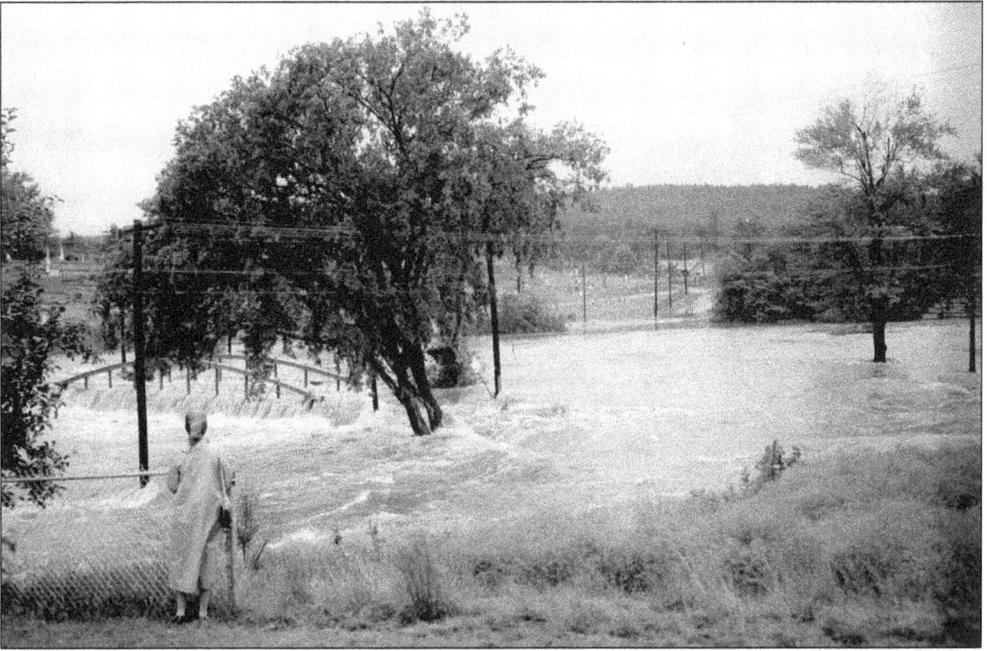

The levels that water reached in the 1955 flood were extraordinary. Despite the fact that the bridge crossing the railroad tracks on Mill Street was nearly 20 feet in height, it did not escape the rushing waters. Following the resumption of rail service, the New Haven Railroad had to rely on U.S. Army locomotives for a considerable time due to its loss of equipment in the flood. (Contributed by Robert Morin.)

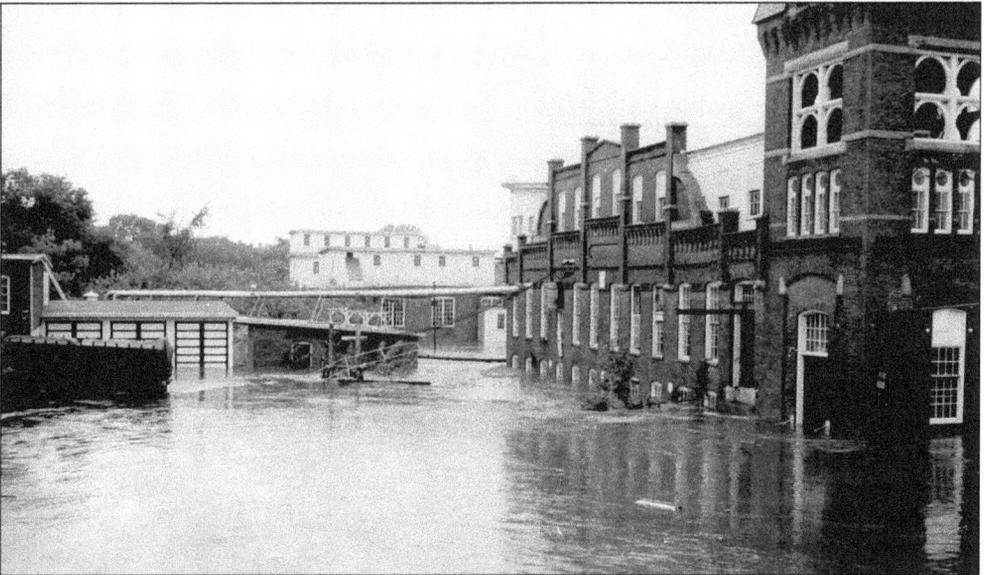

The local civil defense agency, police department, and fire department did an outstanding job in dealing with a very difficult situation. Residents who did not experience flood problems played a key role in supporting and assisting their less-fortunate neighbors. The factories and businesses experienced tremendous losses along the entire length of the river. This photograph of the South Village Mills area is a testament to that fact. (Contributed by Robert Morin.)

A gathering of prominent news people of the era was held at the home of selectman Joseph Patenaude, sometime around 1940. Pictured are, from left to right, the following: (front row) Tom Sweeney, Alfred Kleindienst, Joseph Patenaude, Eva Patenaude, Larry Daly; (second row) Jimmy Waldron, Mark Braniff, Marion Norton, Tony Saborowski, Gerry Norton, and John McCormac. (Contributed by Bruce White.)

The *Webster Times* is the publication of record for Webster. Since its first issue in 1859, the weekly (and at one time daily and biweekly) newspaper has covered the political, social, and athletic events of the community. Pictured here are compositor George Normandin, and well-respected journalists Edward Patenaude and Marion Norton, working on the *Times's* 100th anniversary issue in 1959. (Contributed by Webster-Dudley Historical Society.)

www.ingramcontent.com/pod-product-compliance
Lightning Source LLC
Chambersburg PA
CBHW050609110426
42813CB00008B/2506